BOMBAY TALKIES

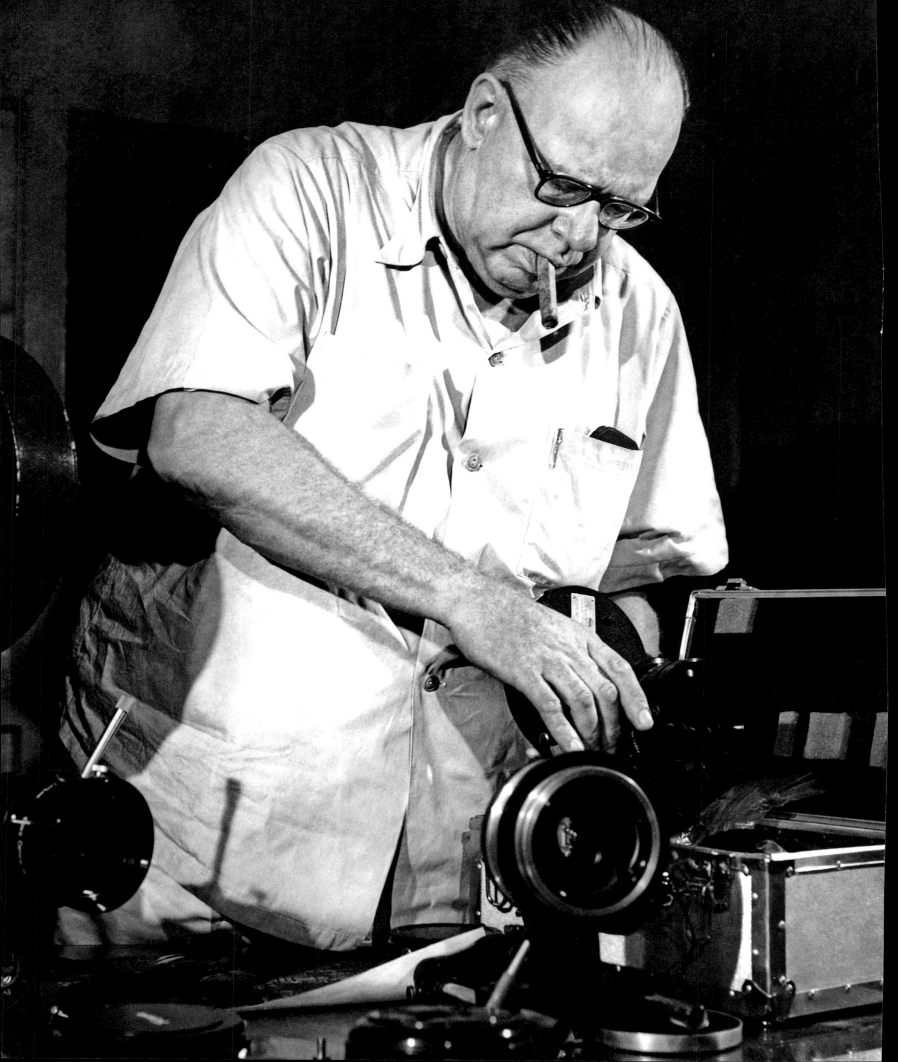

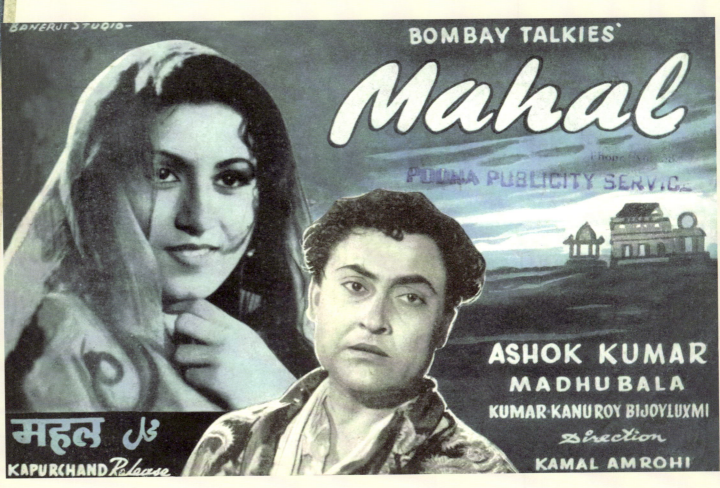
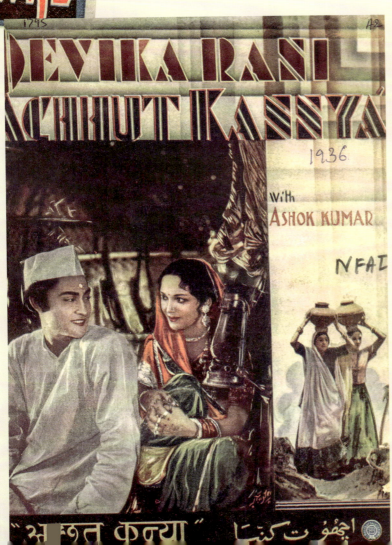
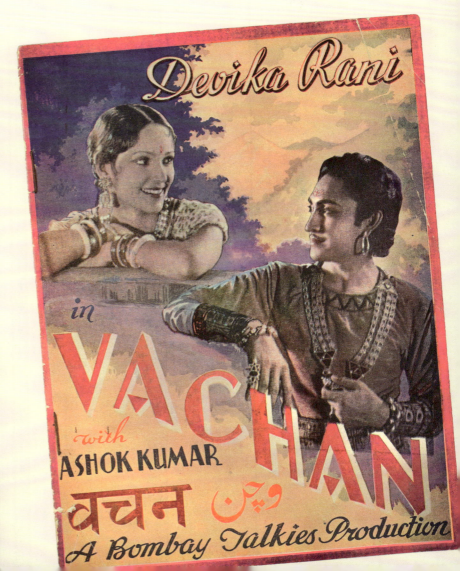

Josef Wirsching Archive

BOMBAY TALKIES

AN UNSEEN HISTORY OF INDIAN CINEMA

Edited by **Debashree Mukherjee**
Foreword by **Georg Wirsching**

Alkazi Collection of Photography in association with **Mapin Publishing**

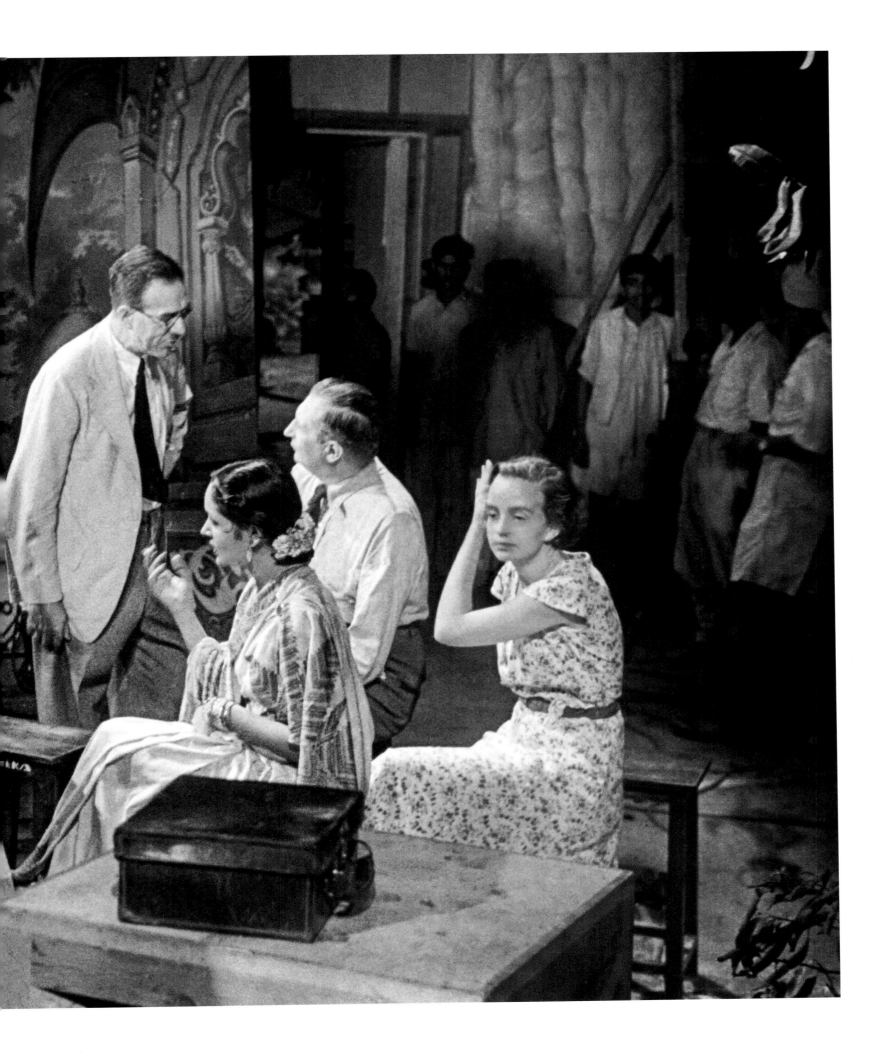

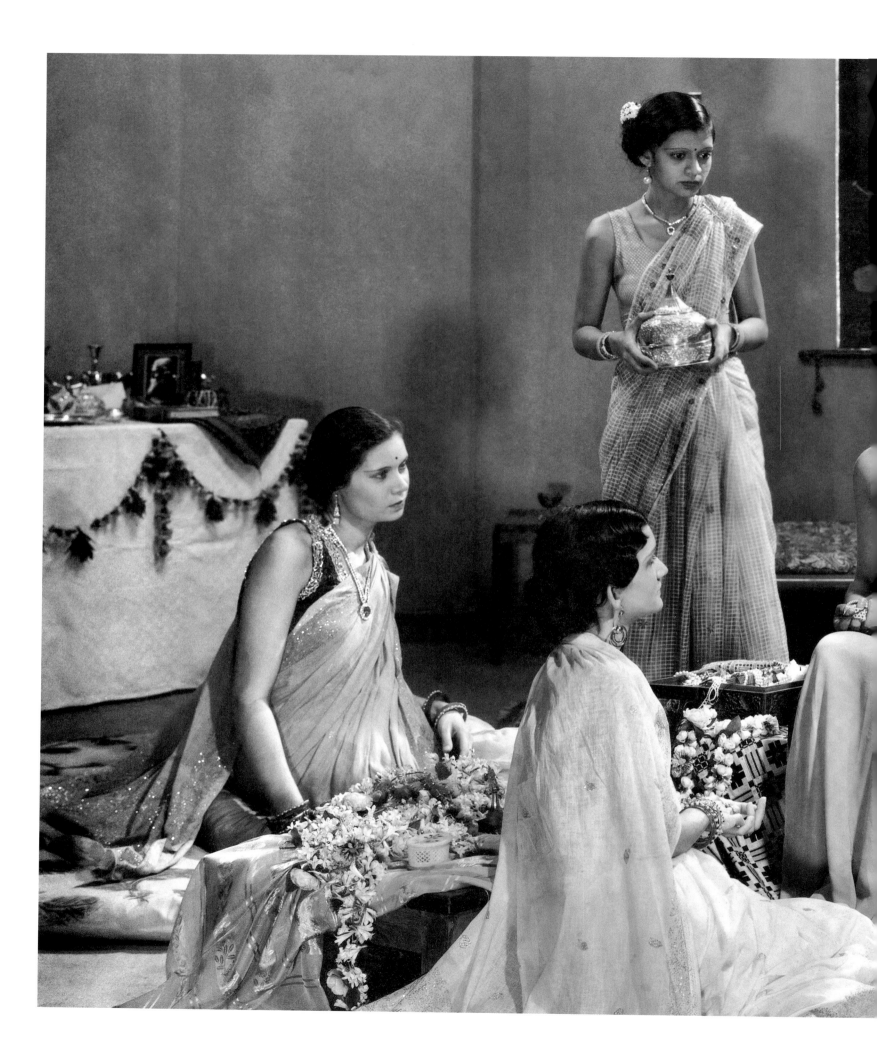

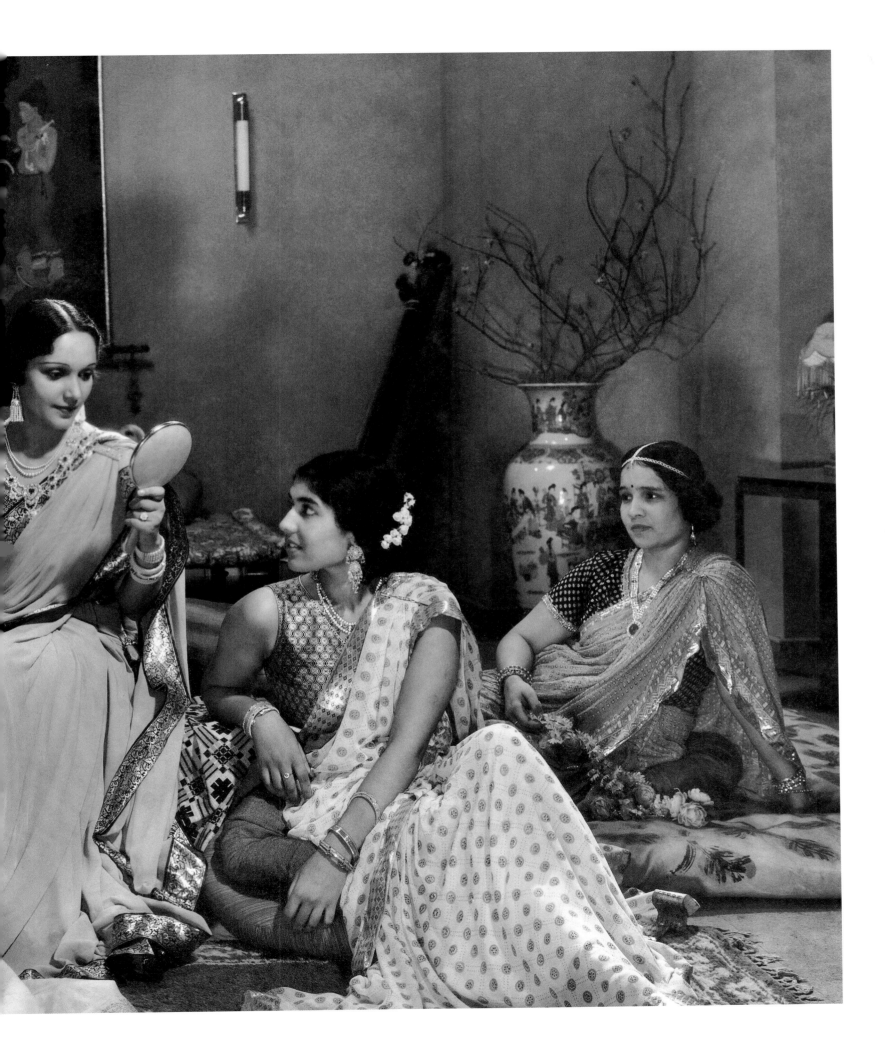

First published in India in 2023 by

Mapin Publishing
706 Kaivanna, Panchvati, Ellisbridge
Ahmedabad 380006 INDIA
T: +91 79 40 228 228 • F: +91 79 40 228 201
E: mapin@mapinpub.com • www.mapinpub.com

in association with

The Alkazi Collection of Photography
M 141 Greater Kailash-2,
New Delhi 110048 INDIA
T: +91 11 41437426/27
E: alkazifoundation01@gmail.com
www.alkazifoundation.org

International Distribution

North America
ACC Art Books
T: +1 800 252 5231 • F: +1 212 989 3205
E: ussales@accartbooks.com • www.accartbooks.com/us/

United Kingdom, Europe and Asia
John Rule Art Book Distribution
40 Voltaire Road,
London SW4 6DH
T: +44 020 7498 0115
E: johnrule@johnrule.co.uk • www.johnrule.co.uk

Rest of the World
Mapin Publishing Pvt. Ltd

Text © Authors
Image captions © Debashree Mukherjee and
Georg Wirsching
Illustrations © Josef Wirsching Archive/Alkazi Collection of Photography unless otherwise noted.

All rights reserved under international copyright conventions. No part of this book may be reproduced or transmitted in any form or by any means, electronic or mechanical, including photocopy, recording or any other information storage and retrieval system, without prior permission in writing from the publisher.

The moral rights of Debashree Mukherjee, Sudhir Mahadevan, Priya Jaikumar, Rachel Dwyer, Kaushik Bhaumik, Virchand Dharamsey, Eleanor Halsall and Georg Wirsching as authors of this work are asserted.

ISBN: 978-93-85360-78-7

Copyediting: Mithila Rangarajan/Mapin Editorial
Editorial Assistance and Coordination:
 Jennifer Chowdhry Biswas and Hitanshi Chopra/
 The Alkazi Foundation for the Arts
Proofreading: Marilyn Gore/Mapin Editorial
Design: Gopal Limbad/Mapin Design Studio
Production: Mapin Design Studio
Printing: Naveen Printers, New Delhi

This publication is also in conversation with the previous exhibition 'A Cinematic Imagination: Josef Wirsching and the Bombay Talkies,' co-curated by Debashree Mukherjee and Rahaab Allana with creative collaborator Georg Wirsching. It was first presented at Serendipity Arts Festival (Goa, 2017) in collaboration with the Alkazi Foundation for the Arts.

Captions:

Front Cover
Jawani ki Hawa, 1935
(See, p. 22)

Front Endpapers
Song booklet covers
Jawani ki Hawa (1935), *Achhut Kanya* (1936),
Mother and *Always Tell Your Wife* (1936),
Bombay Talkies, d. Franz Osten
Courtesy: National Film Archive of India, Pune

Prem Kahani (1937), *Vachan* (1938),
Bombay Talkies, d. Franz Osten
Josef Wirsching Archive

Mahal (1949),
Bombay Talkies, d. Kamal Amrohi
Courtesy: National Film Archive of India, Pune

Page 2
Josef Wirsching
1958
Gelatin Silver Print, 165 x 127 mm
JWA/ACP: 2020.01.0077

Pages 4–5
Jeevan Naiya, 1936
(See, p. 47)

Pages 6–7
Jawani ki Hawa, 1935
(See, pp. 110–111)

Pages 10–11
Jawani ki Hawa, 1935
(See, p. 166)

Back Endpapers
Song booklet covers
Jeevan Prabhat (1937), *Nirmala* (1938),
Nav Jeevan (1939), *Jeevan Naiya* (1936),
Bombay Talkies, d. Franz Osten
Josef Wirsching Archive

Pakeezah (1972), Mahal Films/Kamal Pictures,
d. Kamal Amrohi
Courtesy: Debashree Mukherjee

Back Cover
Izzat, 1937
(See, p. 60)

This book is dedicated to the memory of

Wolfgang Peter Wirsching (1939–2016) and **Rosamma Wirsching (1940–2021)**

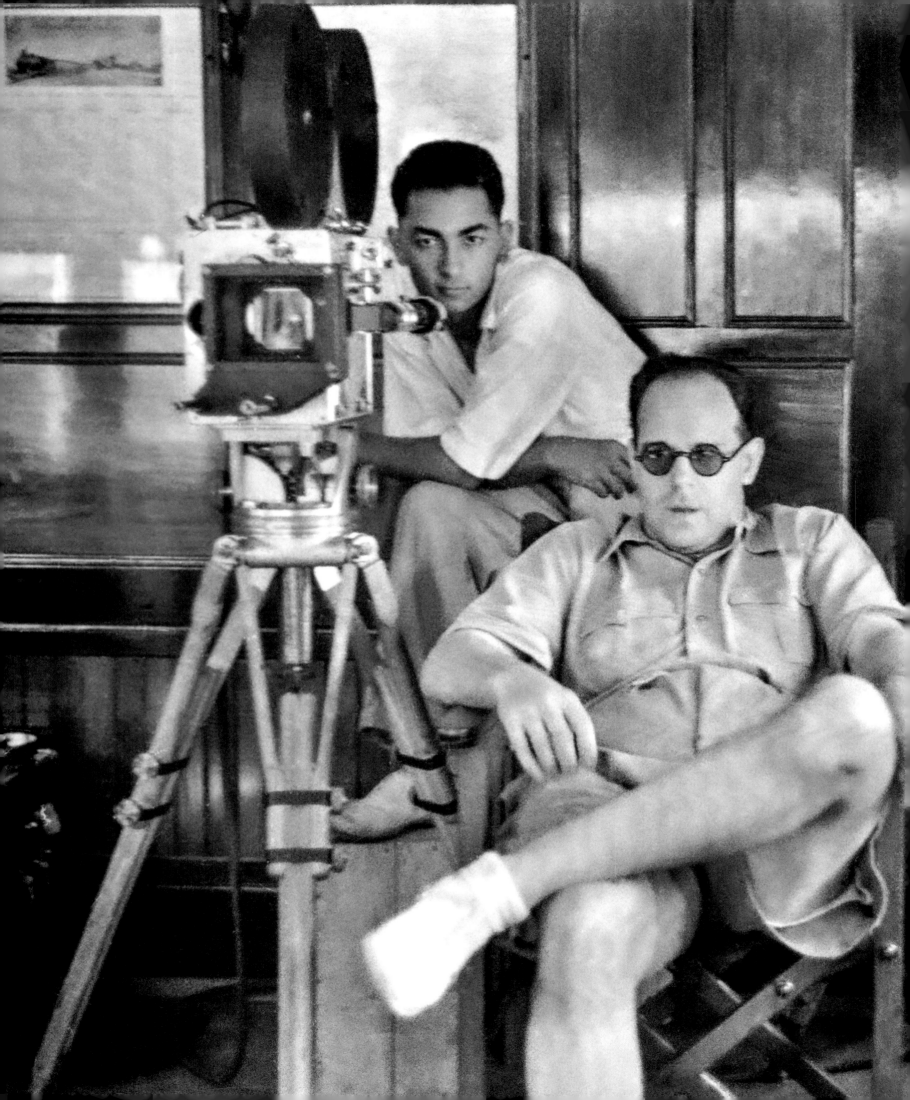

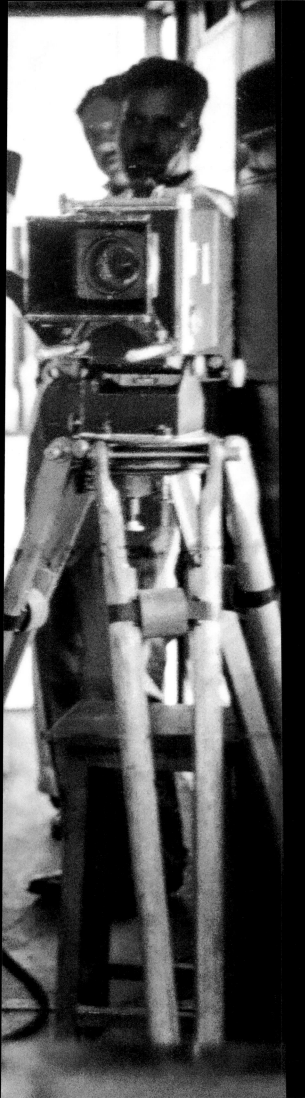

Contents

Foreword
Georg Wirsching

Introduction
What Photography Can Tell Us About Cinema's Past
Debashree Mukherjee

1. **How Photography Gives an Account of Itself**
 The Wirsching Collection as a Nation of Photography
 Sudhir Mahadevan

2. **The Knot**
 A Scholar and an Angel Unravel Izzat (1937)
 Priya Jaikumar

3. **A German Eye on Indian Beauty**
 Josef Wirsching's Portrayal of the Female Star in Hindi Film
 Rachel Dwyer

4. **Between the Studio and the World**
 Built Sets and Outdoor Locations in the Films of Bombay Talkies
 Debashree Mukherjee

5. **Re-Visioning Bombay Talkies: Restoring Parallaxes to an Image**
 A Conversation with Virchand Dharamsey
 Kaushik Bhaumik

6. **Josef Wirsching and the *Kreuzer Emden***
 The Entangled Politics of the Interwar Period
 Eleanor Halsall

Josef Wirsching's Filmography

Acknowledgements

Works Cited

Index

Foreword

■ Georg Wirsching

In May 1967, Wolfgang Peter Wirsching received a distressing and fateful telegram from his father, Josef Wirsching, informing him that his dear mother, Charlotte, was on her deathbed, and if he wanted to see her again he'd have to come to India immediately. Peter was in Hamburg, Germany.

This one poignant moment has brought us to where we are today and it helps define the circumstances of how the Wirsching Archive has become what it is now.

Josef Wirsching was a cinematographer who learned and perfected his craft in Germany in the mid-1920s and eventually became a paragon of technical innovation and cinematic brilliance through a career spanning forty years. Most importantly, his love for India is evident in his decision to live in this country and in the stories he captured with his camera's lens.

Josef Wirsching was born on March 22, 1903, into a reasonably well-to-do family in Munich, where his father, Josef Wirsching Sr, ran a successful business as a set designer and theatrical costumer. His father wanted him to become an architect, but when young Josef was gifted a film camera on his sixteenth birthday he found a different calling. After much fighting with his father, Josef started his career as an apprentice photographer and cinematographer at the Weiss-Blau-Film studios in Munich. He also studied photography theory at the state-run trade school in Munich. In 1923, Josef joined Emelka Studios (now Bavaria Films) as an assistant cameraman and laboratory assistant and was soon working as a film cinematographer on the studio's epic film productions.

In 1924, Himansu Rai, an Indian lawyer living in London, convinced Emelka to collaborate on an international co-production for the film *The Light of Asia*, changing Josef's life and the future of Indian filmmaking.

The concept of *The Light of Asia* was based on a script about the life of Lord Buddha, written by Niranjan Pal, an Indian playwright in England who was a good friend of Himansu Rai's. The script was itself based on a poem by the English poet Edwin Arnold. The script was initially envisioned to be a theatrical play, but it was way too expensive to be portrayed on stage and so Himansu Rai decided to make it into a silent film.

Josef Wirsching and Charlotte Wirsching on a holiday to Arthur Lake in Maharashtra in 1965.
Josef Wirsching Archive

After meetings with numerous film studios in England, who were all reluctant to risk making a film of this magnitude, Rai finally approached Emelka Studios. Upon hearing his story, the studio bosses at Emelka were willing to take on the challenge of their first international co-production in India. As part of the collaboration, Emelka provided the main technical crew, consisting of Franz Osten as director, Josef Wirsching as the main cameraman, Willi Kiermeier as the assistant cameraman, and Bertl Schultes for production and translation. Emelka also provided all the equipment and material and handled processing and editing of the final movie. Himansu Rai was to provide an Indian cast and organize finances for expenses, which amounted to Rs 1,00,000; the film would be billed as one of the most expensive to be made that year. *The Light of Asia* was shot completely on location in India with the assistance of the Maharaja of Jaipur at his palace in 1925. The film was completed in 1926 and premiered to large audiences in Europe.

Through this project, Josef Wirsching encountered India for the first time. His second encounter was in 1927–28 when Emelka deputed him to film a travelogue documentary. Along with an assistant cameraman and two drivers, Josef travelled overland from Munich to Calcutta (now Kolkata) in two specially modified Mercedes-Benz automobiles. The team set off across the Mediterranean Sea on August 4, 1927, via a steamer ship to Egypt, from where they continued by land into Lebanon, the Syrian Desert, Iran, Iraq, Afghanistan, and then into India through Lahore. From here they continued on to Bombay (now Mumbai), then to Delhi and Benares (now Varanasi), finally reaching Calcutta in early 1928. When the Emelka bosses reviewed the footage shipped to Germany, they were so impressed that they directed Josef and his assistant to continue filming the travelogue from Calcutta to Rangoon. Due to the rough terrain, the team was unable to use the Mercedes-Benz vehicles and hence this second leg of the journey was done mostly on foot and by any other means available. They left Calcutta on March 7, 1928, and finally left Rangoon by steamer on May 26, 1929. This was an extremely harsh and rugged journey, although an eventful experience for the twenty-five-year-old Josef Wirsching. After returning to Germany, Josef continued filming numerous iconic films for Emelka. In January 1929, Josef married his childhood sweetheart, Charlotte Mühlberger.

In the late 1920s, Himansu Rai and Franz Osten co-directed a few films at the UFA studios in Berlin. The actor Devika Rani had also moved to Germany and together they witnessed the overwhelming fascist political atmosphere that was brewing. Rai now started to plan his own state-of-the-art film studio in Bombay. After successfully procuring the necessary financial assistance from various Indian businesspersons and bankers, Rai was able to institute the Himansurai Indo International Talkies Ltd (HRIIT), which later became Bombay Talkies.

With the advent of the Great Depression, Emelka faced financial problems, even as the Nazi movement took root in Germany. This was when Rai again approached Emelka for technical support. At his request, Emelka Studios offered to help him procure all the equipment that he would need to set up the studio and also offered him the services

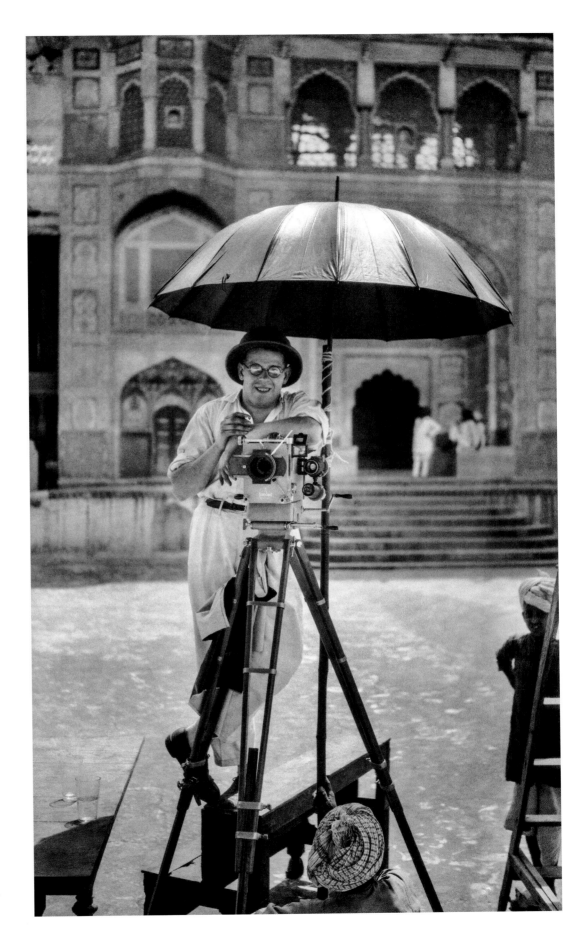

The Light of Asia
1925, Emelka Films & Great Eastern Film Corporation, d. Franz Osten
80 x 140 mm Negative
Josef Wirsching Archive

Josef Wirsching with his Askania camera on a tripod under an umbrella outside the City Palace, Jaipur.

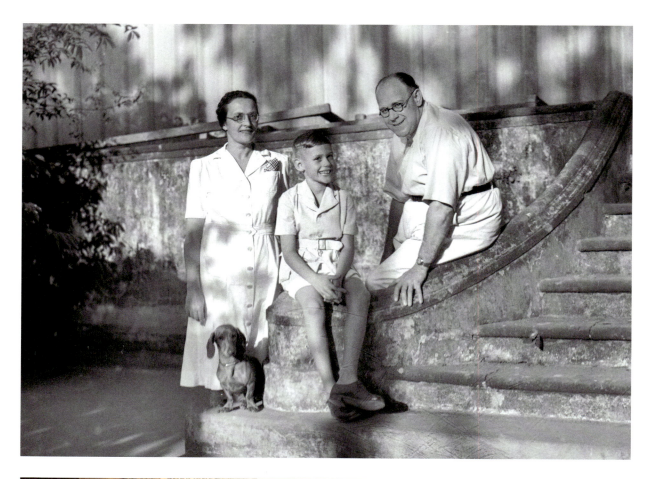

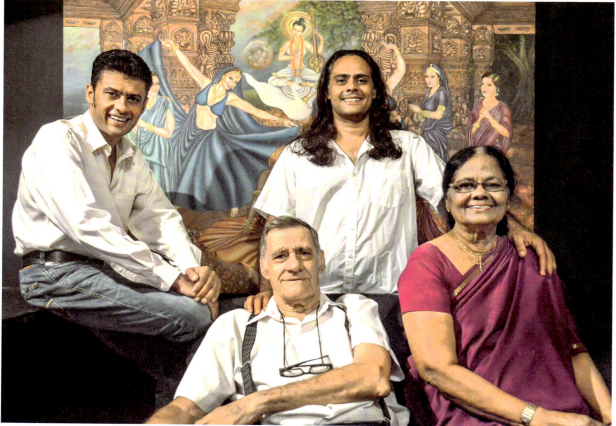

16 Georg Wirsching

of some of their best film experts, including Franz Osten as director, Josef Wirsching as director of cinematography, Karl Graf von Spreti as film architect (set designer), Wilhelm Zolle as the laboratory-in-charge and Benjamin Hartley as the chief sound technician.

Based on conversations with my father, it appears certain that Josef, my grandfather, wanted to distance himself from Nazi ideology and what he viewed as a madness that had gripped his homeland in the early 1930s. Bombay Talkies provided Josef a wonderful opportunity to take himself and his wife away to India to start a new life in a place to which he felt a strong connection. A series of curious encounters confirmed this feeling of connection. In 1925, when Josef first came to India to film *The Light of Asia*, a court astrologer at the Jaipur Palace told him, "Welcome back to India." Josef, a bit taken aback by this odd statement, explained to the astrologer that he had never been to India before but the astrologer simply told him that Josef had very much been an Indian in a previous lifetime, which was why he instinctively knew so much about the country, why he loved the food and why the oppressive heat did not affect him as much as it did the rest of the German crew. Later on, in 1927, when Josef reached the banks of the Indus (or Sindhu) River, as he was entering India on his overland trip, he encountered a travelling fortune-teller who told him that he would marry the love of his life and do great things in India. Finally, in 1928, when Josef reached Benares, he encountered an Aghori ascetic on the banks of the Ganges, who read his palm and predicted that Josef would go on to do great things, leaving behind a great legacy that would manifest itself through his family that would stay on in India after him. These three separate encounters solidified Josef's conviction that coming to India to help start Bombay Talkies would be the next best stage in his life.

Bombay Talkies was incorporated in 1934 and they were ready with their first production, *Jawani ki Hawa*, in 1935. In the years that followed, the studio made several socially relevant movies that questioned the patriarchal norms and social misogyny of the times. Influenced by the Indian freedom struggle, this was a decade of the Indian "social film" and Bombay Talkies made several reformist films and soon came to stand out as a beacon for changing social values. The German crew also trained many young men and women in film craft, and many apprentices of the studio found themselves becoming award-winning actors, directors, editors and producers over the years to come.

Unfortunately, when World War II broke out in September 1939, as a German national living in British India, Josef was immediately interned in the prisoner-of-war camps set up for "enemy aliens." He was first placed in the Dehradun and Deolali camps and then moved to the main camp at Ahmednagar before he was allowed to be reunited with his family in 1944 in the Satara camp, which held the women and children. Josef and his family were finally released from internment shortly before India gained independence. All detainees had to be either sent back to their countries of origin or had to return to their previous jobs in the countries where they were detained; Josef chose to stay in India and return to Bombay

ABOVE
Charlotte, Peter and Josef Wirsching with their pet dachshund Pooky on the steps outside the entrance to one of the studio buildings of Bombay Talkies in the early 1950s.
Josef Wirsching Archive

BELOW
Peter and Rosamma Wirsching with their sons Georg and Josef in one of the last family pictures at their home in Goa in late 2015 before Peter took seriously ill and passed away in August 2016.

Foreword 17

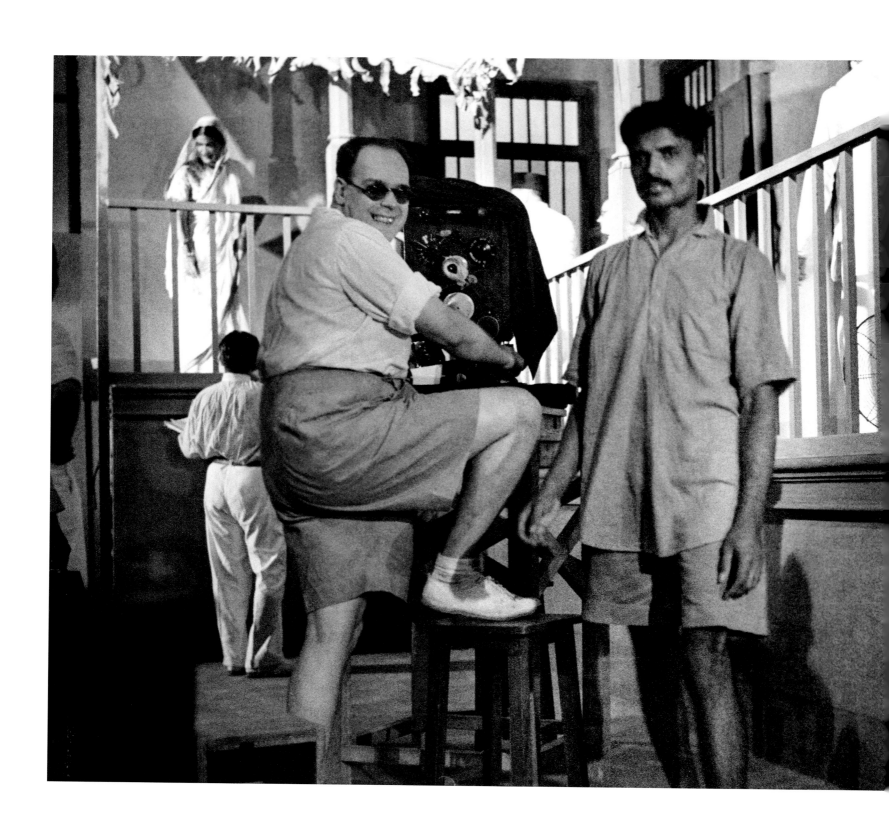

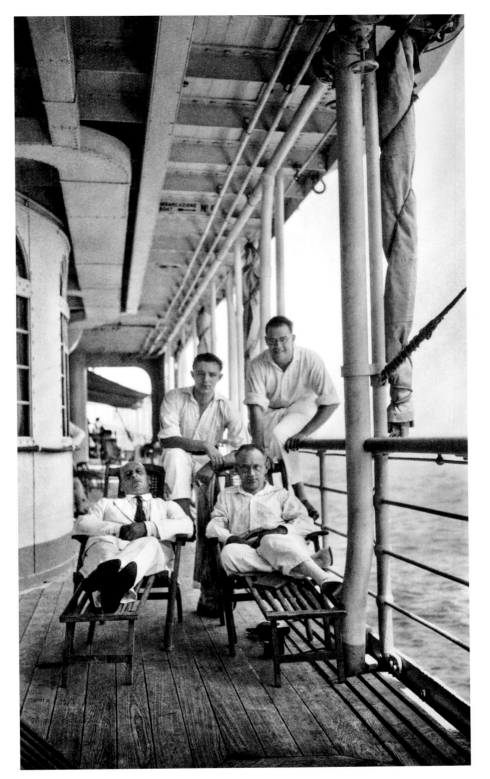

ABOVE
The Emelka Team
c. 1925
65 x 110 mm Negative
JWA/ACP: 2019.01.0044

The Emelka crew on their long sea voyage to India. From left to right: Willi Kiermeier (standing), Josef Wirsching, Bertl Schultes and Franz Osten (seated).

LEFT
Jeevan Naiya
1936, Bombay Talkies, d. Franz Osten
35 mm Negative
JWA/ACP: 2020.01.0023

Talkies. In 1944, Josef's family home in Munich was bombed out by an air raid conducted by the US Air Force and, having nothing to go back to in Germany, Josef decided to live out the rest of his years in India. Bombay Talkies—though considerably altered by Himansu Rai's death in 1940 and the departure of Devika Rani in 1945—was more than happy to welcome Josef back into its fold. The studio finally closed down in 1954. It is to be noted that the history of Bombay Talkies is an important part of the history of the early talkies and Indian film heritage, which in turn is a history shared by Josef Wirsching.

In 1954, Josef joined the newly created production house AMA Limited, set up by W. Hesse, a supplier of photographic equipment in Bombay. AMA was set up to cater to the need for educational films and documentaries commissioned by the Indian Government and the United States Information Service (USIS) during the nation-building efforts of the 1950s. It was during this time that Josef shot several documentaries and advertising films in both colour and black-and-white. When Kamal Amrohi set up his own company in 1958, he invited Josef, his former cinematographer on *Mahal* (1949), to join as Director of Photography. They made three films together—*Dil Apna aur Preet Parai* (1958), *Daera* (1959) and *Pakeezah* (1972), a classic that took sixteen years to complete. Josef Wirsching died in 1967 before the filming of *Pakeezah* was complete, and numerous assistant cameramen desperately tried to mimic his style of cinematography for the last few scenes that were pending.

Josef and Charlotte's only son, Wolfgang Peter Wirsching, was born in Bombay in February 1939 and he spent the first few formative months of his life in the Bombay Talkies studio complex. His early childhood was spent in internment camps (1940–1945). In 1956, at the age of seventeen, he went to Germany to study automobile engineering at the Mercedes-Benz Technical Institute in Stuttgart.

In the years that followed, Wolfgang Peter (known to his family as Peter) finished his technical training and went on to hold numerous positions in various automobile establishments around Germany until he finally found himself in Hamburg as a sales manager for an automobile firm. This is when he received the fateful telegram from his father informing him of the sad news that his mother had been hospitalized. After a decade of being away, Peter threw whatever possessions he had into a suitcase and caught the first flight to India. He reached the hospital on May 24, 1967, where his mother was battling multiple organ failure brought on by cancer. He was just in time to say his final goodbyes before she passed away on May 28, 1967. Over the next two weeks, Peter saw his father mope around the house like a lost soul and on June 11, 1967, Josef passed away in his sleep from a major cardiac arrest. It could be said that Josef died from a broken heart.

As a cinematographer, Josef Wirsching most certainly defined the look of the films he worked on and thus influenced Indian cinema. During his long, illustrious journey he also photographed extensively, on film sets and off, to create a large personal archive of cinematic and ethnographic images, which remained in his collection till his death.

Following the demise of his parents, Peter found himself struggling to prove his identity as the son of Josef and Charlotte Wirsching to numerous debtors and even the Indian Government, who doubted his legacy. He was forced to sell a lot of his mother's jewellery just to keep himself afloat, and had to decide what to do with the room full of camera equipment, lights and studio material which he found in his father's possession. That was when he decided to donate all the cameras and studio equipment that Josef had acquired through his lifetime to the Film Institute of India, where Josef in his final years had been a visiting faculty member. Thankfully, Peter retained all the photographic prints, rolls of negatives and all other albums of photographic images his parents had accumulated over their years in India, and preserved it all in a waterproof, airtight steel trunk, storing it away at his home in Bandra in Bombay.

In 1972, through the aegis of a close family friend of his parents, Peter serendipitously met Rosamma George, a humble girl hailing from a large Christian family in Kerala, who was working at an advertising agency in Bombay at that time. On their first outing, Peter took Rosamma to a premiere showing of his father's last film, *Pakeezah*, which had just been released, and he pointed out to her a scene where his father appears in a cameo role, saying, "This is my father and this movie we're watching was the last movie he made." They courted for a few months and, after duly receiving the blessings of Rosamma's parents, married in January 1973. They had a wonderful wedding ceremony, celebrated in Rosamma's family church in Kerala where Peter was treated like visiting royalty.

Peter and Rosamma Wirsching started their own family in Bombay and they had two sons, whom they christened Josef and Georg, after Peter's father and Rosamma's father, respectively. Throughout the years, wherever Peter, Rosamma and the boys travelled, the steel trunk with Josef Wirsching's photographic work accompanied them. With every change in geographical location, almost every other year, Peter would open the trunk to check on the condition of the photographic material inside.

It was when I was in my teen years that I started asking my father what was in this steel box that we were carting around with us everywhere, and that was when he told me that it was the work my grandfather had done in his lifetime as a cinematographer in German and Indian cinema. I went on to study art, photography, filmmaking and their histories, and I learnt who my grandfather Josef Wirsching was and what his impact on Indian cinema had been. It was then that my father told me that when I was ready I would know what I needed to do with what he had so preciously preserved in that steel trunk all these years.

It is this legacy that we, the descendants of Josef Wirsching, wish to share with the world so that everyone may understand his contributions, and that through simplicity, humility and dedication a lot can be achieved.

<div style="text-align: right;">
Moira (Goa)
January 2020
</div>

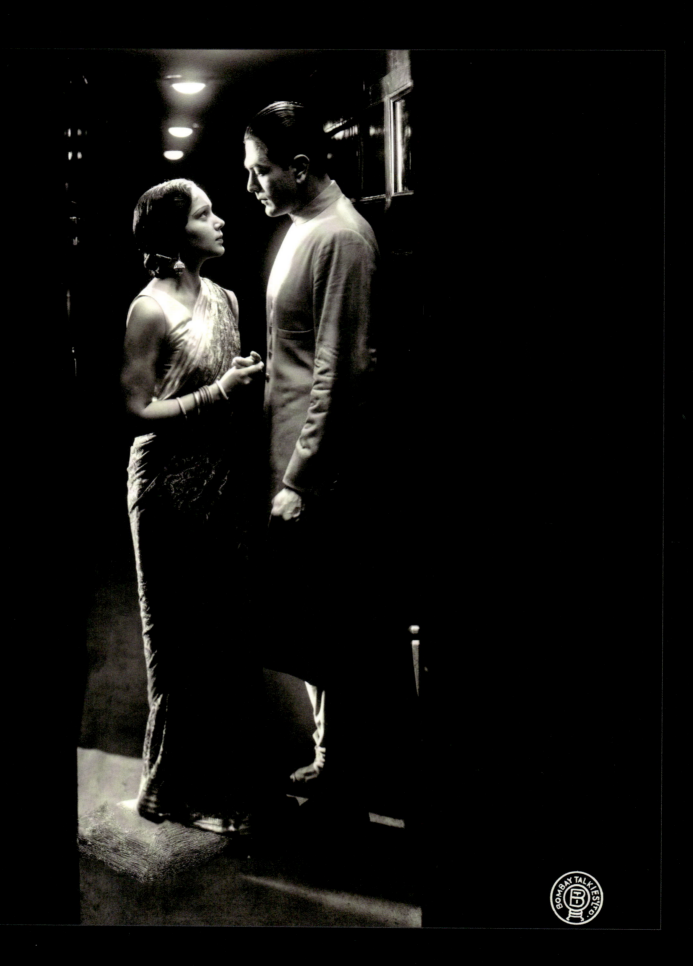

Introduction

What Photography Can Tell Us About Cinema's Past

■ Debashree Mukherjee ■

Ever since films became a popular medium of mass entertainment, audiences have been intensely curious about life and work on a film set. How are films made? we have wondered, hoping that first-hand knowledge of a film set will explain and subdue the hold that cinema has on us. If we could only peer behind the scenes, we might be free of the seduction of the screen. But, fortunately or unfortunately, that has rarely happened. The experience of the film set has historically confounded any straightforward process of demystification. Even the most casual witnesses of a film shoot frequently depart more starry-eyed than before. Consider this testimony from the legendary film journalist B. K. Karanjia:

> My interest in cinema was first aroused in 1934 when a group of us students from Wilson College were taken on a study tour of the Bombay Talkies studio at Malad. The picture being filmed and directed by the German director Franz Osten had the rather intriguing title *Always Tell Your Wife*. The scene being shot showed Najmul Hussain holding Devika Rani in a close embrace, whispering sweet nothings into her ear. Oh, I'd have given anything to be in Najmul Hussain's shoes! In my adolescence, Devika Rani appeared to me the most beautiful girl I had ever seen, the goddess of my dreams!

The young Karanjia was so moved by the spectacle of a live romantic scene unfolding before his eyes that he longed to trade places with the film's hero. And Devika Rani's starry charms, rather than appear diminished in real life, were heightened on set.

In this book, we present a selection of photographs from the personal archive of Josef Wirsching, one of the pioneering film artistes of Indian cinema. These photographs, most

FIG. 1 *Jawani ki Hawa*
1935, Bombay Talkies,
d. Franz Osten
Lobby Card (Gelatin Silver Print), 294 x 246 mm
Josef Wirsching Archive

Kamala (Devika Rani) and Ratanlal (Najmul Hussain) share an anxious moment on board a speeding train in Bombay Talkies' debut feature film.

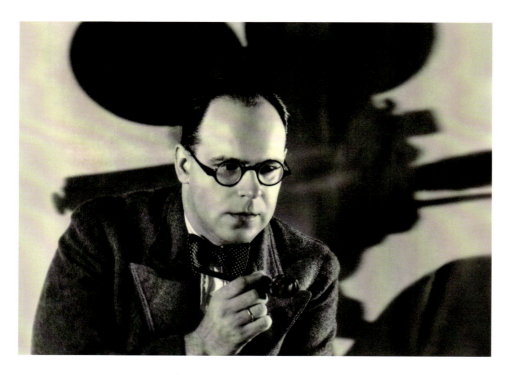

FIG. 2 Josef Wirsching
c. 1924
Gelatin Silver Print,
119 x 154 mm
Josef Wirsching Archive

A dramatic portrait of a young Josef Wirsching, with pipe in hand and the shadow of a film camera in the background. This image was taken in Germany when he was working for Emelka film company.

of them taken on film sets and outdoor locations, show us a world of meaning that was never intended to be projected on the silver screen. These behind-the-scenes photographs add new layers to how we understand cinema and the past.

When first confronted by these images, one feels something in the body. A range of sensations courses through your veins before you can articulate what these sensations signify. If you're a film historian like I am, you might feel surprise and excitement because you were never expecting to see anything like this. The archive of Indian cinema is notoriously fragmented and many of the primary sources that scholars working on Hollywood take for granted, we have accepted as lost. Not only are more than 90 per cent of pre-Independence Indian films considered lost forever, we currently have very limited access to paratextual materials like studio papers, contracts, and screenplays. Production stills of the kind preserved by the Wirsching family are absolutely unprecedented for the 1930s.

Seeing images of film practitioners immersed in the work of making movies, attempting to build a new local industry and shape an emerging art form, unsettles our assumptions about the past in fundamental ways. For one thing, these images show us that early filmmaking in India was often organizationally and technically robust despite the well-known challenges of finance and infrastructure. We are also confronted with the fact that the pioneers of Indian cinema belonged to many different classes, religions, castes, genders, even nationalities, and it would be false to demand a superficial authenticity from the past. Instead, as the essays in this book suggest, the past continues to surprise us as new sources emerge, showing us that history itself is a vital ongoing project.

Josef Wirsching and Indian Cinema

The story of Josef Wirsching is intimately tied in with the story of Bombay Talkies, a film studio that has an undisputed place in the history of Indian cinema. While films like *Achhut Kanya* (1936) and *Kismet* (1943) are considered important milestones in the career of sound cinema from Bombay (now Mumbai), many of the studio's stars and technicians actively shaped commercial filmmaking in twentieth-century India. From Ashok Kumar, who started as a rookie laboratory assistant at the studio, to Dev Anand, who made his acting debut with *Ziddi* (1948), several of India's best-loved stars began their film careers at Bombay Talkies. Interestingly, a review of *Ziddi* in *The Times of India* noted that the film was "distinguished by some of the finest photography we have seen in years on the Indian

FIG. 3 *Izzat*
1937, Bombay Talkies, d. Franz Osten
35 mm Negative
JWA/ACP: 2020.01.0011

Josef Wirsching, Devika Rani, R. D. Pareenja and Franz Osten cool off during a location shoot.

screen—the camera in fact steals the picture," and therefore, according to the reviewer, the real star of the film was not the debutant Dev Anand but Josef Wirsching's cinematography. The work of reinstituting Josef Wirsching within the known history of Indian cinema offers us an expansive perspective on the contours of so-called national cinemas. How can a German cinematographer be considered a pioneer of Indian cinema? And what was he doing in the Bombay film industry in the first place? Tracking these questions leads us to a fascinating network of people, places, and practices that converged on Bombay city in the 1930s. From London to Lahore, Calcutta (now Kolkata) to Berlin, the Bombay film industry was built by people and resources from across the world. When one enquires after the ethnicities, linguistic identities and nationalities of the pioneers of Bombay Talkies, it becomes clear that the category "Indian cinema" is a tenuous construct and includes a wide array of trans-regional and transnational influences, borrowing from Hollywood and Parsi theatre even as its practitioners crossed the borders of old and new nation states.

Born in Munich, Germany, in 1903, Josef Wirsching experienced all the cultural ferment of the interwar years. Cinema was still a fledgling art form at the time, and was radically influenced by Munich's robust theatre and photography scene. For instance, the Ostermayr brothers (Franz, Peter and Ottmarr) ran a photography studio, studied acting and worked at Max Reinhardt's Kammertheater before they turned wholeheartedly to filmmaking.

Josef Wirsching himself was slated to take over his father's costume and set design studios, but had a career epiphany when he was gifted a still camera on his sixteenth birthday. Against initial family resistance, Josef enrolled in an industrial arts school to study

Introduction 25

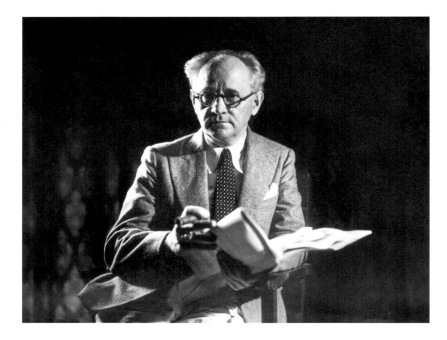

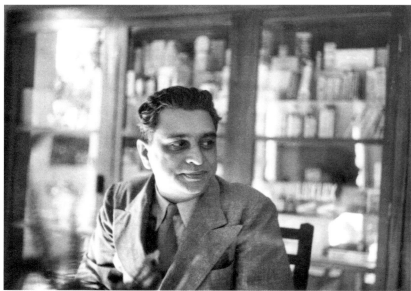

photography and subsequently joined Weiss-Blau-Film as an apprentice photographer. By the early 1920s, Peter Ostermayr's Emelka film company had become a greatly desired destination for young people wanting to make a name in cinema. Josef Wirsching joined Emelka at this time, as did another young man named Alfred Hitchcock.

Back in India, at the turn of the century, Indian artists were actively trying to forge an aesthetic language that could be simultaneously nationalist as well as modern. Frustrated with European academic canons and colonialist stereotypes, they turned to local artistic genealogies and avant-garde movements outside the British Empire. Germany, with its long history of Indological enquiry, became an ally in this endeavour. Thus it is that Rabindranath Tagore visited Germany in the 1920s, and, in turn, the Austrian art historian Stella Kramrisch joined Santiniketan and organized a landmark Bauhaus exhibition in Calcutta (1922). This two-way cultural exchange was keenly felt in the world of cinema; the success of "Oriental" films such as *Sumurun* (1920), *The Tiger of Eschnapur* (1921) and *The Indian Tomb* (1921) was met with the ambition of Indian filmmakers who approached German studios for technical training. Raja Ravi Varma had already popularized German chromolithographic techniques and European approaches to the body through his mass-produced calendar art. In the 1920s, intrepid filmmakers such as V. Shantaram, Mohan Bhavnani and Himansu Rai travelled to film studios in Germany to study cutting-edge cinematic techniques. In the surviving films of the 1930s, one can discern multiple aesthetic influences, from Bengal school portraiture and Art Deco industrial design to newly formalizing Hindustani classical music conventions.

In 1924, Himansu Rai approached Emelka with a proposal to collaborate on an epic on the life of Gautama Buddha. Rai was a lawyer-turned-actor who ran a theatre company with writer Niranjan Pal called the Indian Players, in London. He was a dynamic media entrepreneur and was actively looking for producers to support silent film projects on Indian themes. *The Light of Asia* was Rai's dream project and it tapped into the neo-

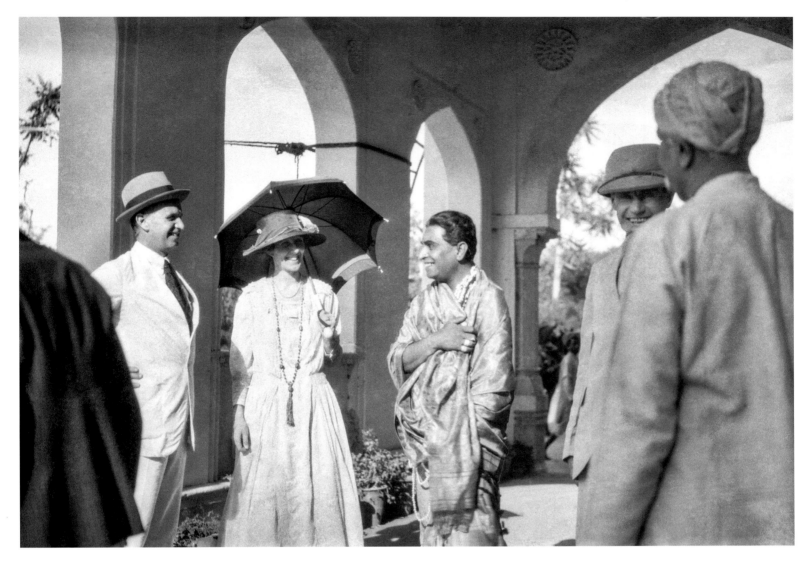

FIG. 6 *The Light of Asia*
1925, Emelka Films & Great Eastern Film Corporation, d. Franz Osten
80 x 140 mm Negative
JWA/ACP: 2019.01.0038

Himansu Rai dressed up as Gautama Buddha in conversation with guests at the Residency Hotel in Jaipur during a break between shots.

FACING PAGE
ABOVE
FIG. 4 **Franz Osten**
Gelatin Silver Print, 117 x 89 mm
JWA/ACP: 2019.01.0003

Franz Osten (1876–1956), born Franz Ostermayr in Munich, directed seventeen Hindustani-language films for Bombay Talkies between 1934 and 1939. Well-adept at photography, acting and direction, Osten was responsible for some of the biggest hits of early Bombay cinema.

BELOW
FIG. 5 **Himansu Rai**
Gelatin Silver Print, 84 x 120 mm
JWA/ACP: 2019.01.0011

Himansu Rai (1892–1940), a student of Rabindranath Tagore who went to London to study law and eventually took up acting, was the founder of Bombay Talkies Ltd, Malad.

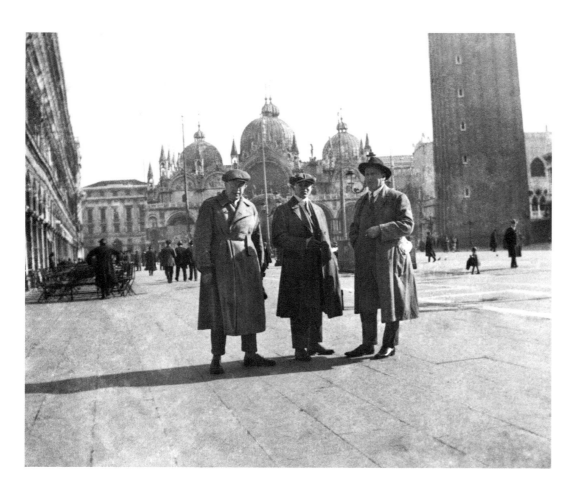

FIG. 7 The Emelka Team
c. 1925
45 x 60 mm Glass Plate Negative
JWA/ACP: 2019.01.0046

Left to Right: Josef Wirsching, Willi Kiermeier and Bertl Schultes in the Piazza San Marco in Venice before embarking on their steamer trip to Bombay.

Buddhist revival in 1920s Germany, evidenced in the works of Thomas Mann, Bertolt Brecht and Herman Hesse. Thus, in 1925, a dream team comprising Franz Osten (director), Josef Wirsching (principal camera), Willi Kiermeier (assistant) and Bertl Schultes (as interpreter) sailed for India. Jointly produced by Emelka and the Great Eastern Film Corporation (Delhi), *The Light of Asia* was notable for being shot wholly on location, in Calcutta, Benares, Agra and Jaipur, with Indian actors, and with minimal use of artificial lights or make-up.

For the Emelka Bavarians, India proved to be a land of great contradictions and extreme emotions. They were impressed with their Indian colleagues and awed by the generosity of the Maharaja of Jaipur who loaned elephants, jewels and costumes for the shoot; but they also suffered greatly from the unfamiliar climate and had to negotiate cultural stereotypes with lived experiences. Nevertheless, Franz Osten collaborated with Rai on two more silent films, *Shiraz* and *A Throw of Dice*, which achieved varying degrees of success. In 1934, both Wirsching and Osten returned to India to help set up Bombay Talkies Ltd. They had known Himansu Rai and Devika Rani for a decade by then and deep friendships had been forged.

Josef Wirsching's decision to move to Bombay in the 1930s seems mainly motivated by the fact that film studios in Germany were being taken over by the Nazi Party and non-Jewish filmmakers were being compelled to make propaganda films. This coercive

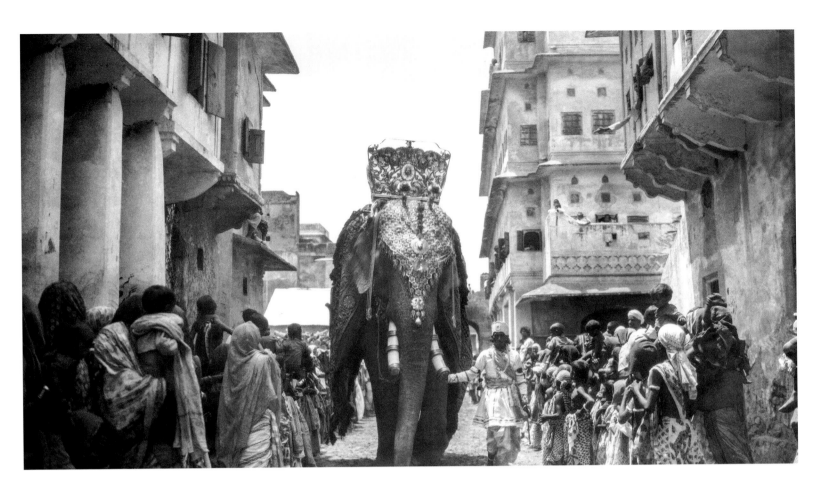

FIG. 8 *The Light of Asia*
1925, Emelka Films & Great Eastern Film Corporation, d. Franz Osten
80 x 140 mm Negative
JWA/ACP: 2019.01.0059

The Light of Asia was especially notable for its lavish use of royal elephants, horses, costumes, jewellery and hundreds of extras, all provided by the Maharaja of Jaipur.

atmosphere made artistic production very difficult for many independent-thinking filmmakers. Wirsching was very young when he shot the silent films and still only thirty-one years old when he chose to join Bombay Talkies. Newly married, the world was wide open for both Josef and Charlotte Wirsching, even as Germany felt constricting. Unlike many others who made the eastward journey to India during the Nazi years, Wirsching was neither Jewish nor a political exile. Still, his decision to migrate to and make a career and home in India is significant. Kris Manjapra has noted that Franz Osten was frustrated by the Nazi government's demands from filmmakers to prove their Aryan roots. A similar "desire to avoid [the] Nazified German film industry" propelled Josef Wirsching to make the momentous decision to migrate to India (2014, 267). Bombay Talkies offered Wirsching the professional status and creative freedom that was not possible in Germany's crowded and politicized film scene. Moreover, the content and themes of Bombay Talkies' films, with their emphasis on progressive reform and the socially marginalized, offered a worthy vision of an inclusive future that was the antithesis of the Nazi project. As Eleanor Halsall outlines in her essay, Wirsching—like countless other German expats, including Franz Osten—technically did join the Nazi Party, but his political commitments will have to be ascertained through his professional projects, personal actions and social networks.

Bombay cinema from the 1930s through the 1950s reveals a strong influence of German Expressionism and Josef Wirsching played a critical role in popularizing this stylized film

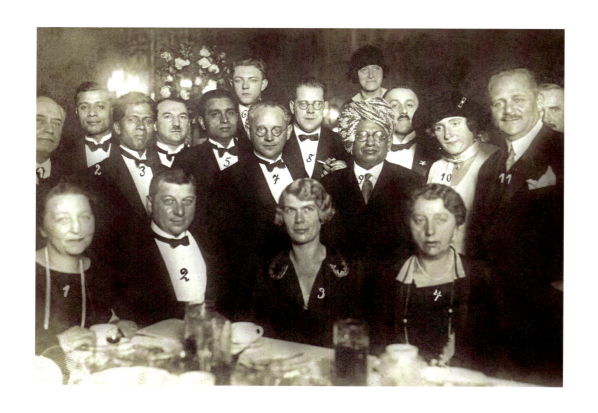

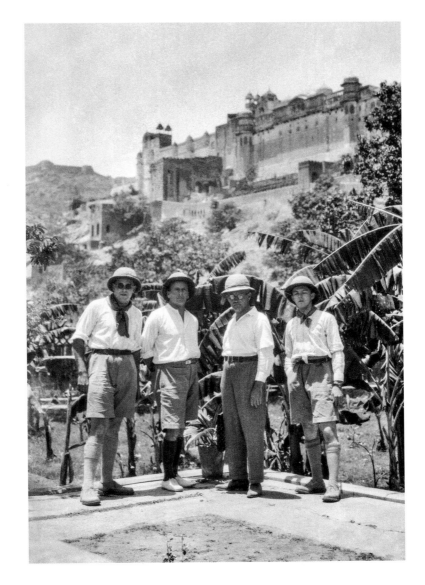

FACING PAGE
ABOVE
FIG. 9 *The Light of Asia* Team
c. 1926
Gelatin Silver Print, 114 x 170 mm
JWA/ACP: 2019.01.0004

The Light of Asia team at a premiere screening. Standing, from left to right: 1. Dr. Rosenthal, Chairman, Emelka Film Co., 2. Modhu Bose, 3. Niranjan Pal, 5. Himansu Rai, 6. Willi Kiermeier, 7. Franz Osten, 8. Josef Wirsching, 9. Pandit Sharma, Managing Director, Great Eastern Corporation.

BELOW
FIG. 10 *The Light of Asia*
1925, Emelka Films & Great Eastern Film Corporation, d. Franz Osten
65 x 110 mm Negative
JWA/ACP: 2019.01.0058

Cast and crew travel to a northern hill station to set up a makeshift developing laboratory. Exposed negatives needed filtered and cool water to avoid bubbles appearing on the film.

FIG. 11 *The Light of Asia*
1925, Emelka Films & Great Eastern Film Corporation, d. Franz Osten
80 x 140 mm Negative
JWA/ACP: 2019.01.0039

Emelka's "Munichwallahs" pose for a group photograph with the majestic Amer Fort in the background. From left to right: Josef Wirsching, Bertl Schultes, Franz Osten and Willi Kiermeier.

form. The Expressionist vocabulary is strongly imprinted in Wirsching's lighting designs and compositions. German Expressionism, in the cinema of the 1920s (e.g. *The Cabinet of Dr. Caligari*), was a strongly non-naturalistic style that used mise-en-scène to exteriorize inner emotions. Sets, costumes, acting and lighting all took on the role of "expressing" complex and dark human psychology. You see this influence most strongly in Bombay Talkies' debut feature film, *Jawani ki Hawa* (1935), a romantic thriller. In it, Wirsching composed frames with huge pools of darkness, sharp highlights, eerie shadows, distorted angles and sets which appear to overwhelm the humans. In his next few films for Bombay Talkies, Wirsching frequently framed characters through arches, doorways and windows; favoured eccentric camera angles; and masterfully moulded light to create accentuated shadows and to sculpt darkness. These Expressionist techniques lent themselves beautifully to Bombay Talkies' melodramatic screenplays, where socially transgressive emotions found visual expression in song and mise-en-scène. The crisis of the alienated individual in post-war Europe was thus transferred, via melodramatic Expressionism, to the crisis of the modernizing self in a colonized nation.

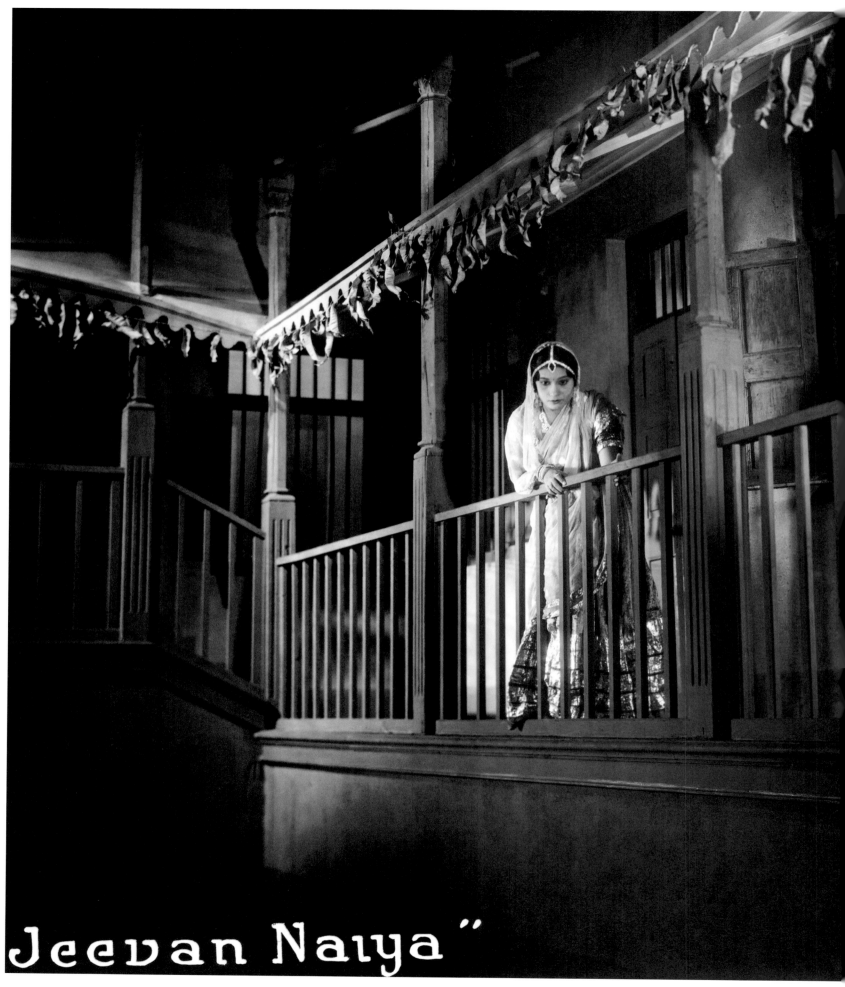

"Jeevan Naiya"

FIG. 12 *Jeevan Naiya*
1936, Bombay Talkies, d. Franz Osten
Lobby Card (Gelatin Silver Print), 241 x 305 mm
Josef Wirsching Archive

A supporting character contemplates a vile deed. The shot is masterfully lit to depict the suspenseful nature of the scene.

Wirsching was a versatile and highly adaptive artist, who moulded his cinematic craft to suit the script and the studio's vision. His cinematic eye for drama allowed him to skilfully switch registers between Expressionism, naturalism and realism. As Bombay Talkies tried to distinguish itself from its local competitors and craft its own aesthetic style, Wirsching experimented with different lighting styles and budget contingencies, using low-key, single-source lighting for emotionally heavy or suspenseful scenes alongside high-key, evenly lit designs. Wirsching's work is memorable for his luminous framing of heroines, crafting glamorous images for some of India's most beloved actresses. Wirsching also proved adept at outdoor location shooting and made full use of the studio's Bombay location to film the natural landscape of the Western Ghats. His use of Expressionist techniques returned in full force in *Mahal* (1949), a Gothic thriller. Wirsching's partnership with Kamal Amrohi through the 1950s and 1960s marked the zenith of his artistic career,

FIG. 13 *Jeevan Naiya*
1936, Bombay Talkies, d. Franz Osten
Lobby Card (Gelatin Silver Print),
243 x 294 mm
JWA/ACP: 2020.01.0054

This publicity still perfectly illustrates Wirsching's use of German Expressionist lighting techniques with a commitment to bright diegetic light sources, offset with deep shadows and large areas of the frame consigned to darkness.

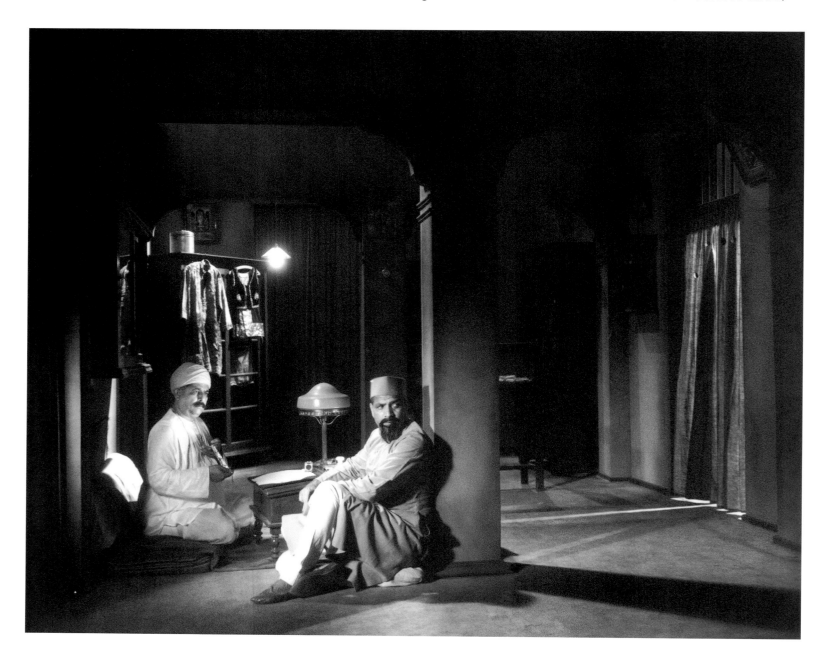

with two stunning black-and-white features, *Mahal* and *Dil Apna aur Preet Parai* (1960), and his first and final colour film, *Pakeezah* (1972).

Bombay Talkies (1934–1954)

The Bombay Talkies studio was inaugurated in 1934, barely thirteen years before India finally achieved political independence from British colonial rule. One of the most exciting gifts of the Wirsching photo archive is the perspective it offers on how a group of itinerant filmmakers produced hopeful cinematic futures for a nation struggling to come into being.

Bombay Talkies' earliest films clearly assumed the task of cinematic nation-building, but one must remember that these films were made by a motley crew of globetrotting practitioners.

Bombay Talkies was set up by producer Himansu Rai and his actress wife, Devika Rani Chaudhuri, in 1934. This Bengali couple met and married in London in the late 1920s, moved to Germany to work at the UFA Studios, worked on a couple of international co-productions, and finally set up their own studio in Bombay in 1934. In Europe, Himansu Rai and Devika Rani had strategically positioned themselves as authentically Indian filmmakers who wanted to accurately narrate Indian stories to Western audiences. Their early co-productions showcase a spectacular, spiritual and ahistorical India, which might seem exotic, even self-Orientalizing to viewers today. But Bombay Talkies' mission was different. Envisioned as an Indian studio producing films for an Indian market, it sought to establish itself as a swadeshi business with a definite regional voice and location. Further, the studio consciously modelled itself as a national institution that would train a creative workforce at par with international standards. Bombay Talkies' team of European personnel headed the main departments at the studio and simultaneously doubled as mentors to young recruits. Josef Wirsching was the head of the camera department.

Devika Rani said in an interview:
> [W]e felt that this was *not* an indigenous industry. So Rai thought it was best, as far as possible, to get experts from abroad for each department. And we had a sort of undertaking from them… to select a number of first-rate students from all over India… It was our aim to attract the best element in Indian society, with an educated and cultured background, to produce the highest type of art.

FIG. 14 List of Bombay Talkies shareholders and directors
Josef Wirsching Archive

The selection parameter of "cultured backgrounds" seems to manifest a caste bias and, indeed, the Indian founders of Bombay Talkies were largely from the Bengali upper castes.

Introduction 35

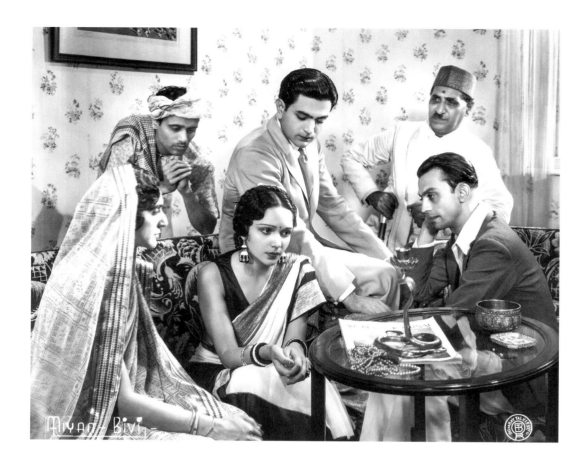

FIG. 15 *Miyaa Biwi* or *Always Tell Your Wife*
1936, Bombay Talkies, d. Franz Osten
Lobby Card (Gelatin Silver Print),
246 x 304 mm
JWA/ACP: 2020.01.0060

Devika Rani receives some distressing news in a letter. Other key characters in the film are played by Manek Homji (left), Najmul Hussain (behind Rani) and H. Masih (right).

Nevertheless, from the first year of its operations, the studio employed a demographically diverse roster of creative personnel. Across the departments of acting, writing, sets, make-up, camera, costume and lighting, the studio hired persons from various strata of Indian society. About 300 students were interviewed in the first year itself. A whole generation of film *industrywallah*s "graduated" from Bombay Talkies, which became a veritable film school with experienced practitioners as well as newbie recruits amongst its ranks: Saraswati Devi (née Khorshed Homji) as music director, Mumtaz Ali as choreographer, Madame Azurie as dancer, Niranjan Pal as scriptwriter, K. A. Abbas as publicist, Gyan Mukherjee as director, Sashadhar Mukherjee as producer, Najam Naqvi as script supervisor, Savak Vacha as sound engineer, Madame Andrée as make-up person, J. S. Casshyap as dialogue writer, Dattaram N. Pai as editor, and R. D. Pareenja as cameraperson. Himansu Rai and Devika Rani insisted that all salaried staff be housed near the studio complex in Malad and ran an on-site medical facility, canteen and recreation room to foster a sense of community and collegiality. The studio's top-notch equipment, multiple sound stages, processing laboratory and cross-departmental training requirements made it a prime destination for film aspirants who wanted to learn the ropes of production. At its zenith, Bombay Talkies had about 400 employees on its rolls.

The cosmopolitan crew at Bombay Talkies—from Munich, Berlin, London, Calcutta, Allahabad, Bombay, Lucknow, Lahore and several other towns and cities—brought together influences from German Expressionist theatre and cinema, Bengal school portraiture,

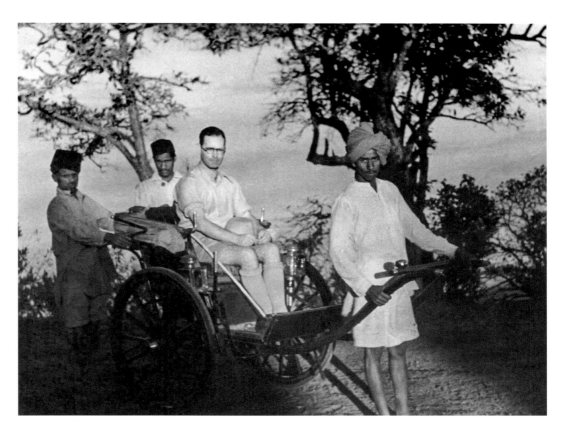

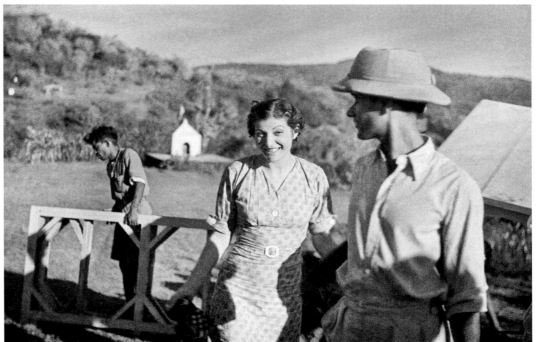

ABOVE
FIG. 16 Karl Graf Von Spreti
Gelatin Silver Print, 94 x 122 mm
JWA/ACP: 2019.01.0009

Karl Graf von Spreti (1907-1970) was the film architect and set designer of all pre-World War II films of Bombay Talkies. In 1968 he was appointed the German Ambassador to Guatemala and was notoriously abducted and assassinated by Guatemalan rebel guerrilla forces in 1970.

BELOW
FIG. 17 Madame Andrée and Savak Vacha
35 mm Negative
JWA/ACP: 2019.01.0022

Madame Andrée, Bombay Talkies' make-up artist, with her husband, Savak Vacha, during the shooting of *Izzat* (1937). Trained in Paris, Savak Vacha was a sound recordist at Bombay Talkies and a key member of the core technical group. Vacha was part of the breakaway group that formed Filmistan in 1943. Around 1945, after the departure of Devika Rani, Savak Vacha and Ashok Kumar returned to try and revive Bombay Talkies.

Orientalist adaptations of Sanskrit literature, British socialist plays, modern Bengali reformist novels, Art Deco industrial design, Bauhaus textile design, Hindustani classical music and Kathak dance conventions. Bombay Talkies played a foundational role in defining India's commercial film form, producing some of the most iconic musical films of the era which foregrounded urgent issues of social reform. These films borrowed freely from East and West to create a heady pastiche that once again begs us to question easy notions of Indian and foreign, traditional and experimental.

Bombay Talkies was launched on the strength of Devika Rani's talent and beauty and, unsurprisingly, all the early films were tailor-made to showcase her work. The studio quickly established a reputation for making socially progressive films with strong female characters.

FACING PAGE
FIG. 18 Madame Azurie/*Jawani ki Hawa*
1935, Bombay Talkies, d. Franz Osten
Lobby Card (Gelatin Silver Print),
249 x 297 mm
JWA/ACP: 2020.01.0048

Born Annette Gueizler, Madame Azurie was a self-taught dancer and a pioneer of film choreography in India.

ABOVE
FIG. 19 R. D. Pareenja
35 mm Negative
JWA/ACP: 2019.01.0010

R. D. Pareenja joined Bombay Talkies' cinematography department as assistant to Josef Wirsching. When Wirsching was interned during WWII, Pareenja took over principal photography for films such as *Bandhan* (1940), *Naya Sansar* (1941) and *Kismet* (1943).

BELOW
FIG. 20 Manek Homji
Gelatin Silver Print, 205 x 130 mm
JWA/ACP: 2019.01.0019

Manek Homji was one of Bombay Talkies' best in-house singers and character actors. Her sister Khorshed Homji was Bombay Talkies' music director, and both women were classically trained by Pandit Bhatkhande. They assumed screen names (Chandraprabha and Saraswati Devi, respectively) when their decision to join the film world created a major uproar in Bombay's Parsi community.

Introduction 39

ABOVE
FIG. 21 Mumtaz Ali/*Jeevan Prabhat*
1937, Bombay Talkies, d. Franz Osten
Gelatin Silver Print, 119 x 165 mm
JWA/ACP: 2019.01.0021

Mumtaz Ali was Bombay Talkies' in-house dancer and choreographer. He also played significant character parts and was equally comfortable in comic and tragic roles. The legendary comedian Mehmood was Mumtaz Ali's son.

BELOW
FIG. 22 *Achhut Kanya*
1936, Bombay Talkies, d. Franz Osten
Lobby Card (Gelatin Silver Print),
241 x 305 mm
JWA/ACP: 2020.01.0042

A young Ashok Kumar (né Kumudlal Ganguly, 1911–2001) poses for a publicity still. Having joined Bombay Talkies as a laboratory assistant, this was one of his first films as a lead actor. Fondly named "Dadamoni" by adoring fans, Ashok Kumar had a long and celebrated career in Indian film and television.

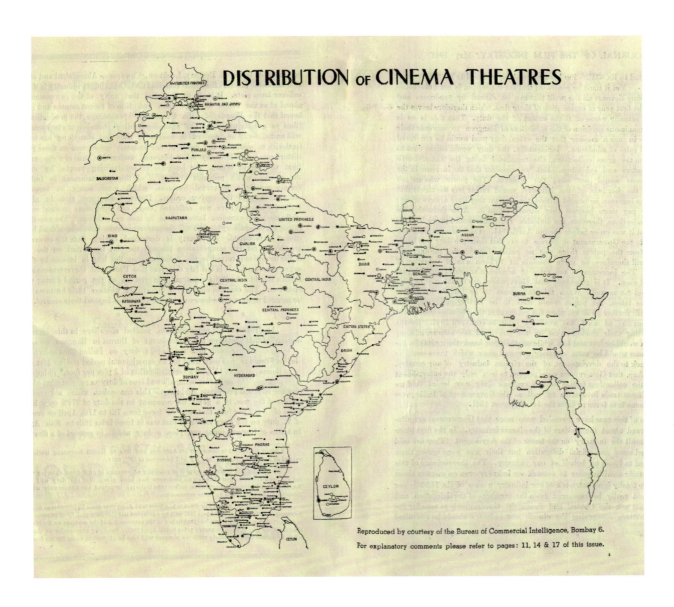

FIG. 23 "Distribution of Cinema Theatres"
1941
Courtesy: Debashree Mukherjee

This map was published in the May 1941 issue of *The Journal of the Film Industry*, the "official organ" of the Indian Motion Picture Producers Association (IMPPA) and the Indian Motion Picture Distributors Association (IMPDA). The map shows the towns in India (including present-day Pakistan and Bangladesh), Burma (now Myanmar), and Ceylon (now Sri Lanka) with one or more cinema theatres.

Films by Bombay Talkies were widely watched and its stars widely adored. Fans wrote gushing letters to Devika Rani at the studio address and dedicated ardent poems to her in film magazines. Ashok Kumar, Leela Chitnis, Hansa Wadkar and Renuka Devi (Khurshid Mirza) had their own loyal followers, while character actors such as Mumtaz Ali and V. H. Desai became key attractions of a film. The number of film theatres per capita was much lower in the 1930s as compared to today but films managed to circulate to cities and towns across India at a staggered pace and often through touring tent cinemas. Hindi-language films were distributed in all the film "circuits" and metropolitan centres, with the largest demand in the Bombay, Punjab and Delhi-UP circuits. Bombay city itself had forty-seven theatres in 1941 and thus, for a long time, Bombay cinema's most lucrative audiences were Bombaywallahs themselves. Figure 23 shows the distribution of film theatres in 1941 across 695 towns in India, Burma (now Myanmar), and Ceylon (now Sri Lanka).

With the outbreak of World War II, Bombay Talkies' German employees abruptly found themselves branded "enemy aliens." Franz Osten was sixty-three years old, in ill health, and

was repatriated to Germany, as was Karl von Spreti, who had influential connections. It is said that Himansu Rai's premature death in 1940 might have been partly due to the great shock of losing his best personnel and friends. After Rai's death, Devika Rani took over the studio and the most popular films of the period were produced under her watch. However, dissatisfaction was brewing in the studio and two rival factions were formed, with Ashok Kumar, Sashadhar Mukherjee, Savak Vacha, and Rai Bahadur Chuni Lall all leaving in 1943 to form their own studio, Filmistan. In 1945, Devika married the Russian artist Svetoslav Roerich and retired from the film industry, paving the way for Ashok Kumar's return to Bombay Talkies as producer. Josef Wirsching did not participate in any of these power tussles or transitions as he spent the entire war period, and longer, in internment camps (see, figure 1, chapter 6). Upon his release, he once again decided to stay on in India. In the post-war years, Wirsching scaled greater artistic heights with *Mahal* (1949), *Dil Apna aur Preet Parai* (1960) and *Pakeezah* (1972), the last completed after his death in 1967.

The Essays

The Wirsching photo archive holds images of varied types, which lend themselves to multiple intended and unintended uses. Candid photos of colleagues as friends, pictures of visitors to the studio, location recce stills, personal photos of family and pets, and tourist snapshots all happily co-exist in this collection. In fact, Josef Wirsching is not the sole author of all the photographs in the collection as he himself appears in several of them. Looking through these images one can almost palpably feel the camera changing hands from one person to the next, as a vibrant filmmaking community visually emerges around a shared camera.

Filmmaking is a fundamentally collaborative practice and Wirsching's photo archive really highlights this. On view are a multiplicity of individual actors, who collectively contributed to the success of Bombay Talkies, from an anonymous light boy to Madame Azurie, the once-famous but now-forgotten dancer. In these images, we see the interaction of individuals, objects and environments, framed by a vision that captures the beauty and drama hovering on the surface of the laborious work of film production. It is the generosity of Wirsching's documentary imagination that enables us to witness the unknown and the known, the little and the great, the everyday and the extraordinary.

As Sudhir Mahadevan notes, before they were publicly shared by the family, these images lived for many years as a personal collection. It is this aspect that Mahadevan prioritizes in his essay titled "How Photography Gives an Account of Itself: The Wirsching Collection as a Nation of Photography." He suggests that the Wirsching photos exist in a relationship of contiguity with other visual genres such as the home movie and the personal photo album. Drawing on the history of the relation between print, photography and film as topical media, Mahadevan argues that a sharp distinction between the private snapshot or home movie and the public topical image did not hold in the context of British India, where the rituals and sights of empire were themselves frequently the object of leisurely

FACING PAGE
ABOVE
FIG. 24 *Jeevan Prabhat*
1937, Bombay Talkies, d. Franz Osten
Gelatin Silver Print, 86 x 116 mm
JWA/ACP: 2019.01.0095

Devika Rani rehearses an outdoor scene with her co-actor Maya Devi. Also visible in the frame are Franz Osten (centre), Josef Wirsching (right), P. Paranjpe (standing beside the camera) and Savak Vacha (left).

BELOW
FIG. 25 *Jawani ki Hawa*
1935, Bombay Talkies, d. Franz Osten
35 mm Negative
Josef Wirsching Archive

A "clapper boy" marks the shot for a location shoot. A clapboard is used to synchronize the visual and audio tracks. Scene, shot and take numbers are marked on the board in chalk. Such wooden clapboards have since been replaced with electronic clapboards.

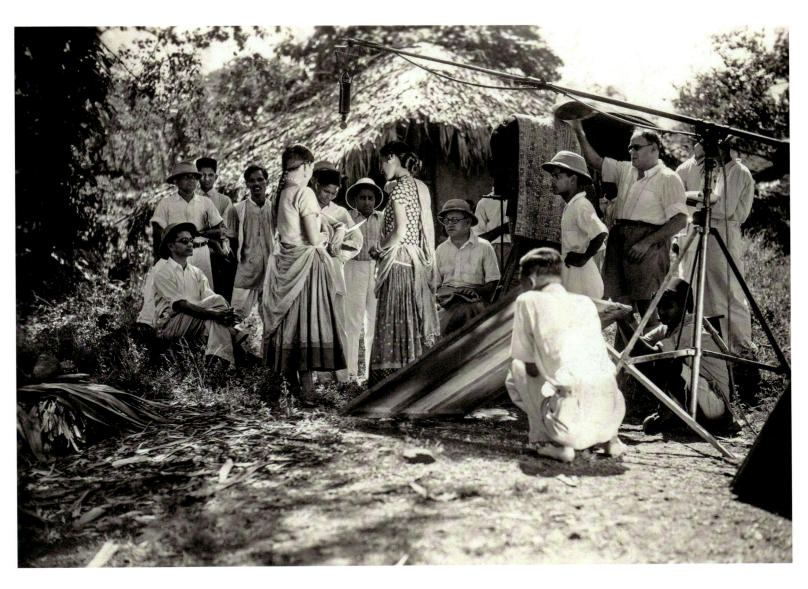

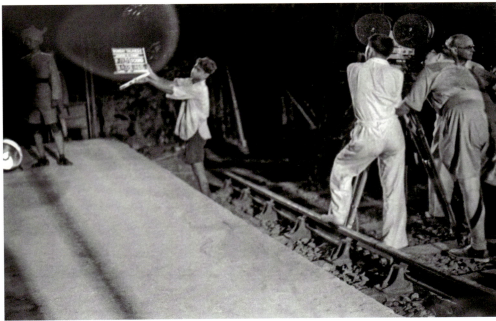

FIG. 26 *Dil Apna aur Preet Parai*
1960, Kamal Pictures, d. Kishore Sahu
35 mm Negative
JWA/ACP: 2019.01.0107

Helen, the dancing diva of 1960s Bombay cinema, rehearses the cabaret number "Itni badi mehfil aur ik dil" (I have just one heart on offer in this large gathering).

personal consumption, via their publication in daily newspapers. The Wirsching collection is therefore caught up in a compromised distinction between the private and the public.

The behind-the-scenes photograph, or the production still, dominates the Wirsching collection, and, as such, immediately captivates the interest of the scholar and the cinephile. As a specific genre, the behind-the-scenes photo expands the limits of the film frame by showing us that which lay just outside, adjacent to and beyond the movie camera. This expanded field of vision shows us that both worlds—the on-screen and the off-screen—were simultaneous and continuous. Priya Jaikumar takes up this simultaneity in her essay, "The Knot: A Scholar and an Angel Unravel *Izzat* (1937)," and speculatively ponders on what she calls Wirsching's "locational photographs." Strictly speaking, many of these production photos are not candid, as Jaikumar points out, because the people and things captured on set or on location are often primed to be filmed, i.e., they are in readiness of photographic capture. Focusing on the film *Izzat* and its use of the bodily themes of bondage and capture, Jaikumar stages a playful conversation between an angel of history and a scholar to unravel the gap between the production still and the final filmed image. This gap is a dynamic and continuous space of rehearsal and possibility, where all objects, emotions or expressions are suffused with the charge of the cinematic and "do not escape cinematic regimes of vision." Devika Rani, seen winking, grinning and laughing in Wirsching's location photos is transformed into Radha in the film, a transformation that alters the actor's bodily energy to signify Radha's very different location within structures of power and desire.

In "A German Eye on Indian Beauty," Rachel Dwyer highlights Josef Wirsching's role as a cinematographer in crafting the star image of three beloved screen divas of Hindi cinema—Devika Rani, Madhubala and Meena Kumari. All three women, from very different backgrounds, were iconically framed by Wirsching as symbols of beauty, grace and allure. Through the use of lighting and mise-en-scène, Wirsching mediates the transgressive force of the powerful characters played by these actresses in films such as *Achhut Kanya*, *Mahal* and *Pakeezah*. Dwyer also considers the off-screen biographical histories of the three women, interweaving questions of religion, caste and gender politics with the complex production of stardom. Wirsching's work with Devika Rani, Madhubala and Meena Kumari also charts the turbulent career of Bombay Talkies from the 1930s to the 1950s, as the studio went through significant changes in management and executive control. By the time Wirsching started work on *Pakeezah* in 1956, Bombay Talkies had folded, but its creative networks continued to inform Bombay's wider film ecology. Ashok Kumar, who

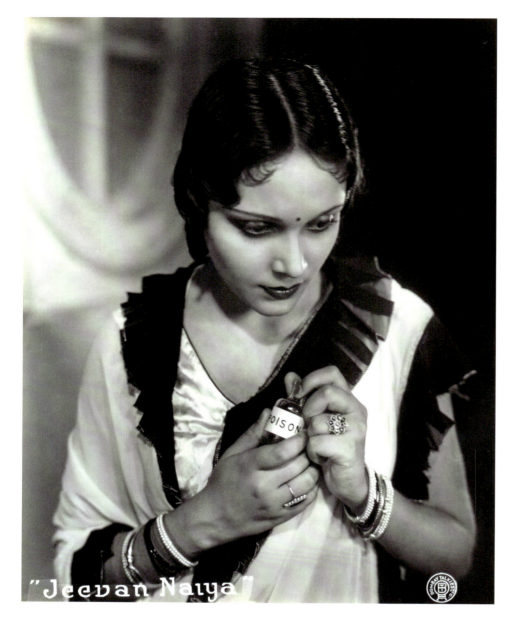

was initially cast in the role ultimately played by Raj Kumar in *Pakeezah*, started his acting career at Bombay Talkies; editor Dattaram N. Pai was also from Bombay Talkies; and Kamal Amrohi himself started his directorial career with Bombay Talkies when Ashok Kumar and Savak Vacha took over as producers.

Debashree Mukherjee's essay, "Between the Studio and the World," looks at the connections between cinematic artifice and filmed reality as seen through the Wirsching archive. How are the indoor and the outdoor, the world of the studio and the many worlds outside, co-constituted through the act of filming? Mukherjee analyses set design and choreographed outdoor locations to interrogate how Bombay Talkies crafted generic visions of a cinematic city and produced visual tropes of "Indianness." Straddling a fine line between particularity and universality, Bombay Talkies' use of mise-en-scène signified abstract values such as the urban, the modern, the natural and the Indian. At the same time, as Mukherjee demonstrates, the material specificity of Bombay city and the Western Ghats pushed its way into the frame and marked these films with a temporal and geographic imprint. In *Bhabhi* (1938), an elaborate set was built to model a generic Indian neighbourhood that could evoke a sense of community even in the midst of urban anonymity, while in *Savitri* (1937), the studio took an unusual foray into the world of mythology and attempted a tale located in an ancient time and place. Using diverse sources, such as paintings and print culture from the 1930s, and in dialogue with urban and infrastructural history, Mukherjee makes a case for the narrative significance of sets and the cinematic significance of a studio's immediate environment.

Kaushik Bhaumik's interview with pioneering film historian Virchand Dharamsey builds on the Wirsching archive to open up a freewheeling discussion of personnel, films, networks and anecdotal histories of Bombay cinema. A film studio is more than the sum of its parts;

FACING PAGE
FIG. 27 *Jeevan Naiya*
1936, Bombay Talkies, d. Franz Osten
Lobby Card (Gelatin Silver Print),
301 x 247 mm
Josef Wirsching Archive

Lata (Devika Rani), contemplates suicide in this publicity still from the film.

RIGHT
FIG. 28 *Vachan*
1938, Bombay Talkies, d. Franz Osten
35 mm Negative
JWA/ACP: 2019.01.0065

Himansu Rai, Franz Osten, Richard Temple, Devika Rani and others on the studio floor.

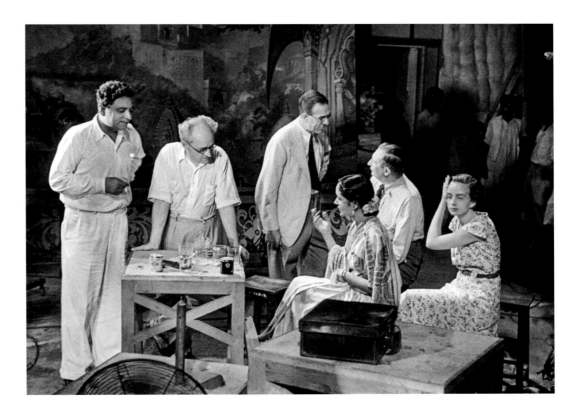

the story of Bombay Talkies is connected to several other filmmaking institutions and personnel, historical events and technological changes that surrounded it. From the earliest known European filmmakers in India to Bombay Talkies' Indian cast and crew, Dharamsey and Bhaumik tease out several individual and professional film journeys that help us situate Bombay Talkies within a dispersed ecology of production.

The final essay in this collection is by Eleanor Halsall, who helps us unravel the complicated question of Josef Wirsching's political affiliations. Halsall tracks multiple filmic retellings of a military attack by the German battleship *Emden* on Madras (now Chennai) during the First World War, arguing that the *Emden* can be seen as a symbol of the power struggle between Britain and Germany across two world wars and a motif to understand Wirsching's entanglement in the antithetical political visions of fascism, imperialism and anti-colonialism. Building on meticulous archival research, Halsall presents startling new facts about Wirsching's life. At the same time, she cautions that official archives of bureaucratic paperwork can only tell one side of a story that needs to be filled in with details of the everyday, affective and creative practices of individuals.

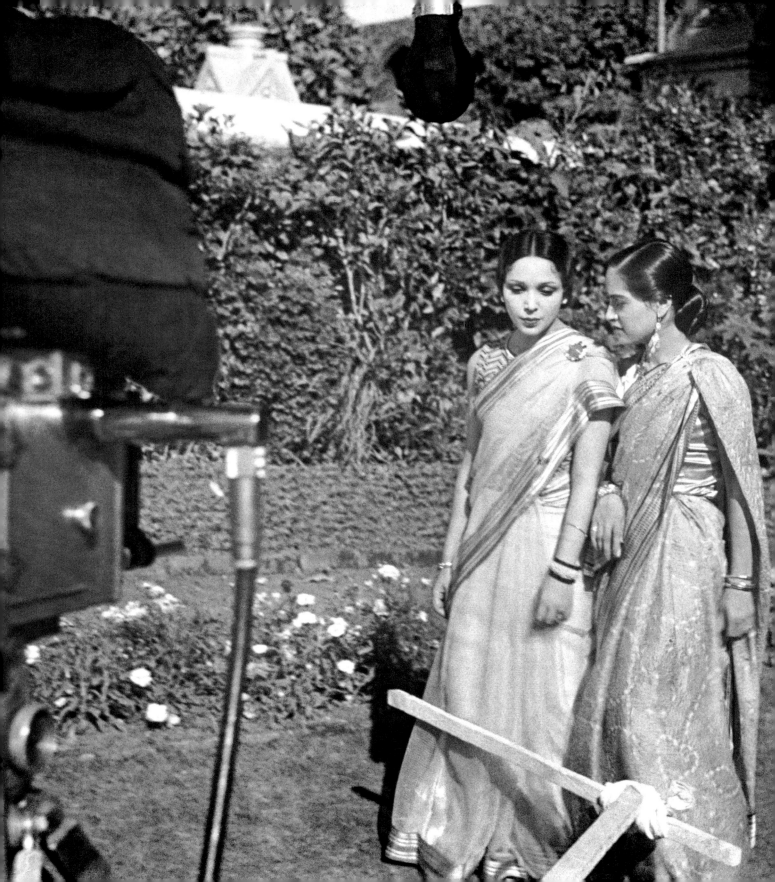

How Photography Gives an Account of Itself
The Wirsching Collection as a Nation of Photography

■ Sudhir Mahadevan ■

FIG. 1 *Nirmala*
1938, Bombay Talkies,
d. Franz Osten
35 mm Negative (detail)
JWA/ACP: 2019.01.0082

Devika Rani and Maya Devi rehearse a tracking shot with dialogue.

A riveting photograph in the Wirsching collection is a behind-the-scenes picture of the shooting of *Savitri* (1937). The image could be read as a document of a production process; the caption used in the 2017 exhibition of these photographs asked us to notice the clapboard, microphone, lighting assistant and reflector.[1] But a gaze drawn to particularities would notice a different and dizzying configuration of elements: chalk and watercolour, board and canvas, metal and leaf, rope and cloth, light and shade—a dense profusion that disables our attempt to turn sense into significance (figure 2). The canvas, with its watercolour and its radiating support, evokes the dedicated space for the representation of a distinct reality from which everyone is alienated: the actor in make-up, the crew around him, as well as the viewers of this photograph: an allegory of the cinematic itself, perhaps, provided we recognize that this allegory is only one element of a more confounding phantasmagoria of compacted elements in which humans and images, media and matter, occupy the same space.[2]

Yet, formal patterns, abstractions, concepts and symbols gradually reassert themselves. The paired elements are noticeable: actor Ashok Kumar, in flesh and blood, and the figure on horseback that he is painting on canvas, both in profile, both partially obscured; the two kinds of hats on the heads of the production crew members that mirror each other, the graphical matches of the canvas and the reflector. Numbers and words (in varying fonts and sizes), painting and photography, language and image: all are brought together in this "spatial inventory," this "warehousing of nature" (Kracauer 1993, 435). In director Franz Osten and cinematographer Josef Wirsching's native Germany a decade earlier, in 1927, Siegfried Kracauer would use precisely those phrases in his coruscating critique of the flood of photographs that were being published in Germany's illustrated newspapers, of which one of the most famous, the *Berliner illustrierte Nachtausgabe*, also makes a

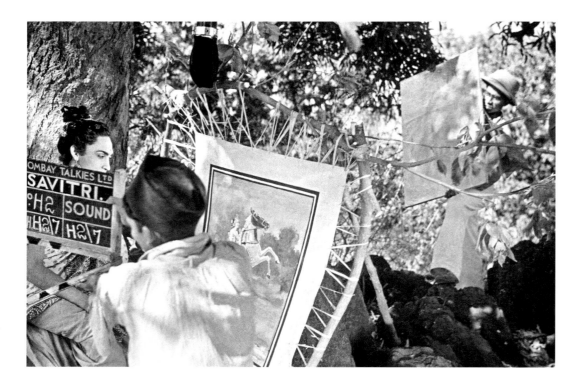

FIG. 2 *Savitri*
1937, Bombay Talkies, d. Franz Osten
35 mm Negative
JWA/ACP: 2019.01.0085

cameo appearance in this very collection of images. The flood of images disabled contextual understanding. Kracauer argued that if photography's warehousing of "disintegrated elements" indicated a total alienation from nature, if spatial inventories and temporal inventories (in the form of historicism) conspire against an adequate understanding of our shared reality, it was incumbent on *us* to establish "the provisional status of all configurations," even perhaps to find the right order of elements out of the profusion of images produced by photography (435–36).

It is the aim of this essay to extrapolate this notion of configurations and apply it to this collection, but without the aim of establishing the "right order" of elements (the individual photographs) in the collection. The latter is a curatorial task. Instead, I want to suggest that this collection amounts to something like an expression *by* photography of itself, "giving an account of itself," in Edward Steichen's words (Stimson 2006, 24). There are good reasons to think along these lines. The collection belonged to Josef Wirsching, a German cinematographer who moved to India in the 1930s and helped establish, along with fellow German Franz Osten and the UFA-trained couple Himansu Rai and Devika Rani, one of the iconic studios of pre-Independence Indian cinema, Bombay Talkies. However, it is difficult to find a singular vision stamped across this collection. After all, Wirsching himself is the subject of many of these photographs, alongside Osten, Rai, Rani and others. Further, the collection contains a remarkable diversity of genres of photography: event photography, candid pictures, publicity and production stills, images taken during location scouting that could easily be imagined in the photo-illustrated newspapers of the time in India, as well as documentary images of the production of films at Bombay Talkies. So, it would be a mistake to attribute all the photographs in this collection to a single vision.

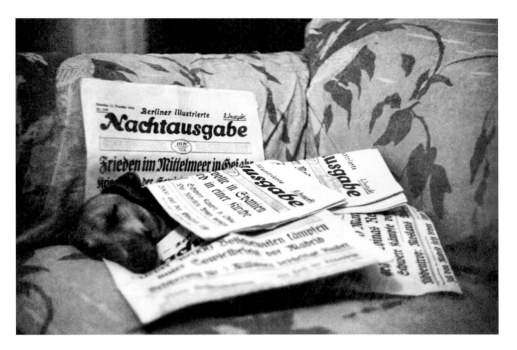

FIG. 3 Nicky, the Wirschings' pet dog
35 mm Negative
JWA/ACP: 2019.01.0047

Nevertheless, the search for an idea that might encapsulate the collection is tempting, and we could also imagine this collection as expressive of the *nation of photography*.[3] Taken together, the photographs embody and envision new forms of post-nationalist belonging under the aegis of a film studio, at a time when India was moving inexorably towards independence from the British Empire. A remarkably "cosmopolitan crew" at Bombay Talkies drew together, to paraphrase Debashree Mukherjee, German Expressionism, Art Deco, Bauhaus, Bengali reformist novels, Hindustani classical music, Orientalist adaptations of Sanskrit plays and more in their productions of social reformist films imbued with the spirit of nationalism (Mukherjee 2018, 57). As we shift our gaze from one photograph to the next in this collection, we realize that we are gazing at images pertaining to the workings of a film studio that brought together Indians and Europeans in a contingent and provisional community, even as the images themselves are inescapably informed by the forces that shaped photography in the context of empire (on which more below).

Jacques Rancière reminds us that photography has to "be grasped within a wider form of visibility and a wider plot of intelligibility" (Rancière 2009, 36). What is that wider form of visibility? What makes this collection intelligible? It goes without saying that cinema is indispensable to such questions. These images were produced at a time when cinema's "sensuous incitements" and provocations were of thematic concern within the movies, as well as central to the contexts around them.[4] Films such as *Achhut Kanya* (1936), *Jawani ki Hawa* (1935), or *Nirmala* (1938) tracked private desire's spillover into the public realm as a matter of social negotiation between modernizing conceptions of romance and traditional worldviews of fate, social order and hierarchy. The reformist "social film" in which Bombay Talkies specialized, a genre defined by its topical concerns and present-day time period, visualized and narrativized contemporary preoccupations. At the level of industry and institution, studios like Bombay Talkies, with their highly visible workforce, continuity scripts and divisions of labour, emblematized the aspiration towards a viable national film industry (Mukherjee 2015; Mukherjee 2020). More generally, politics in South Asia was itself a theatrics of appearances—of mass processions and rallies that were in turn recorded

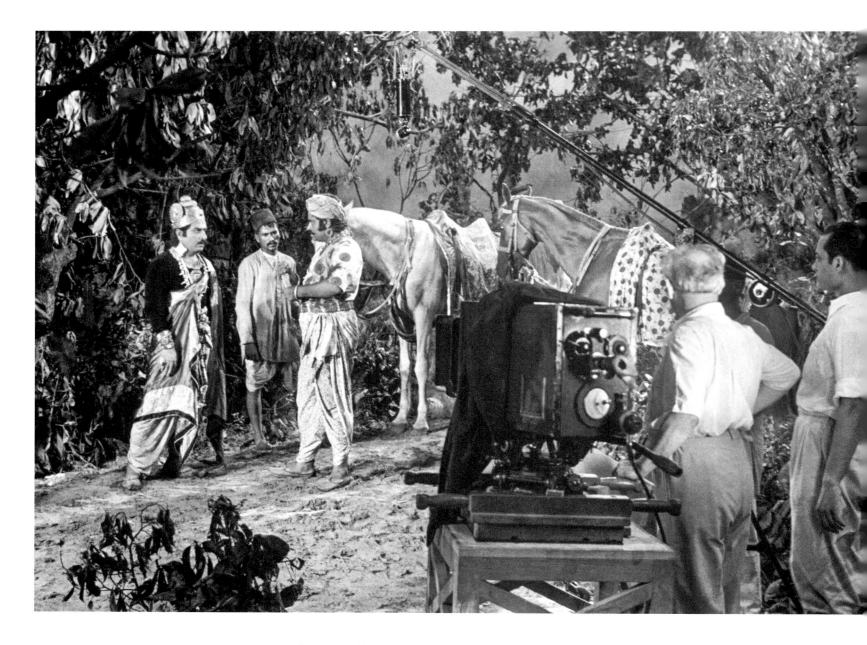

FIG. 4 *Vachan*
1938, Bombay Talkies, d. Franz Osten
35 mm Negative
JWA/ACP: 2019.01.0104

Franz Osten supervises a scene rehearsal while Sashadhar Mukherjee assists him.

and screened in movie theatres, of the spaces in front of movie theatres appropriated for political gatherings, of redistributions and partitions of the sensible, to adopt Rancière's terminology (Mahadevan 2015, 138–44).

Yet, something about this photographic collection, despite its origins in cinema, veers in a countervailing direction, not towards the open and seditious edge of mass-publicity (Mazzarella 2013, 37), or towards the drama of the politics of representation, but towards what Patrizia McBride calls the "chatter of the visible,"[5] of still images varied enough to evoke a range of sentiments: wonder, absorption, contemplation, dispassionate observation, reflexivity and more. I shall have more to say about the specific photographs in this collection that encompass the gamut from collective labour, solitary thought and conviviality, to picturesque views, public celebrations and images of infrastructure. Such variety in affect and subject matter compels me to untether this collection from the

ABOVE
FIG. 5 *Nirmala*
1938, Bombay Talkies, d. Franz Osten
35 mm Negative
JWA/ACP: 2019.01.0108

A hired goon tries to abduct the groom, Ramdas (Ashok Kumar), from his wedding procession in this shot.

BELOW
FIG. 6 *Jawani ki Hawa*
1935, Bombay Talkies, d. Franz Osten
35 mm Negative
JWA/ACP: 2019.01.0113

Josef Wirsching (under the camera blind) rehearses a tracking shot. A major portion of the film is set inside this dining car and Wirsching's camera is highly mobile in its treatment of the space and the performers.

cinema to which it owes its *raison d'être* and instead to search for its place in the history of photography in South Asia. It is to that history that I now turn.

Afterlives and Origins

Having resided in a personal collection for decades, the images of the Wirsching collection are now available as a resource for scholars of film and photography interested in the history of the medium in the context of empire. The evolving nature of the spaces within which the Wirsching collection has resided reminds us of the broader conditions of access and preservation that have shaped photography and its uses in South Asia.

Official ethnographic and archaeological photography in the nineteenth century was produced at a scale meant to generate a photographic archive for posterity. These archives in turn have generated rich contemporary scholarly histories on the intersection of photography and colonialism. At the same time, a different set of circumstances having to do with the intersection of commerce and technology ensured the continued viability of the photo studio and a patron-client relation that mediated access to photography, for most Indians, well into the latter half of the twentieth century.[6] Accordingly, studio portraiture, too, has generated a significant number of scholarly histories. Other genres, such as photojournalism, snapshot and amateur photography, industrial photography and the like, have received comparatively less attention.[7] The Wirsching collection's value resides therefore in its remarkable internal diversity of imagery, emerging, it seems, out of a plethora of perceived functions: as private keepsakes of a social life, as in a family album, but also as documents recording the manufacture of movies. The collection therefore confounds histories of photography that might segregate by genre or mode of production.

I also see continuities between some of the images in this collection, and those that might appear in the photo-illustrated press. An elaboration of this claim requires situating the collection in the visual cultures of everyday life in the British Empire, one that undermines the distinction between the private and the public. For instance, the public world of imperial ritual became an object of privatized visual consumption: hence the illustrated halftone albums, released in the wake of the grand rituals of the Delhi Durbars (1877, 1903 and 1911), that could be purchased for private leisurely perusal. Concomitantly, the hand camera turned every (mostly European) "Kodak fiend" into a participant in a casual search for a happenstance, picturesque grasp of the Indian life-world: street scenes, topical events, ethnographic observations and European social life, such as sporting events and tournaments. In turn, photo-illustrated newspapers published these amateur snapshots. It isn't hard to envisage the image of Wirsching's dog Nicky, or the long view of the Gateway of India at Bombay, or Franz Osten and Josef Wirsching in conversation with an Indian boy on the pages of the *Illustrated Weekly of India*, a newspaper that sourced snapshots from amateur as well as professional photographers for a largely European readership. While the marketing of the hand camera in the United States may have produced a clear distinction between the public photojournalistic image and the private family album snapshot, such

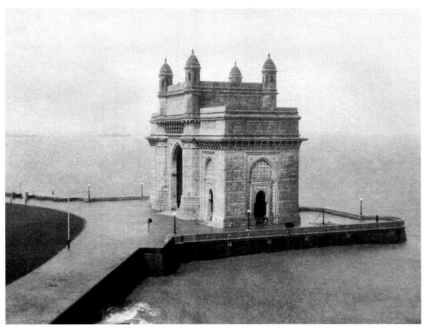

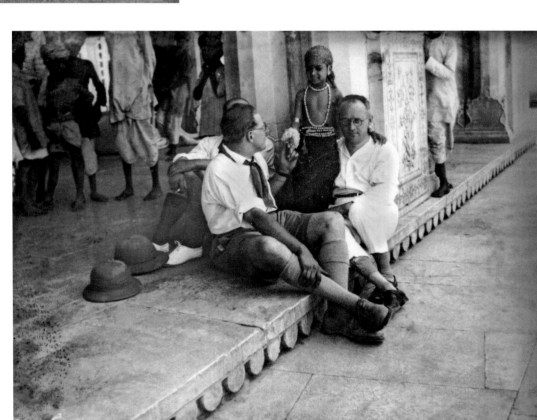

ABOVE
FIG. 7 An aerial view of the
Gateway of India
c. 1925
45 x 60 mm Glass Plate Negative
JWA/ACP: 2019.01.0043

BELOW
FIG. 8 *The Light of Asia*
1925, Emelka Films & Great Eastern Film
Corporation, d. Franz Osten
45 x 60 mm Glass Plate Negative
JWA/ACP: 2019.01.0041

Josef Wirsching and Franz Osten in conversation with a child during their location recce.

a distinction between the public halftone image and the private photo-album is harder to sustain in India under the British Empire (Mahadevan 2015, 110–21).

Recent research on the way the Kodak camera was marketed in India further undermines the distinction between the private snapshot and public photojournalism. In the 1920s, the famous "Kodak Girl," a young white woman, appeared in *The Times of India*, targeting readers of the English-language newspaper. As Jennifer Orpana notes, in Kodak's advertisements, "the Kodak Girl and her companions explore the country largely unburdened by any sense of obligation, whether familial or domestic… Indeed, she seems to observe Indian street and village life without drawing attention to herself, as if her presence were as natural a part of the landscape as are the subjects of her gaze."

Gorgeous architectural ruins, *fakir*s with hookahs, temples and picturesque pathways; these crossed media, appearing not just in films like *The Light of Asia*, but also in the pages of newspapers, as well as in private photo albums. It wasn't till the 1940s that Kodak would update its iconography to the middle-class Indian family unit, replacing the Kodak Girl with the "father-photographer" (Orpana 2018, n.p.). These fluid pathways between imperial ritual and everyday life, between the amateur snapshot and the photojournalistic image, give us some pause in fixing the Wirsching collection as a set of personal images belatedly become public, even as we acknowledge that the grandiosity of the cinema makes way in these images for a different scale of time and space.

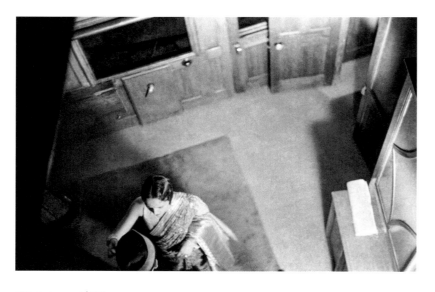

FIG. 9 *Jawani ki Hawa*
1935, Bombay Talkies, d. Franz Osten
35 mm Negative
JWA/ACP: 2019.01.0034

A top-angle candid shot of Devika Rani in one of the train compartments specially built for the film.

Of course, in Wirsching's native Germany as well, the illustrated press drew on the ordinary and the everyday as source material for popular visuality. In one of the most intimate images of this collection (see figure 3), which I referenced earlier, Wirsching's sleeping dog is swaddled in multiple editions of the daily *Berliner illustrierte Nachtausgabe* (henceforth *Berliner*). A legible headline in the picture is from 1936, and it blares "Peace in the Mediterranean," capturing the tumultuous political context of the time. *Berliner* was the leading illustrated newspaper in Germany by 1929, with a weekly circulation that exceeded that of other international publications, and photo-historian Anton Holzer states that the illustrated press was "the central form of visual mass media" (Holzer 2018, 2) in the Weimar years, aside, of course, from film. The German bourgeois illustrated press often drew on "everyday topics" of public life, writes Holzer, such as scenes in front of a shop window, a dentist's office or life in a prison (15). At the same time, topical spreads increasingly veered towards photo-reportage: a stronger graphic relation between image and text, pronounced narrative arcs and "a link between the factual account and the journalist's subjective stance" (16). Might these elements have influenced Wirsching's eye and resulted in images that seem at once factual and subjective, at once descriptive and Expressionist, such as the "top-angle candid shot" of Devika Rani in the set of a train compartment?

Event, Process, State: Keeping Time

"The fact that images may themselves appear as punctual, virtually without duration, does not mean that the situations they represent lack any quality of duration or other qualities related to time," writes Peter Wollen (2007, 109). In Wollen's taxonomy, photographs may capture events, as in news photos that capture a dynamic situation, or they might convey processes, as documentary photographs often do, attending to the ongoing and iterative nature of a process, or they may convey stable and unchanging states, as art photographs do, inviting contemplation. The Wirsching collection contains examples of all three modes of registering time in a still image.

For instance, we find a series of photographs taken of an event, the premiere of *Jawani ki Hawa* in 1935. Other images document processes: the loading of equipment on to a boat, Wirsching at a desk poring over one of his lenses, Wirsching in profile behind a camera at a shoot, surrounded by his production crew. These images adopt a snapshot approach to time, a moment grabbed without too much premeditation from out of a flux of moments. Their function may be to document the mundane work of film production, but such an approach to time is also evident in other pictures in the collection that might best be categorized as candid photography: images of Devika Rani with a glass of lemonade in her hand (see, figure 19, chapter 3), or smoking a cigarette, perhaps between takes (see, figure 5, chapter 2), or chatting amongst a group of European women (figure 14). The most evocative of this lot is one taken of Rani on the grass, a still camera in hand, looking up over her shoulder, as if she were acknowledging and possibly saying something to the photographer (see, figure 11, chapter 5). The accentuated grain of the image, the shallow focus that turns much of the image into a dreamy, hazy blur of shapes, the intricate lace patterns on the sari Rani is wearing in this picture, and the oblique angle that almost makes the ground appear like a vertical wall; these details recall a frame one might perhaps find in a French impressionist film, such as *Rose-France* (Marcel L'Herbier, 1919) or *Ménilmontant* (Dimitri Kirsanoff, 1926), a profoundly subjective view of a radiant figure. Collectively, these images of Devika Rani paint a remarkable picture of the modern working woman.

One or more sets of images invite sequencing in time, such as those of director Franz Osten and actor Devika Rani rehearsing a gesture, followed by an image with Rani and Ashok Kumar performing the same gesture (discussed in detail in Priya Jaikumar's essay in this volume). However, the lapse of time between the two images suggests not the sequencing of a single action à la the nineteenth-century chronophotographs of Étienne-Jules Marey, for instance, but that of a photo-roman, of discrete moments occurring in broad succession in narrative time. In other words, motion in and across these still images is supplied by the viewer, as opposed to being an outcome or an effect of a mechanized projection of images, as is the case in cinema (Nardelli 2012).

Equally evocative are those that portray members of the production crew waiting, perhaps between takes (figure 15), or Rai and others on a verandah, looking over a nighttime

ABOVE
FIG. 10a *Jawani ki Hawa*
1935, Bombay Talkies, d. Franz Osten
35 mm Negative
JWA/ACP: 2019.01.0048

Crowds gather outside the Imperial Cinema in Bombay before the premiere of Bombay Talkies' debut feature film. Himansu Rai's decision to hire two local Parsi women as music director and singer had led to violent protests and picketing outside the theatre. Thus the police deployment, as seen in figure 10b.

CENTRE
FIG. 10b *Jawani ki Hawa*
1935, Bombay Talkies, d. Franz Osten
35 mm Negative
JWA/ACP: 2019.01.0049

BELOW
FIG. 10c *Jawani ki Hawa*
1935, Bombay Talkies, d. Franz Osten
35 mm Negative
JWA/ACP: 2019.01.0050

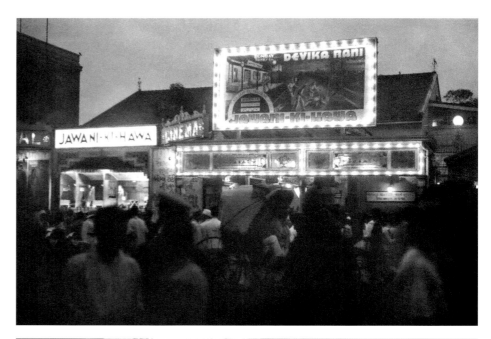

FACING PAGE
ABOVE
FIG. 11 *Achhut Kanya*
1936, Bombay Talkies, d. Franz Osten
35 mm Negative
JWA/ACP: 2019.01.0054

The crew prepares for a shoot at Madh Island.

BELOW
FIG. 12 Josef Wirsching
1958
Gelatin Silver Print, 111 x 144 mm
JWA/ACP: 2019.01.0001

Josef Wirsching servicing his camera equipment at Kamalistan Studios.

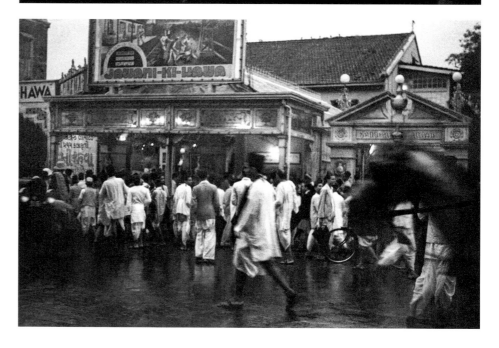

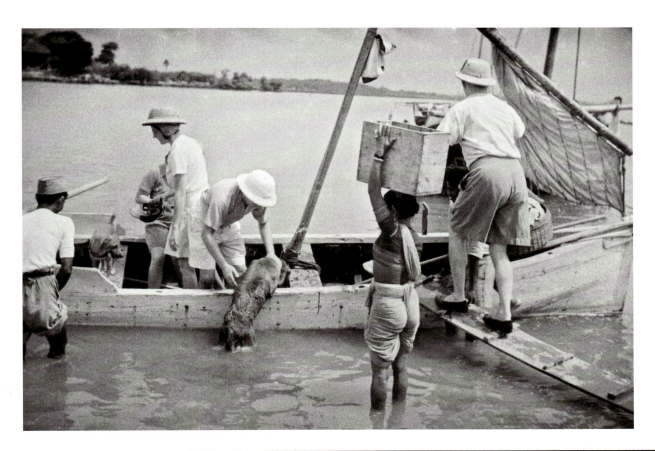

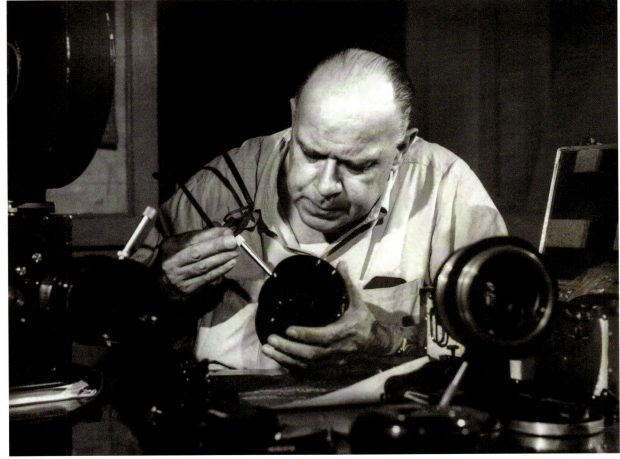

How Photography Gives an Account of Itself 59

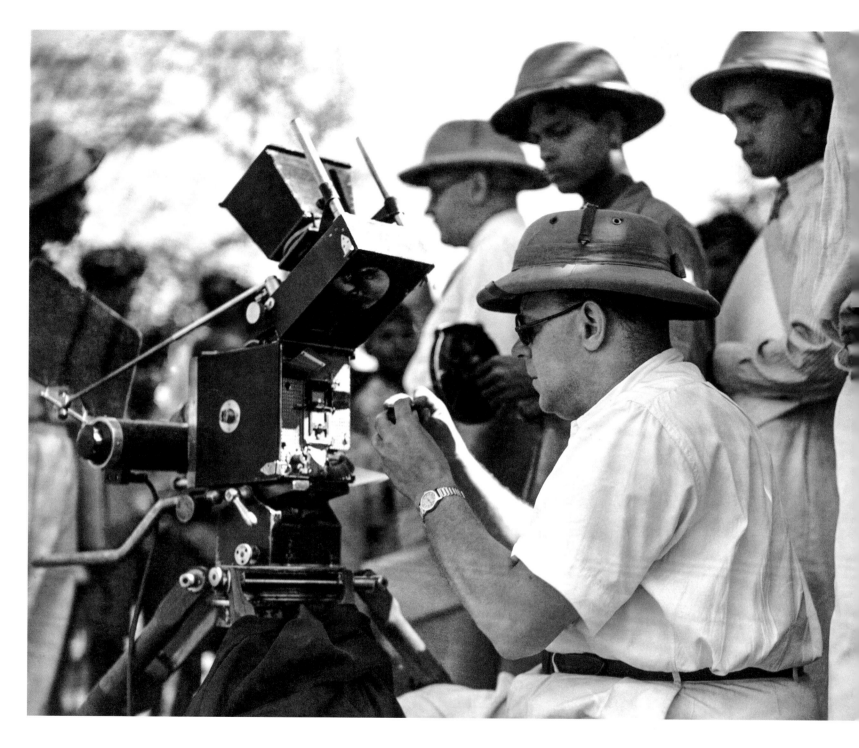

FIG. 13 *Izzat*
1937, Bombay Talkies,
d. Franz Osten
Gelatin Silver Print, 86 x 116 mm
JWA/ACP: 2019.01.0067

shoot (see, figure 3, chapter 5). Wollen might call these photographs of states—of being, of expectation, of waiting or of repose. The open-ended sense of time in such images reminds us of Roland Barthes's preference for the photograph over the circumscribed duration of movies.

The heterogeneous temporalities of the images in this collection: time at work and time at leisure, time in action and time in attendance and expectation, analogize Debashree Mukherjee's discussion of Bombay cinema in this period as a "processual terrain of shifting

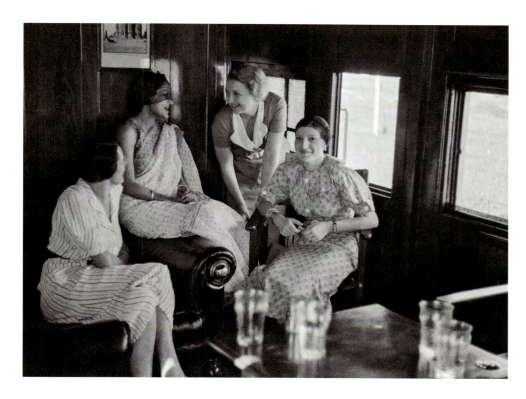

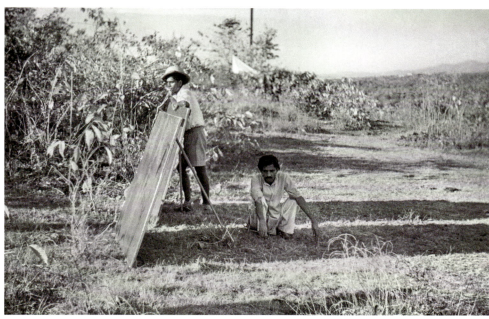

ABOVE

FIG. 14 *Jawani ki Hawa*
1935, Bombay Talkies, d. Franz Osten
35 mm Negative
JWA/ACP: 2019.01.0064

From left to right: Charlotte Wirsching, Devika Rani, Ellen Osten and Madame Andrée enjoy a moment of light conversation on board a train of the Great Indian Peninsula Railway.

BELOW

FIG. 15 *Izzat*
1937, Bombay Talkies, d. Franz Osten
35 mm Negative
JWA/ACP: 2019.01.0078

An assistant rests against a light reflector, while another crew member takes a break.

How Photography Gives an Account of Itself

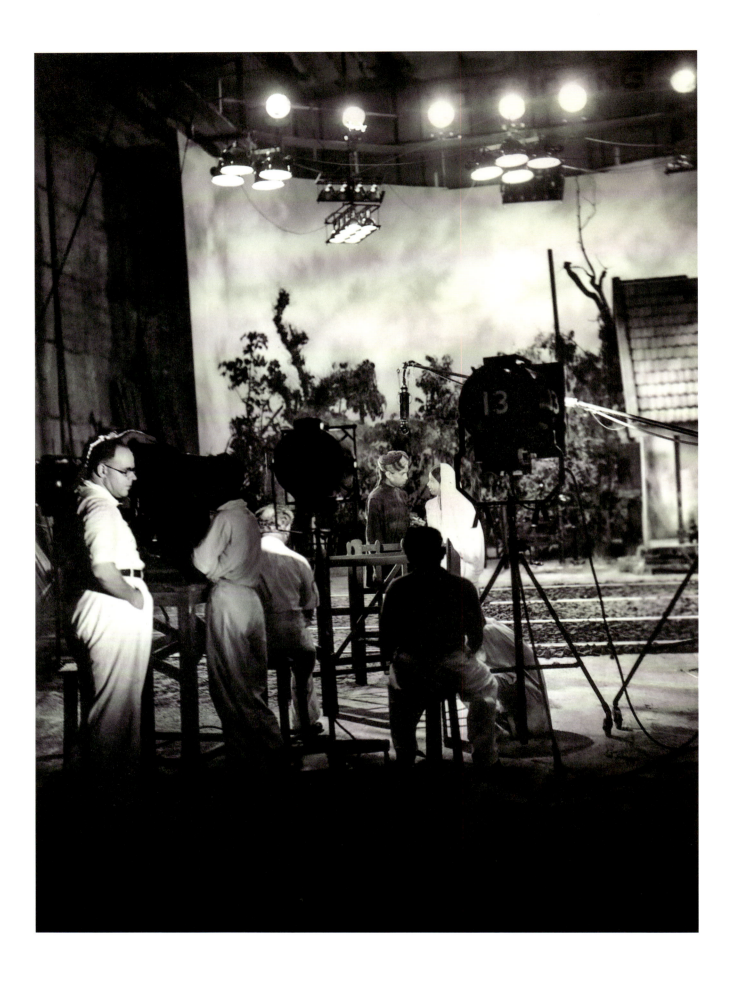

FACING PAGE
FIG. 16 *Achhut Kanya*
1936, Bombay Talkies, d. Franz Osten
Gelatin Silver Print, 114 x 86 mm
JWA/ACP: 2019.01.0002

Josef Wirsching shoots an exterior daytime scene on an indoor set. Actors Najam Naqvi and Pramila rehearse a moment of confrontation.

ABOVE
FIG. 17 *Jawani ki Hawa*
1935, Bombay Talkies, d. Franz Osten
35 mm Negative
JWA/ACP: 2019.01.0070

A lighting assistant waits amidst a bustling train set constructed inside the Bombay Talkies studio. A large portion of the film is set inside a moving train.

intensities and emergences" (Mukherjee 2015, 95). Film financing seemed akin to the "risk-prone practice of futures trading," a form of "entrepreneurial adventurism" (96). A movie could take up to three years to reach its widest possible audience—a slow-durational accrual of profits (99, 110). Female extras, presumed to come from prostitution and the dancing classes, were required to wait outside studio premises till they were needed. In this case, waiting and killing time becomes another durational form of the "gendered distribution of risk" (260), much as the young film fan, discussed by Mukherjee, eagerly awaiting a big break in the movie industry, also engages in a waiting game of sorts. The photos in this collection capture something of these variegated textures of time.

Backstage Media and the Space of Production

"[Infrastructuralism]'s fascination [is] for the basic, the boring, the mundane, and all the mischievous work done behind the scenes… A doctrine of environments and small differences, of strait gates and the needle's eye, of things not understood that stand under our worlds," writes John Durham Peters (2018, 769). Several images in this collection are "backstage" photos that function as infrastructural media. These are images that depict the filming of a scene, encompassing the mise-en-scène in front of the movie camera, as well as the production crew, equipment and larger set within which the filming is occurring. The photograph of Wirsching shooting an exterior daytime scene from *Achhut Kanya* (figure 16) as well as the one of the light boy on the sets of *Jawani ki Hawa* (figure 17) are emblematic of this mode and among the most evocative; in both of these, the technical personnel are in the foreground but almost completely silhouetted in a way that speaks to the historiographical challenges of making "below the line" labour

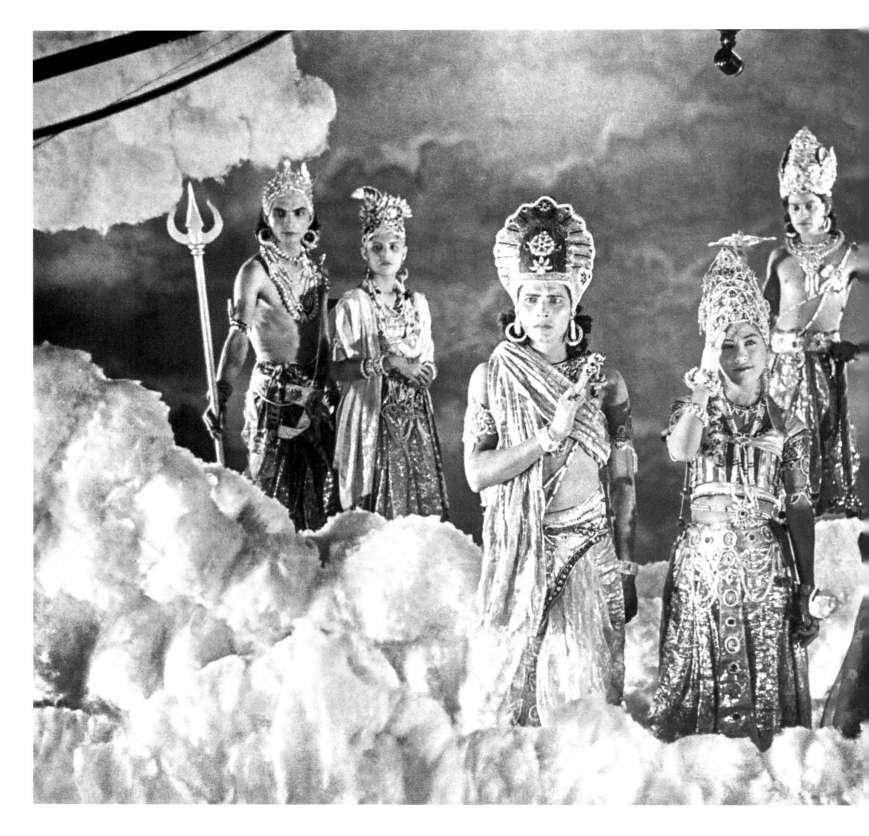

FIG. 18 *Savitri*
1937, Bombay Talkies, d. Franz Osten
35 mm Negative
JWA/ACP: 2019.01.0105

The gods contemplate Savitri's future in this scene featuring cotton clouds, tired actors and a boom microphone. Savitri was the studio's only Hindu mythological film.

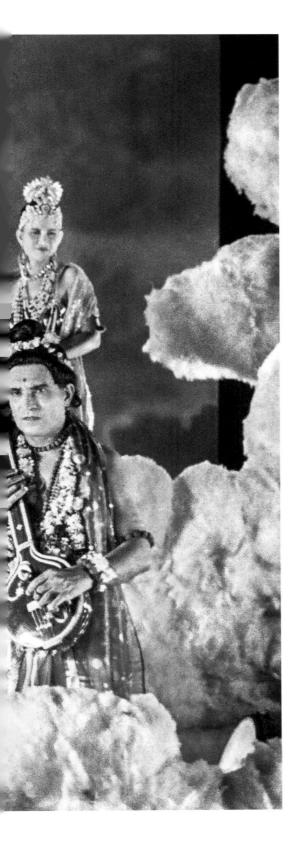

visible, as Mukherjee's (2015) research demonstrates. Like moths drawn to light, our eyes gravitate towards the brightest portion of the image, the space of performance in front of the movie camera, only to then notice the production crew, almost as an afterimage. My use of the word "backstage" invokes the more familiar "backstage musical," a movie genre that focuses on the efforts to mount a show on stage. The backstage musical dramatizes the spaces of production and rehearsal, giving them a narrative and formal function, sometimes even in excess of the eventual show on stage. In the images in this collection, the space of production, of crew and equipment, is neither "behind the scenes" nor behind the wings, as it were; rather, it is more often in the foreground. Yet, as I have indicated in my description of the aforementioned photographs, the images demand that we almost de-dramatize our gaze, that we train our eye to look at the production crew in the foreground, instead of gravitating instinctually towards the dramatic and lit stage of performance in the background of the image. It is as if the photographs took to heart the idea that "ontology, whatever else it is, is usually just forgotten infrastructure" (Peters 2018, 771).

Our encounter with these two spaces, profilmic as well as production, takes varying forms in these images. Quite a few of the images seem at first cursory glance to be publicity stills or frames from a movie, until we notice an overhead microphone peeking into the frame and injecting a strong dose of anachronism into the world of divinity hovering in the cotton clouds, as is the case for the image from the mythological *Savitri* (1937). In still others, the two orders, of production and performance, of crew and actors, are almost indistinguishable, and catch our eye at the same time in a straight-angle view, as is the case with the image of the shooting of a scene from *Bhabhi* (1938) (see, figure 4, chapter 4). Everyone in the image seems to be looking off-frame in the same direction, a collective enterprise oriented towards the intentions of an unseen *metteur-en-scène*, or director. In contrast, in other images taken from an elevated angle or from sufficient distance, a clearly cartographic ambition reveals the entirety of the space of production and therefore prescribes in advance how we are to view the image: as a totalizing, omniscient view of the production of a movie. Such is the case with the bird's-eye view of the elaborate lighting set-up for *Achhut Kanya* (see, figure 11, chapter 4), or the distanced view of Devika Rani and other cast members waiting for the boom microphone to be fixed during the filming of *Jeevan Prabhat* (1937) (figure 22).

How Photography Gives an Account of Itself 65

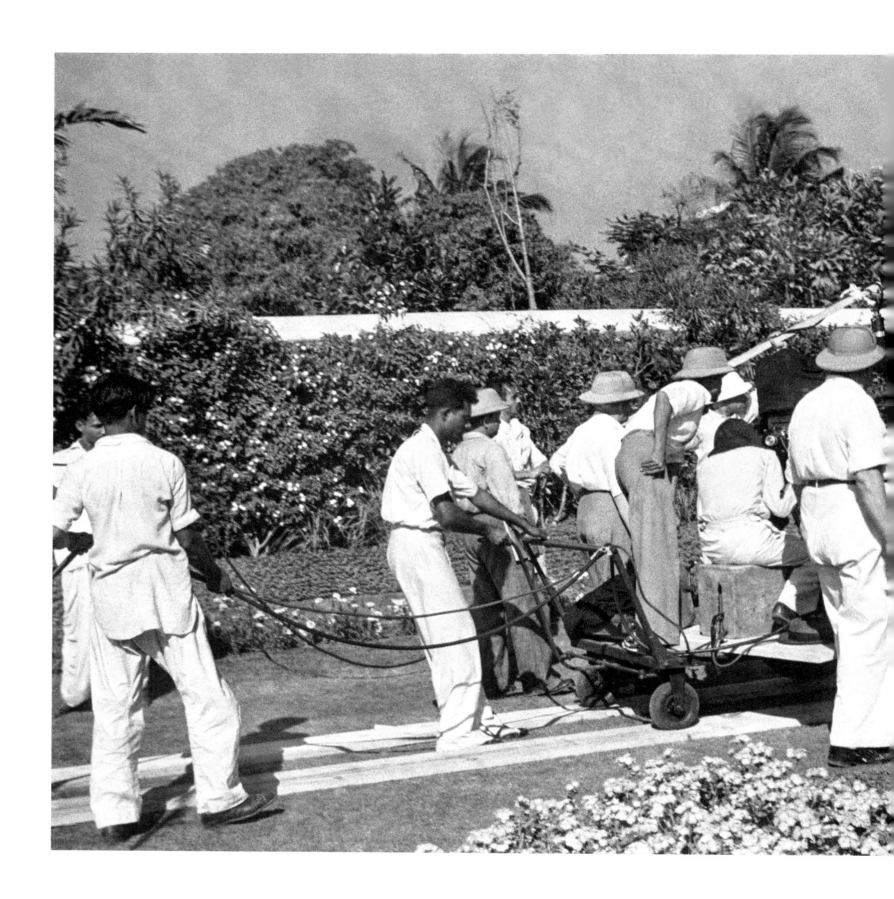

LEFT

FIG. 19 *Nirmala*
1938, Bombay Talkies, d. Franz Osten
35 mm Negative
JWA/ACP: 2019.01.0083

Set-up for a tracking shot taken in the Bombay Talkies compound. A microphone can be seen suspended on a boom directly over the camera and just out of frame, while assistants operate the camera and pull focus during the take. Josef Wirsching and Franz Osten monitor the action on either side of the trolley. Sashadhar Mukherjee (far right) holds a script.

RIGHT ABOVE

FIG. 20 *Nirmala*
1938, Bombay Talkies, d. Franz Osten
35 mm Negative
JWA/ACP: 2019.01.0082

Devika Rani and Maya Devi rehearse a tracking shot with dialogue.

RIGHT BELOW

FIG. 21 *Jawani ki Hawa*
1935, Bombay Talkies, d. Franz Osten
35 mm Negative
JWA/ACP: 2019.01.0116

A lighting assistant positions a directional light for a train compartment scene.

How Photography Gives an Account of Itself

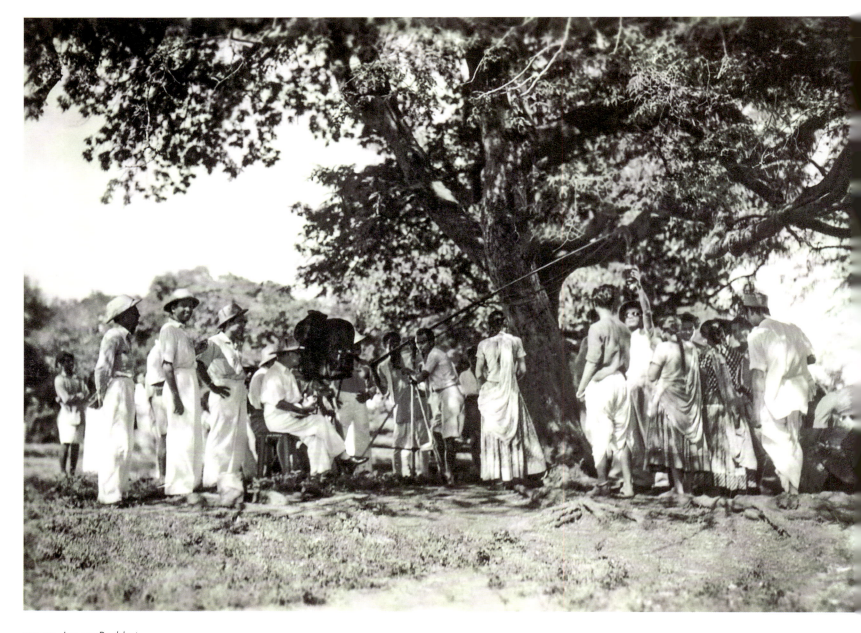

FIG. 22 *Jeevan Prabhat*
1937, Bombay Talkies, d. Franz Osten
Gelatin Silver Print, 83 x 116 mm
JWA/ACP: 2019.01.0094

Devika Rani, Maya Devi and Mumtaz Ali wait for Savak Vacha to fix the boom microphone during an outdoor shoot.

FACING PAGE
ABOVE
FIG. 23 **Sashadhar Mukherjee**/*Izzat*
1937, Bombay Talkies, d. Franz Osten
35 mm Negative
JWA/ACP: 2019.01.0018

Sashadhar Mukherjee peering through the camera with a clapper boy bending over in the background during a break in outdoor location filming of *Izzat*. Sashadhar was an assistant in the sound department at the time, and is uncredited in the film.

BELOW
FIG. 24 *Izzat*
1937, Bombay Talkies, d. Franz Osten
35 mm Negative
JWA/ACP: 2019.01.0090

Savak Vacha adjusting the microphone stand during an outdoor shoot.

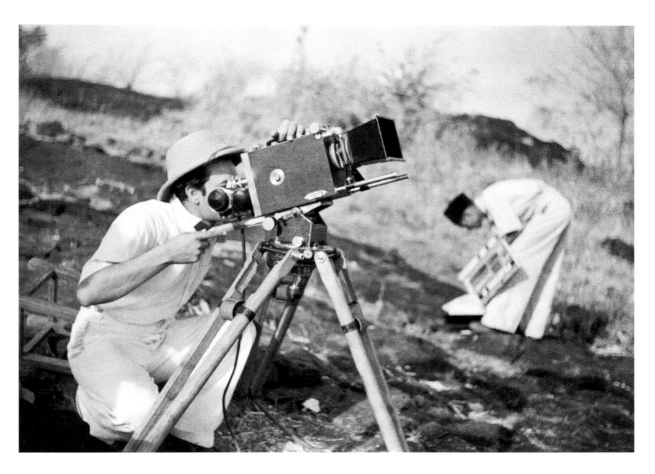

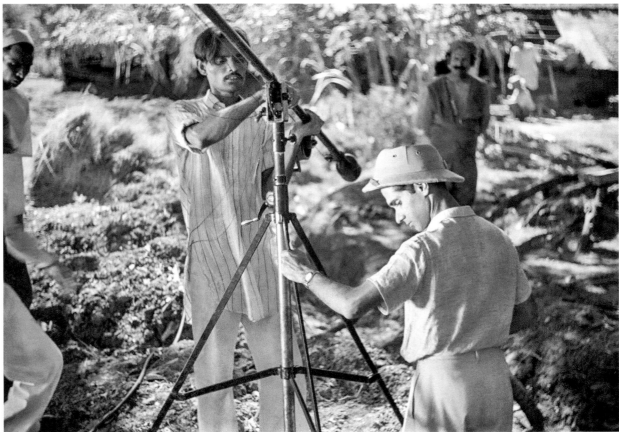

How Photography Gives an Account of Itself 69

FIG. 25 *Vachan*
1938, Bombay Talkies, d. Franz Osten
35 mm Negative
JWA/ACP: 2019.01.0103

A recreated forest on one of Bombay Talkies' three sound stages.

The production still from *Vachan* (1938) stages the picturesque as an accelerated movement through the foliage of trees on ground level to an illustrated backdrop in which our eye ascends upwards to painted temple tops to then rest, still higher, on a hazy fortress partially concealed by the clouds (figure 18). An electrical light source on a pedestal, combined with other unseen sources of lighting, adds spatial depth. The exhibition caption for this image asked us to notice the "artificial trees," but how is one to know these are artificial?[8] Are these artificial in the sense of being plastic, or artificial in so far as these might be branches cut from real trees, and brought to serve a function in the studio setting? The photograph is at once, in photo-historian David Campany's words, "descriptive, straight and true" (the foliage, the painted backdrop, and the lights all indisputably stood before the photographer's camera) and "indirect and allegorical" (Campany 2008, 119), staging the coexistence of technology and nature, the material and the immaterial, the tactile and the visible, as if to point not just at how movies are made but also to the crazy-making potential of the medium of photography, one that reminds us, to appropriate Maurice Merleau-Ponty from a slightly different context, that every visual image is "a continuation of [visibility's] own sovereign existence" (Merleau-Ponty 2007, 394).[9] David Campany's words were written for his discussion of Edward Weston's and John Swope's famous photographs of the Metro-Goldwyn-Mayer Studios, taken in 1939, just a year after the production still from *Vachan*, in 1938. Campany cites Clement Greenberg's appreciative review of Weston's photograph of a painted backdrop because the photograph showcased, in Greenberg's backhanded compliment to photography, the "sharply focused eye" of the camera that presents artifice as fact (Campany 2008, 119). John Swope's photograph of the same backdrop, by contrast, includes, in an anti-illusionist gesture, the scaffolding of the sets that are absent from sight in Weston's image. Yet, anti-illusionism is only relevant in

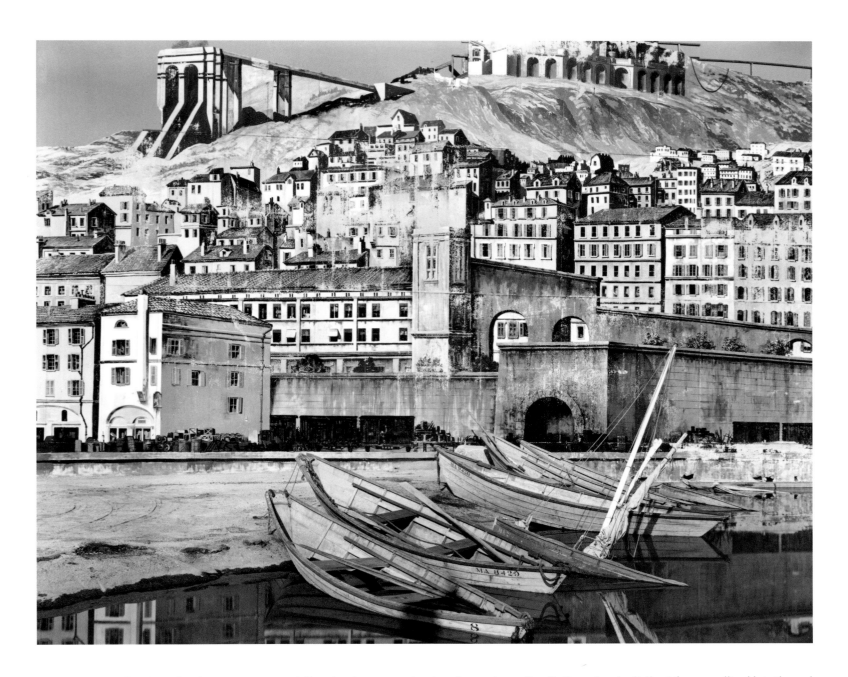

FIG. 26 MGM Studios (waterfront)
Edward Weston
1939
Gelatin Silver Print, 193 × 244 mm
Acc. No. 81.251.130
Courtesy: Collection for Creative
Photography © Center for Creative
Photography, Arizona Board of Regents

A photographic view of a movie set on a MGM studio lot.

relation to cinema understood as a deceptive fiction clearly distinct from reality. Untethered from a Frankfurt-school tradition of critiquing mass culture, we arrive at a more supple appreciation of the visual worlds that the "backstage" images of the Wirsching collection present for us. Even Kracauer, to whom we return once again, in his observations of the UFA set in Neubabelsberg in 1930, paired his condemnation of the illusion-factory of cinema with language that seems more ambiguous in retrospect. While Kracauer describes the props of a film studio as "a bad dream about objects that has been forced into the corporeal realm" (Kracauer 1995, 281), in the same essay, an *anti*-anti-illusionist stance is also evident. There is no politics here, he writes, of the film set with its varied settings, ready at hand: "a Bolshevist guardroom turns into a peaceful Swedish railway station" (283). Is that the description of a fantastical scene in a movie? Or a commentary on it from the outside? There is nothing false about the materials we see in the UFA lots, Kracauer goes

How Photography Gives an Account of Itself 71

on to say. "One could also make real things out of them, but as objects in front of the lens, the deceptive ones work just as well. After all, the lens is objective" (286). Humans and objects are integrated in cinema because "light melts them together" (286). That, we could add, would apply to photography as well, including many of the backstage pictures of this collection.

What am I looking at?

The publicity still may either be a frame from a movie, or a photograph produced specifically for the purpose of publicity. Or the moment may have been captured by the still photographer at some point either during a take or after. Such interstitial and intermedial ambiguity marks a number of images in this collection that, sans captions, and sometimes even with available captions, are riveting precisely because we cannot tell what we are looking at. Consider figure 27, an image from *Miyaa Biwi* (1936). Was the picture taken during rehearsals? The musician on the left is looking at the camera. So presumably is the dancer, whose entire presence is oriented towards the camera, one that

FIG. 27 *Miyaa Biwi* or *Always Tell Your Wife*
1936, Bombay Talkies, d. Franz Osten
35 mm Negative
JWA/ACP: 2019.01.0071

This dance sequence is missing in the surviving copy of the film, making this photograph the only visual record of the lost scene.

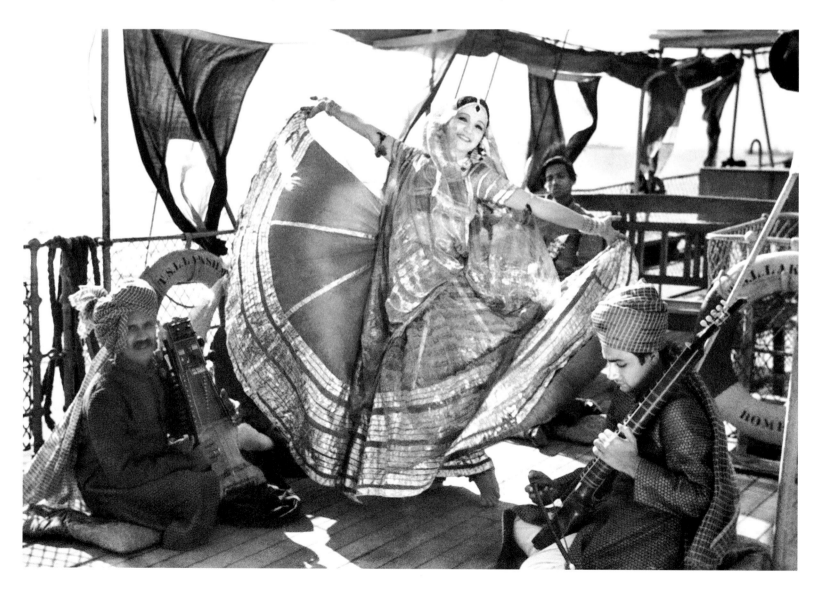

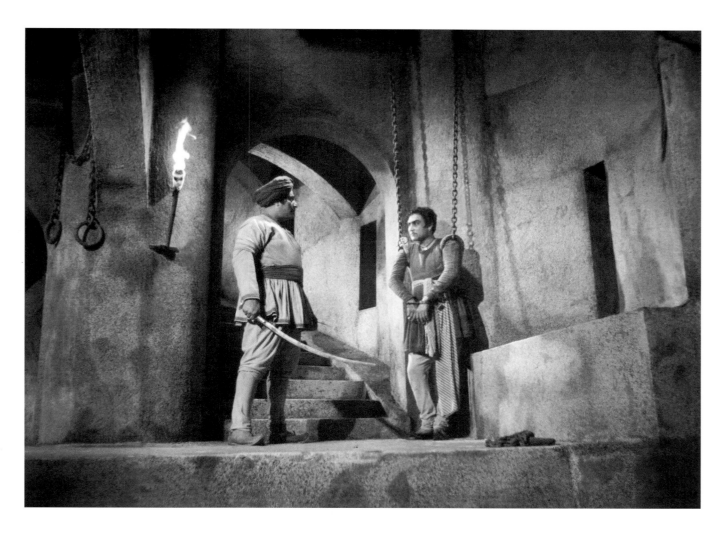

FIG. 28 *Shamsheer*
1953, Bombay Talkies, d. Gyan Mukherjee
35 mm Negative
JWA/ACP: 2019.01.0106

melds costume and figure, apparel and posture into a form. But their looks carry different implications: the dancer caters to the conventions of spectatorship through the frontality of her performance for a camera (still or moving? Or both?). The musician's direct glance at the camera invites a different reading, as if he were noticing the still photographer rather than performing his gaze for an implied spectator, diegetic or otherwise. Like film critic André Bazin's use of the asymptote as a metaphor for filmic representation's relation to reality (Bazin 2005, 82), the musician's gaze departs from the regime of the visible carved by the dancer, pulling the photograph in an uncertain direction. Or consider, among other examples, the frame from *Vachan* (1938) of Ashok Kumar on horseback (see. figure 14, chapter 5), or the one from *Shamsheer* (Gyan Mukherjee, 1953) in which we see Ashok Kumar in a dungeon (figure 28). Both images, of the actors' poses and expressions fully formed, seem to reside in a state of permanent and eternal stillness. Publicity stills stage tableaux—idealized condensations of a film's running time. The publicity still circulates often in advance of a movie, and alongside its commercial running. In this collection, such images are distanced by time and our retrospective access from the movies to which they belong, and they function akin to what Victor Burgin (2004) calls a "sequence image," an image that we recall from the movies, when it does not seem to matter whether the image

precisely recalls a particular sequence of a specific movie or even an actually existing one. For the film historian so far removed from this period and by archival vagaries, the sequence image—and we might consider these implacable images as such—activates our sense of not just a movie but also a genre, an ethos, a studio, a period of film history, in ever-expanding circles of significance. But it is equally the case that for the photo-historian interested in these images *qua* photographic expression, these photographs hover somewhere uncannily between theatricality, absorption and distraction, between the posed still and the candid snapshot.[10]

Conclusion

I began this essay with an image that spoke to the dense visualities afforded by the medium of photography. By way of conclusion, consider two exceptional images, perhaps on the other end of the spectrum of the opening image, both from the sets of *Jawani ki Hawa* (1935). The exhibition captions confirmed the gravitational pull of these images. The first one (figure 29) was captioned: "An evocative moment with inanimate lights, wires, and an empty set waiting for the human cast and crew to arrive." This is one of the few images sans any view of figures, human or animal, and sans any view of the fictional settings. The image presents us with the infrastructure *behind* the infrastructure of filmmaking.

The second one (figure 31) was captioned: "A view of the intricate set constructed for the train interiors in the film. Note also the backdrop painted on a rotating cylinder. This is an ingenious technique to indicate passing landscape through a train window, an alternative to the technique of back projection." The adaptation of a diorama-like arrangement for set design in place of rear projection is jaw-dropping and begs further research as to its origins and the extent of its use, in Bombay Talkies and beyond. But I also wonder if the photographer was moved in both of these distanced and elevated views of infrastructure by a strongly modernist interest in abstraction, for the sheer play of lines, diagonals and semi-circles. The push and pull of photographic modernism, the desire to produce illusionistic space, but also to draw the viewer to the surface of the image, is evident in both these images.

Assuming Wirsching might have taken these photographs, what drove him to produce such images? In Wirsching's native Germany, an anti-Pictorialist, anti-Expressionist approach to photography, called Neue Sachlichkeit, or New Objectivity/Sobriety, had already acquired definition in the late 1920s in the photographs of Albert Renger-Patzsch and August Sander, an approach quite distinct, we might add, from the photo-montage marriage of film and photography that was also evident, alongside Renger-Patzsch's and Sander's photographs, in the iconic "Film Und Foto" exhibition at Stuttgart in 1929, organized by the Deutscher Werkbund. "[A] clear, distinct representation of objects with a clearly arranged formal structure," proposed one definition of this New Objectivity movement from 1929 (Stetler 2011, 294). The sharp focus of the camera, the "visual investigation of form," the "formal similarities between natural, architectural and mechanical objects," (292) such are the

FACING PAGE
FIG. 29 *Jawani ki Hawa*
1935, Bombay Talkies, d. Franz Osten
35 mm Negative
JWA/ACP: 2019.01.0115

Lights, cables and a built set wait in readiness for the next shot. The crew built train compartments as the central indoor set.

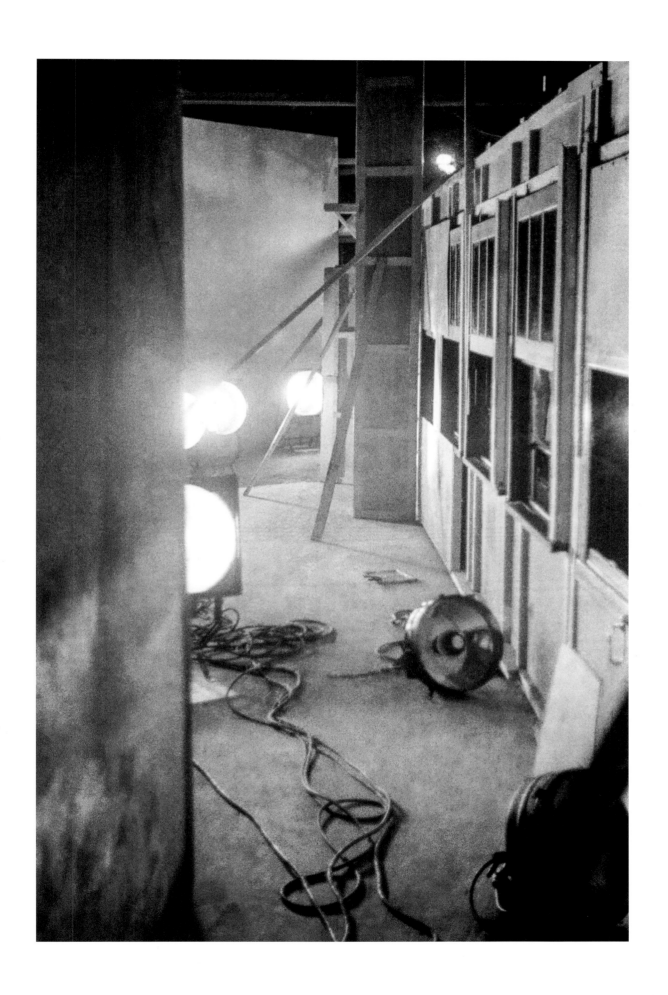

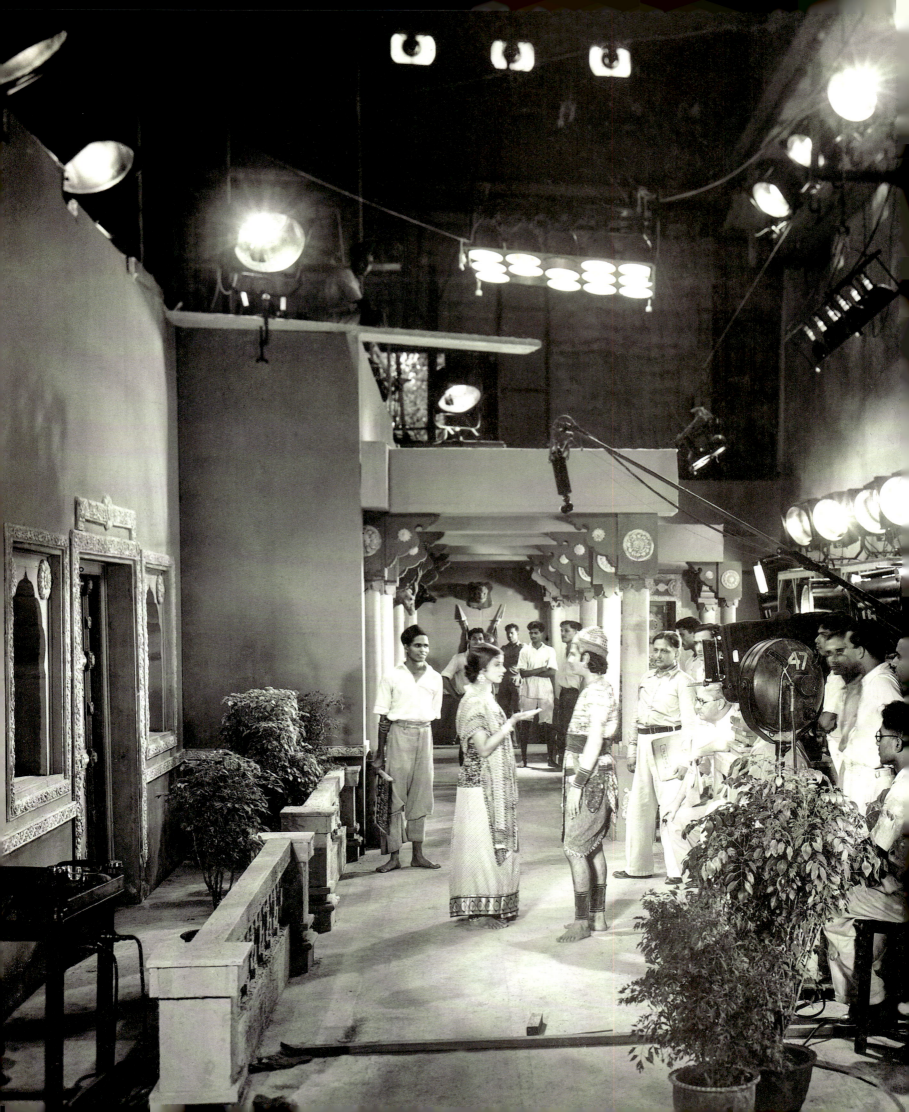

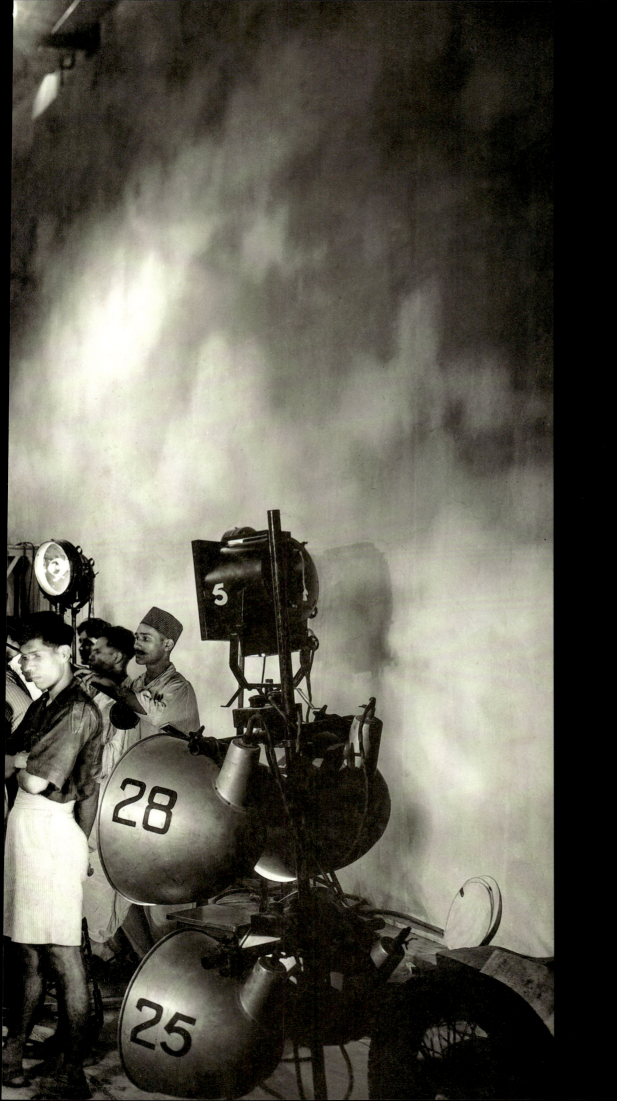

FIG. 30 *Vachan*
1938, Bombay Talkies,
d. Franz Osten
Gelatin Silver Print, 162 x 205 mm
JWA/ACP: 2019.01.0096

Debutante actress Meera and Bombay Talkies veteran Mumtaz Ali rehearse a scene from the film, a historical costume drama. Sets were designed by Y. E. Hate and N. R. Acharya.

FIG. 31 *Jawani ki Hawa*
1935, Bombay Talkies, d. Franz Osten
35 mm Negative
JWA/ACP: 2019.01.0117

A top-angle view of the intricate train set reveals a painted backdrop on a rotating cylinder (right).

attributes evident in these two images as well. In France, the movement of documentary photography into the realm of the avant-garde and its publics, with the inclusion of Eugène Atget's photographs by André Breton and the surrealists (albeit with Atget's refusal to allow his name to published alongside his images) occurred in 1926. This was just a year prior to the celebration of Renger-Patzsch's photographs in 1927, in another iconic German journal, *Die Form*. In both countries, artistic authorship and production became the general precondition of photography's induction into the avant-garde (293, 295).

It seems noteworthy in contrast, therefore, that this collection belonging to Josef Wirsching—an émigré who was likely familiar with these trends in photography in his native Germany and who had a fruitful, lifelong career in Bombay cinema—should evince so many disparate strands, which mitigate against the attribution of a singular consciousness and vision to it, whether German Expressionism, French Impressionism, topical photojournalism that incorporated the traditions of the picturesque and the exotic, representations of European everyday life in South Asia, candid and documentary photography, film publicity stills, as well as the tendencies of the photo-illustrated press in Germany and in India at the time. This collection is the outcome of the cross-fertilization of cultural influences at Bombay Talkies, a *dépaysement*, a rendering into exile and (self)-alienation, of media and people, drawing in the histories of photography, print media and cinema, and ranged across continents and cultures. This indeed is a "nation" of photography.

Notes

1. Photographs from the Josef Wirsching archive were exhibited publicly for the first time in 2017, at the Serendipity Arts Festival in Goa, India. The exhibition caption said: "A classic behind-the-scenes moment, where you see the clapboard, microphone and a lighting assistant with a reflector during an outdoor shoot."

2. I have in mind Noam Elcott's (2018) typology of media *dispositifs* in which the "cinematic" refers to proximity through distance and displacement, while the "phantasmagoric" assembles humans and images in a common space and time.

3. For an extended discussion of the hopes invested in photography's ability to transcend cold war politics to produce a "nation of photography", see Blake Stimson's (2006) discussion of the iconic photographic projects of the post–Second World War period, such as 'The Family of Man' exhibition at the Museum of Modern Art, curated by Edward Steichen.

4. I borrow the phrase "sensuous incitement" from Mazzarella (2013). The relation between "sensuous incitement and symbolic order" (3) is central to the claims of sovereign power and the exercise of censorship in Indian cinema, argues Mazzarella.

5. I'm borrowing the phrase from Patrizia McBride but using it in an altered and perhaps more colloquial sense, to measure the difference in volume or "noise" between a collection of photographs perused over individually and the big-screen sights and sounds of a movie aimed at a mass public. McBride uses the phrase to index the physiognomic dimensions of Weimar visual culture in which the combination of image and text in photomontage demanded that "words be viewed like pictures and images decoded like signs" with the assumption that "visible surface of reality speaks to us in a language of sorts" (McBride 2016, 4). McBride's observation regarding photomontage nevertheless also applies to my reading of the combination of word and image in the first photograph I have analysed above. Indeed, the idea of words being treated like visual signs, as well as the idea of a somatic and physiognomic dimension to visuality, has appeared both in theories of visual culture and in ethno-histories of visuality in the global South (Mitchell 2002; Pinney 1997).

6. For an extended discussion on the relation between the cultures of photography in South Asia, the archives that have been generated by those cultures and how those archives have in turn shaped the dominant directions of scholarly histories, see Mahadevan (2013).

7. For a recent essay on documentary and industrial photography, see Roychoudhuri (2017).

8. Exhibition caption, 2017: "A production still indicating the scale of an indoor set replicating a forest. Note the painted backdrop, artificial trees, lights and track and trolley paths."

9. "Whence does it happen that [in looking at objects, the gaze] leaves them in their place, that the vision we acquire of them seems to us to come from them…? What is this… singular virtue of the visible that makes it, held at the end of the gaze, nevertheless much more than a correlative of my vision, such that it imposes my vision upon me as a continuation of its own sovereign existence"? (Merleau-Ponty 2007, 393–94). Every visual becomes a "concretion of visibility" (394) in general, argues Merleau-Ponty, before going on to likewise question the separation of touching and the touched, the sentient and the sensible, in a thorough-going articulation of an immersive, relational and synesthetic corporeality and materiality that subtends our experience of the world.

10. For a discussion on absorption and theatricality as opposed modes of depicting selfhood in painting and photography, see Fried (2007).

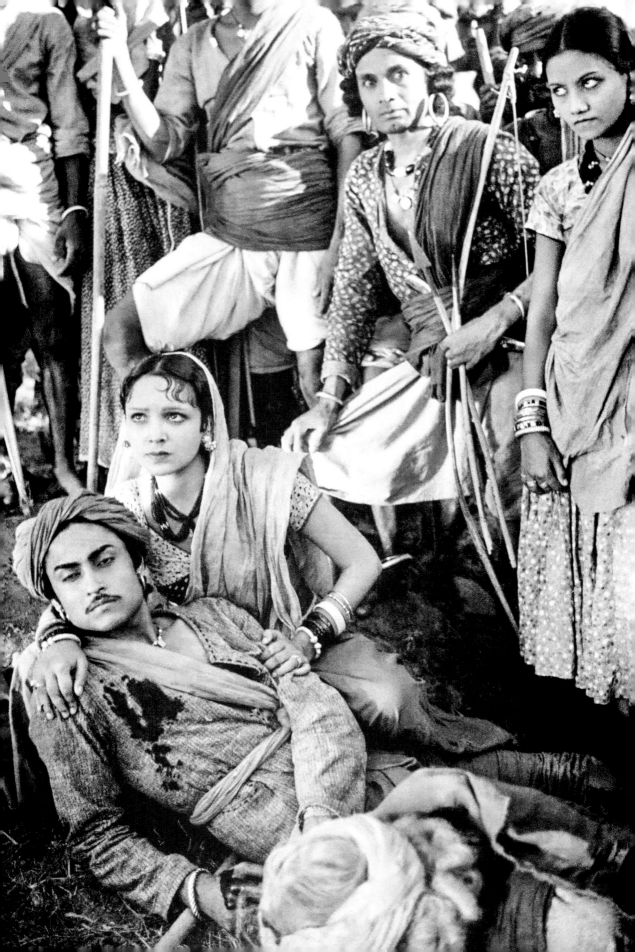

The Knot

A Scholar and an Angel Unravel Izzat *(1937)*

■ Priya Jaikumar ■

This piece is in the form of an indirect exchange between two voices. The first voice is that of a film scholar who speculates on a few images, using visual and written evidence to make her case. The second voice appears to belong to an angel of history, as inscribed in a bound volume found in the office of a now-deceased Senior Clerk at the Maharashtra Housing and Area Development Authority, along with a collection of other objects recovered from the 2005 Mumbai floods.

All-seeing possessors of perfect memory, angels exist outside human scales of meaning, comprehension and compassion. In contrast to a scholar's loquacity, angels speak infrequently, so what follows is a rare document. The past, present and future often collapse in an angel's eternal vision, which makes their speech challenging to decipher. Nor is it always easy to discern who the angels are speaking about when they speak, as they mention proper names only when it pleases them. After considerable research and debate, historians now largely agree that the angel here is referring to the same images as those discussed by the scholar. Both are talking about the husband and wife team of Himansu Rai and Devika Rani, who established the Bombay Talkies studio in colonial India in 1934. Like the scholar, the angel appears to be preoccupied with the company's production of *Izzat*, directed by Franz Osten in 1937.

Some historians continue to contest this claim.

FIG. 1 *Izzat*
1937, Bombay Talkies,
d. Franz Osten
35 mm Negative
JWA/ACP: 2019.01.0008

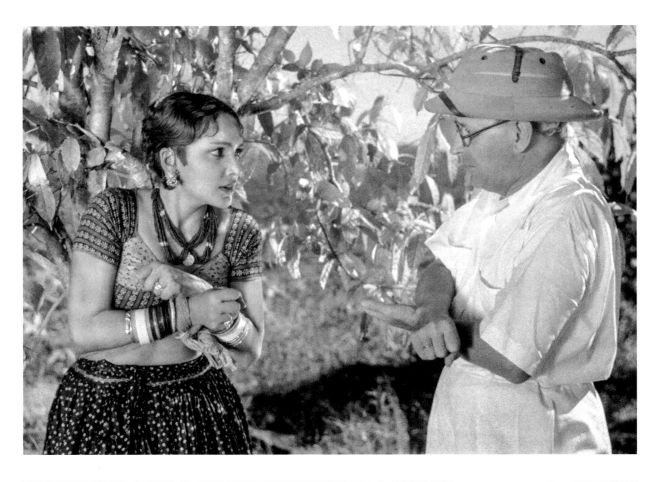

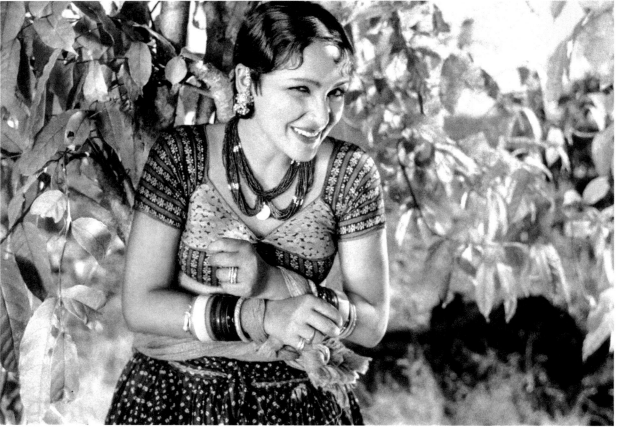

FACING PAGE
ABOVE
FIG. 2a *Izzat*
1937, Bombay Talkies, d. Franz Osten
35 mm Negative
JWA/ACP: 2019.01.0079

A photographic series in which Devika Rani and Ashok Kumar prepare for a scene under the direction of Franz Osten. The scene shows Devika Rani being bound to a tree by Ashok Kumar.

BELOW
FIG. 2b *Izzat*
1937, Bombay Talkies, d. Franz Osten
35 mm Negative
JWA/ACP: 2019.01.0031

FIG. 2c *Izzat*
1937, Bombay Talkies, d. Franz Osten
35 mm Negative
JWA/ACP: 2019.01.0080

Scholar: In this essay, I discuss the function of gesture and desire in Himansu Rai's *Izzat* (Osten, 1937), by thinking about the bodies of the film's characters in relation to the bodies of the film's actors. My analysis is inspired by a few photographic stills from the Josef Wirsching collection of *Izzat*'s shoot in and around Bombay. Wirsching's locational photographs accompanying this essay document scenes that preceded, succeeded and, on occasion, potentially overlapped with shots that appear in *Izzat* (for which Wirsching was the cinematographer), allowing us glimpses into the gestures and postures that were rehearsed and eventually adopted by the actors in the film. In most of the images, actors are taking their positions in the profilmic space. I follow Tom Gunning's definition of the profilmic as "everything placed in front of the camera to be filmed" (1994, 19) because it opens up the process-oriented nature of something that is *to be* filmed. It makes visible the connections and subtle distinctions between the gesture and placement of actors in a film's setting, as opposed to the image that appears projected on-screen and bound by a film frame. It brings into relief the connections and gaps between a film's profilmic and onscreen spaces by giving the former its own density and significance. In other words, Wirsching's cinematography in the film *Izzat* and his production stills from the shoot convey overlapping but non-identical scenarios.

Wirsching's photographs of *Izzat*'s shoot capture the environmental space reproduced in the film, but are temporally adjacent rather than simultaneous to the filmed shots. With a critical reading that oscillates between Wirsching's photographic images of the film's profilmic spaces and the film's narrative, I elaborate on the "filmed spaces" (Jaikumar 2019) of *Izzat* to provide an account of the casual as well as curated relational dynamics of the production company's creative team. Further, I argue that while these photographs

The Knot 83

do give us some behind-the-scenes glimpses of *Izzat*'s production team, they do not escape cinematic regimes of vision. They do not so much show us what escapes *Izzat*'s cinematographic camera as reveal cinema's extensive technologization of human bodies and environments outside the rubric of any particular film's aesthetic and narrative frame.

Angel: It was manufactured in Piccadilly, London, and promised a finely blended, high quality of tobacco. The round tin was wrapped with mustard yellow paper and its blue top was embossed with the brand name that he caressed, often unconsciously, with his left thumb, as he cradled the tin behind his back and strolled around film sets. He talked to himself all the time. The words were rock pythons. They had no venom but constricted him slowly from within. When you mention that time, it comes to me first as the sweet fumes of State Express 555 cigarettes riding distractedly around his mouth. Then as the damp smells of a soil that hushed all human sound. It was an insignificant episode in time. No one thinks of it. It is of no interest to anyone. Why do you bother with it? Who will remember your questions?

Scholar: In figures 2a–c accompanying this essay, director Franz Osten is preparing Devika Rani for a shot in which she has her hands bound and tied to a tree by her co-star Ashok Kumar. Figure 3 shows what may have been used for the film's publicity, with Devika Rani's character in a position of recoil. In figure 5, Devika Rani is taking a cigarette break. The studio would not have wanted the last of these five images to circulate publicly. Rani's screen image was one of guilelessness and feminine innocence, which is disturbed by this vision of a cigarette-smoking elite urbanite.

FIG. 3 *Izzat*
1937, Bombay Talkies, d. Franz Osten
35 mm Negative
JWA/ACP: 2019.01.0007

Let us begin with the film. The *izzat* (honour) of the film's title refers to the injured pride of a group of Bhil tribals in central India, when they are ridiculed and robbed of their land by the nephew of an ailing Maratha chief. The nephew's betrayal of a long-standing peace treaty between the Marathas and Bhils proves to be a fatal shock for the Maratha chief (Patel) as well as the Bhil leader (Naik).[1] Their death precipitates the disappearance of the old order, leaving the Bhil tribals at the mercy of the scheming nephew, Balaji (played by M. Nazir), who usurps control over their territory of Ashti. *Izzat* depicts the Bhil fight to earn back their honour, land and savings under the guidance of Kanhaiya Bhil (played by Ashok Kumar), who is the dead Naik's son. Kanhaiya is successful in his mission. In a parallel plot, the film follows his romance with the beautiful Bhil woman Radha (played by Devika Rani) to a more tragic conclusion. Reminiscent of William Shakespeare's *Romeo and Juliet*, near the film's denouement each lover believes the other to be deceased, resulting in the deaths of both Radha and Kanhaiya.

The film is available for viewing online, and the surviving footage can be supplemented with plot descriptions from *Izzat*'s song booklet to give us a complete sense of the film.[2] The film's dramatic tension is built less by its meandering plot than by a staccato series of theatrical episodes depicting inequalities of power, desire and control in matters of love and territorial possession. History and myth contribute to this drama of inequality. Produced during a time when both historicals and mythologicals were popular film genres, *Izzat* draws on the history of the Bhil tribe whose land and subsistence were eroded by the Marathas in the eighteenth century, but who nonetheless served as valuable allies to the Marathas during the latter's subsequent battles against the British East India Company. The historical ambivalence of the Marathas toward indigenous Bhil communities is infused in the film with religious and mythic elements, with the introduction of Radha and Kanhaiya, both named for Hindu deities (Kanhaiya is another appellation for Krishna). In *Izzat*, the romantic duo's names, dialogues, songs, costumes and gestures often allude to the divine couple of Krishna and Radha, lending the film overtones of the mythological genre. In Hindu folk, popular and classical traditions, Radha and Krishna are evoked as the archetype of true love. Their love is portrayed as eternal but not as necessarily equivalent. Radha's love for Krishna is frequently depicted with a quality of yearning and self-obliterating devotion, as against Krishna's playful dalliance. In the multitude of Hindu traditions, this couple's relationship takes on different forms. In some, Radha is Krishna's older married maternal aunt. In the south of India, Krishna's wives are Rukmini and Sathyabhama, not Radha. In these instances, Radha's unconventional erotic devotion to Krishna shows an affinity with female seekers in the Bhakti tradition.[3]

It is the scent of unequal power and desire in *Izzat* and in the bodies and gestures of the actors in Wirsching's photographic stills that I follow in this essay. In the film, the Bhil women are explicit about their desire for Kanhaiya. So, in addition to a sanctified deification of the central couple, heterosexual female desire is unexpectedly open and direct in *Izzat*. If, on the one hand, the film's narrative adheres to the patriarchal

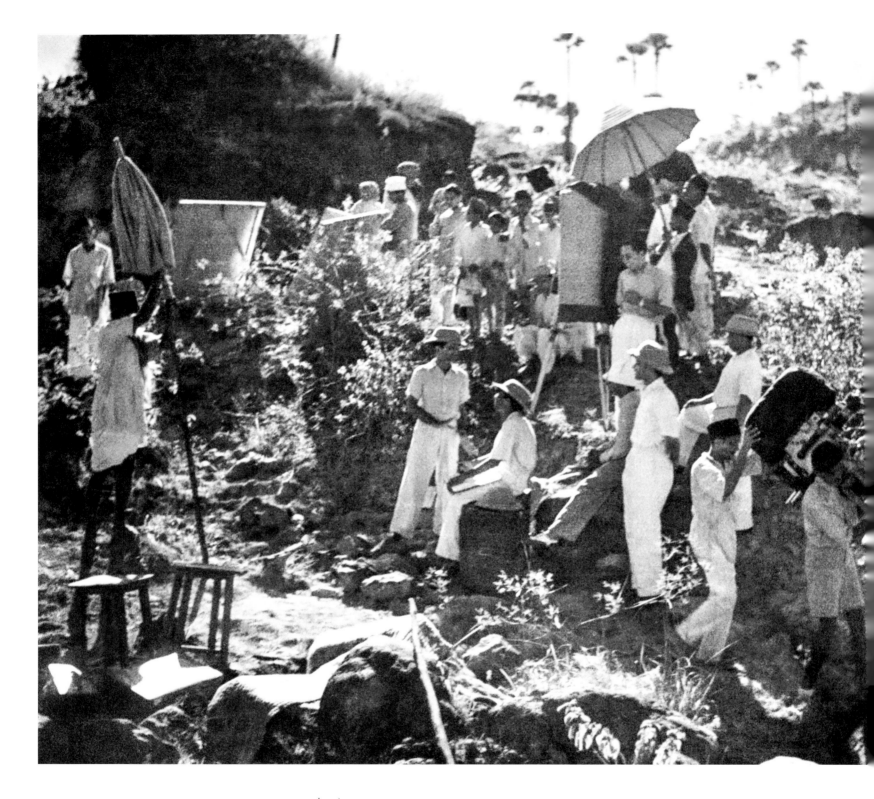

FIG. 4 *Izzat*
1937, Bombay Talkies, d. Franz Osten
35 mm Negative
JWA/ACP: 2019.01.0077

This image sums up the collaborative nature of filmmaking, as diverse crew members get ready to move to the next location. Note also the uniform use of white clothing and *sola topis* (pith helmets) by the inner circle of the production team.

presuppositions of its time and carries a veneer of deified sanctity, then, on the other, desire runs in many directions in the film's visual design and song picturizations, modifying the narrative's hierarchy of gendered desire in ways akin to other socially progressive films from Bombay Talkies. Female desire does not take second place to male needs. This articulation of female desire is enhanced in the two romantic triangles that complicate Radha and Kanhaiya's romance (similar to other Bombay Talkies productions that depict love triangles, most famously *Achhut Kanya*). A Bhil woman, Chanda, is in love with Kanhaiya. And Appaiya, a Bhil man, is Kanhaiya's rival in the contest over Radha and over tribal leadership. Chanda and Appaiya collaborate with each other and their Maratha enemies to foil the romance between the main protagonists. Kanhaiya's allure to Radha and Chanda, combined with Appaiya's resentment of him, makes the erotics of desire and power an explicit part of this film's narrative and visual composition.

The film's erotic charge settles uneasily on actor Ashok Kumar's young and somewhat awkward gait as he plays Kanhaiya with more diffidence than is called for by the part. In contrast, Rani's confident assaying of her role in relation to Kumar's raw and untutored dialogue delivery points to relational asymmetries within the Bombay Talkies production unit. Photographs from the Wirsching collection show us the bodies of actors being rehearsed and trained to conform to the gestural hierarchies of power and desire in the filmic world. They also reveal the actors' bodies in relation to each other and to the environment, *outside* the parameters of the film's narrative and visual frame.

> ***Angel:*** *The reds, yellows, purples and blues spilled over, but her hands always went to shades of cerulean. Memories of the Continental sky from her teens. Her co-star got a shirt shot through with strands of orange and yellow homespun* khadi *fibres but her hands and eyes went to airy cottons and watery silks. Homespun was okay for politics but not for the screen. It was her idea, even if they thought it was theirs. She and the women were talking of yeast. What it does. How it is necessary but invisible. In the naan bread her husband liked. In the sweet* Dampfnudels *the Germans brought to set five days ago. Twisting the fabrics in a heap, tying knots, laughing when they were hard to unravel. Can knots of cloth be as hard as metallic link chains? Isn't it all bondage of one sort or another? Why else do they want to make political statements by wearing homespun cloth? Who are they, who am I? What person or persona do I bind myself to? Her cerulean skies were now out of reach but here was exquisite fabric.*

Scholar: *Izzat* was the fourth film produced by Bombay Talkies to reprise the successful pairing of Ashok Kumar and Devika Rani in the romantic lead, following *Jeevan Naiya*, *Achhut Kanya* and *Janma Bhoomi*, all released in 1936. *Jeevan Naiya* gained fame and notoriety when Devika Rani, the film's female lead, who was also Himansu Rai's wife and co-founder of the studio, eloped with the film's male star, Najmul Hussain. Both Hussain and the footage were dropped and Ashok Kumar, a laboratory assistant newly added to

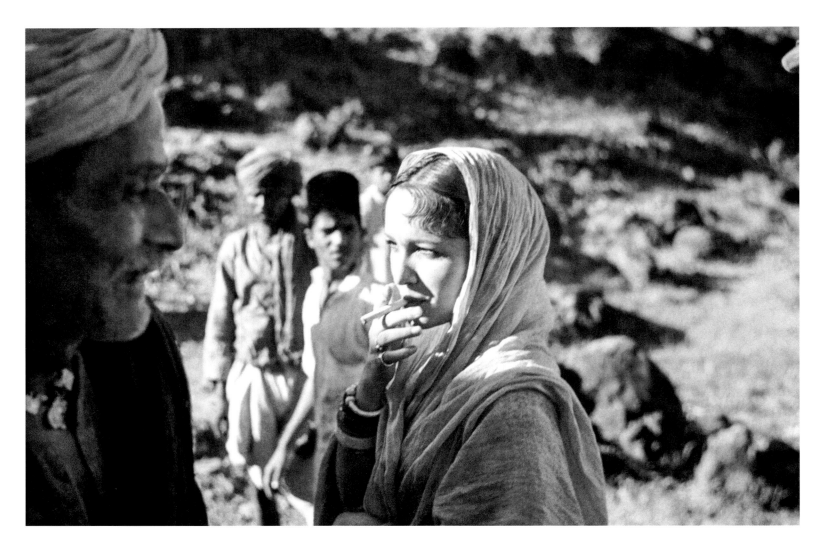

FIG. 5 *Izzat*
1937, Bombay Talkies, d. Franz Osten
35 mm Negative
JWA/ACP: 2019.01.0026

Devika Rani takes a cigarette break while co-actor Kamta Prasad looks on.

the Bombay Talkies payroll, was thrust into stardom when producer Rai persuaded him to step in front of the camera as the male lead. *Jeevan Naiya* was a success. *Achhut Kanya* surpassed its popularity and made Kumar and Rani the hit couple of the 1930s in ways consolidated by *Janma Bhoomi* and *Izzat*.

Izzat did not share the turbulent production history of *Jeevan Naiya*. Nor did it enjoy the fame of the reformist social *Achhut Kanya*. But its ordinariness and fourth place in the series of Kumar-Rani starrers reflects the studio's interest in playing to audience expectations. Similar to some of the preceding films, for instance, the Kumar and Rani coupling is foreordained but doomed in the film. Social conflicts and personal misunderstandings cause Rani to become a sacrificial figure.

Izzat's final sequence has Kanhaiya walking to the gallows because he has murdered the man responsible for pushing Radha down a precipitous cliff. (We do not see the precise events that transpire because of what appears to be missing footage). Until this fatal conclusion, the film tarries with gestures of capture with playfulness. Repeatedly in *Izzat*, characters have their hands bound in knots in front of their bodies or behind

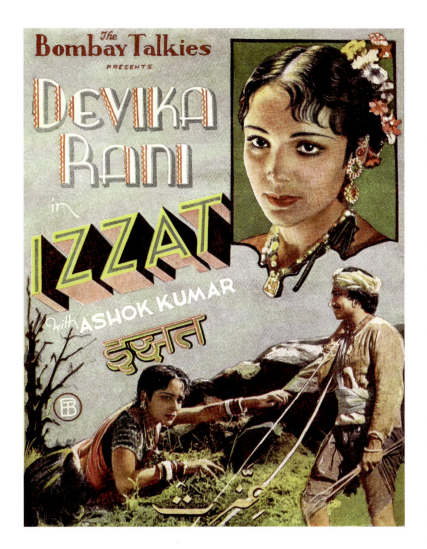

FIG. 6 *Izzat*
1937, Bombay Talkies, d. Franz Osten
Song booklet cover
Josef Wirsching Archive

their backs with a *dupatta* (a long cloth scarf typically draped around the head or chest), a *kamarband* (belt) or a *saafa* (turban or headscarf). Time after time, lovers and enemies are overpowered and immobilized by knotted twists of fabric. This light-heartedness disappears as the capture moves indoors to a prison in the finale. In prior scenes of capture, skirmishes are fought in the open and people are tied up with nothing more threatening than improvised ropes of cloth. Gestures of tying and of being tied, of incapacitating someone with a garment transformed into a binding knot, establish strong relationships of love and loyalty. Equally, they elicit pledges of hatred and vengeance between captors and victims. These ties lock the film's characters into primal postures of affiliation or aggression. The following description offers a breakdown of some of these instances in the film:

(a) Kanhaiya ties a protesting and screaming Radha with her scarf to a tree when she stops him from setting off to Ashti in search of the offending Balaji. This is the sequence director Franz Osten is rehearsing with Devika Rani in figures 2a–c and 3. In the photographs, we see Osten showing Rani her position, and Rani smiling and half-winking at the camera as she readies herself for the shot.

In the film, Kanhaiya laughingly walks away from Radha after tying her up, and she cries, "*Kya kar rahe ho, chhodo mujhe!*" (What are you doing, let me go!)[4] Soon after, Radha's friends Amrit (Mumtaz Ali) and Harni (Sunita Devi) find her bound up and sing a song about the mythic Radha and Krishna. Harni prevents Amrit from untying Radha because, as she teasingly claims, "*Prem dor ko baandhney wala hi khol sakta hai*" (Only the one who has tied the strings of love can release you). Adopting the mythic Radha's subject position, Harni sings, "*Prem dor mein baandh hamein kit chale gaye, Girdhari?*" (Where have you gone, Krishna, leaving me tied in these threads of love?). Amrit eventually unties Radha.

(b) Another occasion of bondage occurs when Kanhaiya ties up his rival Appaiya. Appaiya is motivated by his unrequited love for Radha to stealthily follow Kanhaiya on his journey to Ashti, with the intent to kill him. The newly released Radha gets wind of Appaiya's plot. She injures Appaiya with an arrow, and as Kanhaiya ties the dastardly Appaiya with his scarf, she sings a song about Kanhaiya's inability to escape from her: "*Kit jaoge, Kanhaiya, man ke*

basaiyya, hum soo neha lagake?" (Where can you go, Kanhaiya, you who live in my heart, after romancing me?)

(c) Meanwhile, Balaji's men attack Somaji and Bhimaji (the film's Rosencrantz and Guildenstern figures). At the start of the film, Balaji commissions them to kill Kanhaiya and his father. They are now chastened by Kanhaiya's kindness toward them, because the just Kanhaiya (unlike Hamlet) realizes that the real villain is Balaji and not his stooges. Kanhaiya and Radha come upon the two stooges under attack by Balaji's vengeful men and defeat the attackers. The couple ties up Balaji's men with their *saafa*s. Somaji and Bhimaji are safe and shift their allegiance to Kanhaiya.

(d) Balaji has given the Bhils' stolen savings to his wealthy friends for safekeeping. Kanhaiya takes back this stolen property from Balaji's friend's house. True to his code of honourable conduct, he only takes what is due to his people, tying up the guards with their *kamarband*s and *saafa*s as he leaves.

Without enumerating the scenes of captivity exhaustively, the repetition of shots involving improvised bondage is already notable with these examples. Daring captures and escapes were a staple of historical and stunt films in the early silent and sound period. So we can assume that *Izzat*'s trope of capture, where people are tied up frequently and effectively with a provisional piece of cloth, is precisely that: a trope connoting rapid reversals of fortune. Captivity serves as a device that drives the plot forward and creates obstacles for protagonists to overcome. At the same time, there are marked occasions when acts of capture exceed their plot functionality to become a kind of play-acting or role-playing, to be enjoyed as a theatrical gesture. This is true in the case of (a) and (b) above, where the occasion of binding someone is extended by a song. On both occasions—when the film's hero ties his beloved to the tree, and subsequently when the hero ties up his enemy—the act serves as a pretext for a romantic song that transforms the act of bondage into a performative and romantic/erotic event.

> ***Angel:*** *Words. Coiling words upon words upon words you exhaust yourselves with your knotted scripts. Understand that they walked with demigods so their exhaustion was not served up in verbs, nouns, apostrophes and humid qualifiers for five humans to nibble on in their swivel-eyed distraction. No. Perched above, she drew the eyes of multitudes. None who met her forgot her face.*
>
> *Hot plasma transmutes into states of matter. The earth redraws it. It is her creation. She alters everything. In the thin, dark lines turning down to her temples and in the stencilled curves inside a natural careening of lips, some see the Dietrich brow and others the Bow mouth. But it would not have worked, none of it, in the subcontinental bluster, if it were not altered. By the small bend of the body, the twisting smoothness of fragility and devotion performed as and when needed.*

It was not a lie. It was true to the scripts of her time and her place. It was not true beyond those scripts because there was always more, and he saw that. It did him credit that he saw that. She loved him for it. It is why she stayed. She was earth. She altered everything.

Scholar: Impersonations are a central part of the first two acts of bondage described above. As noted, when Harni and Amrit chance upon the bound Radha, Harni sings in the voice of the mythic Radha to Amrit as her Lord Krishna, while the character Radha is their (literally captive) audience. Despite a display of annoyance, Radha is pleased by this eroticization of her predicament. She fantasizes that she is singing the song with her Kanhaiya. In her fantasy, she is tied up with flower garlands and not by her scarf. The double fantasy elevates the scene into a significant emotional hiatus within the film's forward-moving plot.

As a film from the first decade of Indian sound cinema, *Izzat* should be considered in relation to Hindi cinema's acculturation of its audiences into cinema's performative, gestural and aural idioms of drama, music and dialogue. To this end, the placement of musical numbers is of interest. What seems abrupt to present-day audiences could be considered part of Hindi cinema's cultivation of expectation around the beat of its dramatic sequencing. In this instance, we move from Radha's immobilization to a romantic song sequence. A little later, Radha sings a romantic number while Kanhaiya binds their enemy Appaiya. This song is followed immediately by a duet between Radha and Krishna. For audiences, such sequencing creates associational links. Episodes that flirt with danger by playing at bondage are associated with Radha and Kanhaiya's performative love, which is repeatedly interrupted by new dangers for them to triumph over (until the end, when they don't). With this configuration we enter the film's rhythm of pleasure, which intensifies the melodrama of a central romantic union by threatening its disruption even as the lovers themselves tarry with games of bondage. The dynamic reveals the film's dramaturgical pattern. Power play—or theatrical enactments of asymmetrical social and relational power performed through choreographed gesture—is central to how this film seeks to please its audiences.

Angel: He remains silent as others shift with restlessness. They would have done better without her, they think. But then she, too, would have done better without them. They grow vicious and despondent when she stands near them. They hide their confusion over the curves and the bends and the fragility and the strength and the scorn. They marvel at those who are unmoved.

You forget those who are unmoved by these demigods of another skin. You forget them but they are present in silent and uncaring observance like the peepal *and the* vad *and the* amla. *The* Ficus religiosa, *the* Ficus benghalensis *and the* Phyllanthus emblica *stand at ease and watch for saplings and flashes of their heartthrob, the*

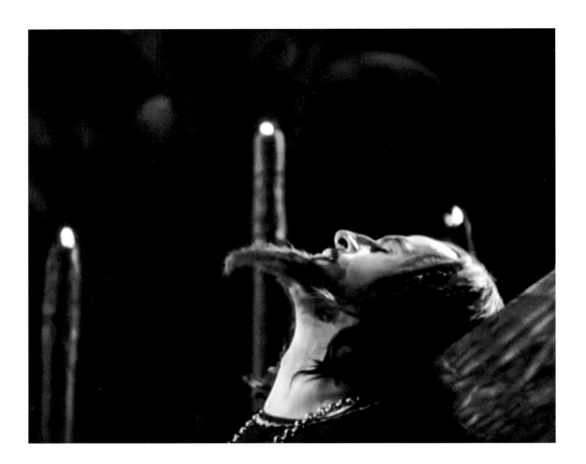

FIG. 7 *Ivan the Terrible (Part I)*
1944, d. Sergei Eisenstein

Nikolay Cherkasov as Ivan the Terrible, in a screen grab from the film that illustrates Roland Barthes's point about the third meaning of a filmic image.

golden oriole. You do not ask about the people who are like lumber more than silk. They are gone but their lives cling to your margins and will undo them before noon, in the year of ten solar eclipses.

Scholar: I have referred to Radha, Harni and Amrit's adoption of an alternative fantasy of Radha's captivity as a form of impersonation. In the song "Prem dor mein baandh hamein" (Tying me in the threads of love), the three characters slip in and out of the skins of mythic beings, while also projecting themselves onto each other's predicaments. Harni plays at being her friend Radha as well as the goddess Radha. Meanwhile, Devika Rani, as Radha, goes from being the captive, to imagining herself as Radha (as her friend Harni sings), to becoming the mythic Radha bound to Kanhaiya (as Krishna) by flowers. The song becomes a pretext for characters to transcend themselves and slip into a secondary persona, creating a liberating or fantastical romantic scenario in a manner that would become a staple of Hindi cinema. The use of songs as a pretext for character impersonations and fantasies allow us to consider two additional acts of imaginative projection and self-reflexive commentary, namely spectatorial projection and directorial play. Fantasy and impersonation, in this context, signify an important gambit of the film viewing and filmmaking process.

Roland Barthes (1977) similarly uses a filmic image to launch a discussion of directorial signification and spectatorial perception in his essay "The Third Meaning." In the essay,

Barthes speaks of a filmic image's third or *obtuse* meaning as that which exists outside its (first) literal and its (second) symbolic meaning. Barthes is scrutinizing stills from Sergei Eisenstein's *Ivan the Terrible* (Part I) and *Battleship Potemkin*. Looking at a still from *Ivan* where the czar raises his head, Barthes argues that the obtuse meaning of a filmic image "has something to do with disguise," which becomes apparent when the film is frozen on an image where the sharp point of the czar's beard cuts across the frame (which happens often in the film). The exaggeratedly tapered beard, angled in a perfectly parallel line to the frame's horizontal axis (see figure 7), repeatedly "declares its artifice but without... abandoning the 'good faith' of its referent (the historical figure of the czar)" (58).

Barthes notes that upon looking at such an image, viewers cannot help but see the czar as an actor with an absurd beard, hinting at Eisenstein's subtle commentary on the czar through the fake beard as a "derisory fetish" (58). Simultaneously, what stilling the film on this frame has let us perceive is the "multi-layering of meanings which always lets the previous meaning to continue, as in a geological formation" (58).[5] Barthes is interested in recuperating the value of a still photographic frame because, for him, it is the still that paradoxically transports us to filmic meaning, more than the film itself. Filmic meaning lies, for Barthes, "not in movement, but in the inarticulable third meaning" (66) sensed when a filmic image is understood within the "framework of a [film's] permutational unfolding" (67).[6] We need the still, in his view, to catch a glimpse of what is suspended in isolation as the fragment of a film. Viewing the still, we comprehend Eisenstein's commentary embedded, like a palimpsest, inside the film's dramaturgy and visual scheme. For Barthes, this is our fleeting encounter with the obtuse meaning of the filmic image, disguised within other layers of significance in the film without destroying them.

Barthes is invested in redeeming the still image in cinema, but what is equally suggestive is his expansion of the filmic beyond a film, to realms of (directorial) commentary and (spectatorial) perception. It raises the larger question of where we locate the filmic experience. This question has returned to the discipline of cinema and media studies in the digital era, when technologies of filmmaking reproduce reality by converting the profilmic into code, untethering reproduced images from an indexical relationship to their referent as digital cameras reconstruct the world with numerical precision rather than analogic devotion (Rodowick 2007). Refuting the corollary claim that virtual cinematic technologies alienate us from the referent, Tom Gunning ingeniously brings up the repressed "linguistic contamination" of the word "digital": a term that literally refers to our digits, or fingers, and by extension to our gestures and bodies (2014, 1). In dialogue with feminist scholars of embodiment (Sobchack 1992; Marks 1999; Barker 2009), Gunning makes a historical case for cinema's technological transformation of touch and gesture. As he notes, cinema promises us a proximal and tactile sense of the world that it can never fully deliver, even as experimentations to elicit sharper and more vivid sensations shape cinema's evolution (2014, 17).

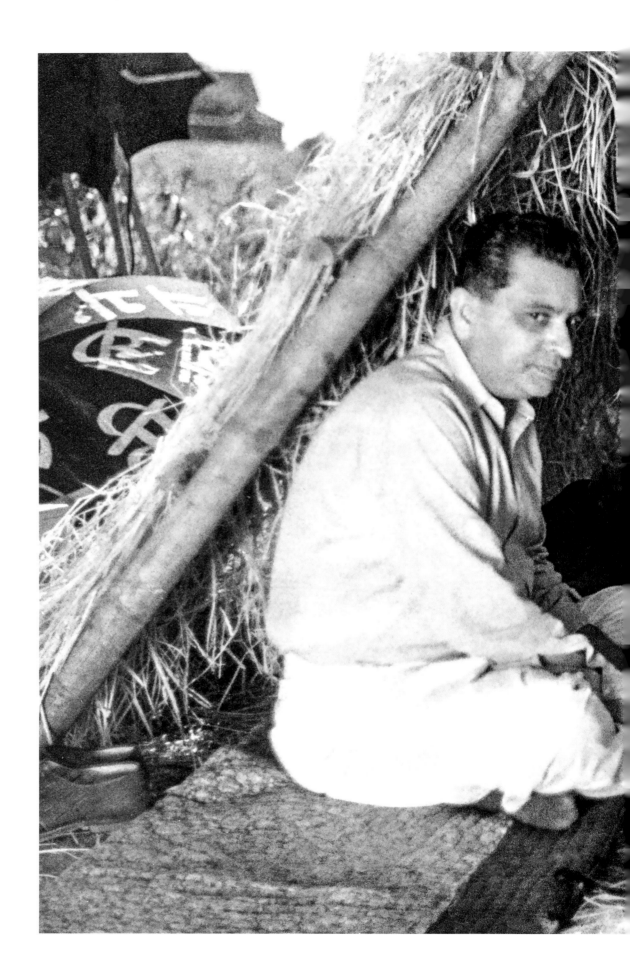

FIG. 8 *Izzat*
1937, Bombay Talkies, d. Franz Osten
35 mm Negative
JWA/ACP: 2019.01.0063

Himansu Rai, Devika Rani and Ashok Kumar sit down to a shared lunch during the outdoor shoot of *Izzat*.

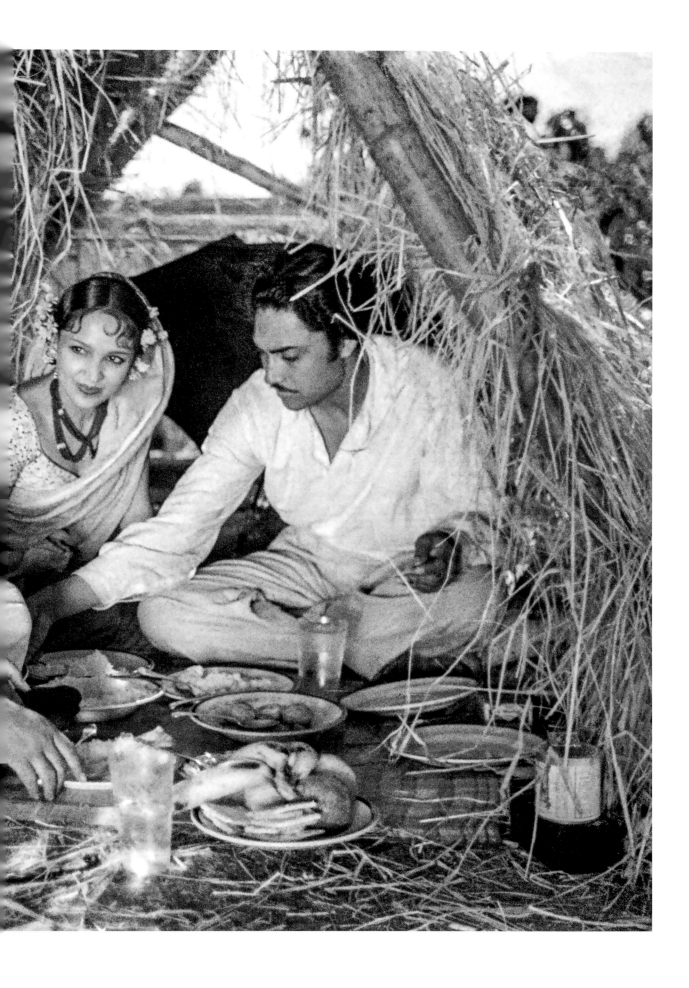

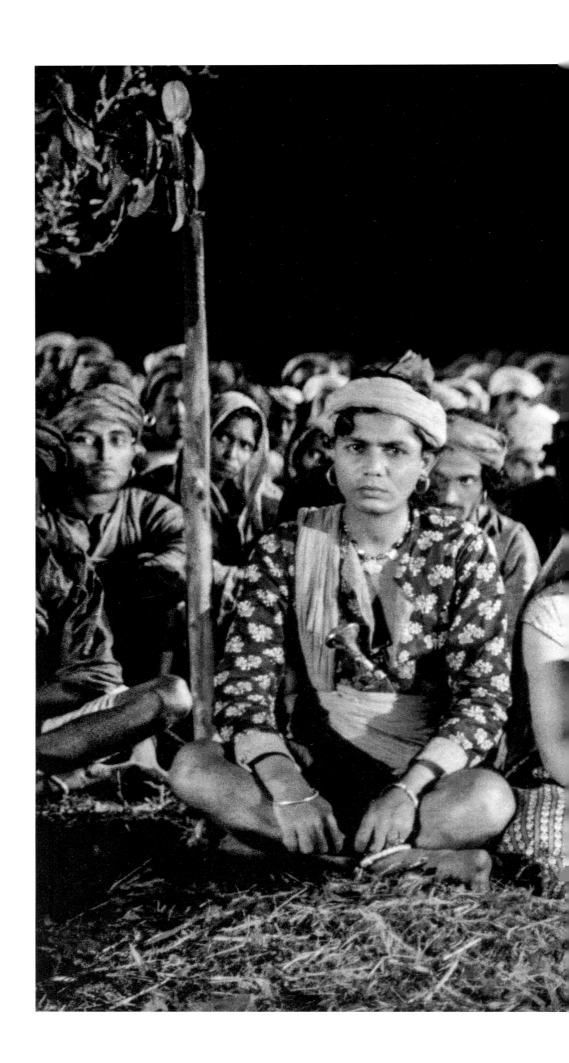

FIG. 9 *Izzat*
1937, Bombay Talkies, d. Franz Osten
35 mm Negative
JWA/ACP: 2020.01.0006

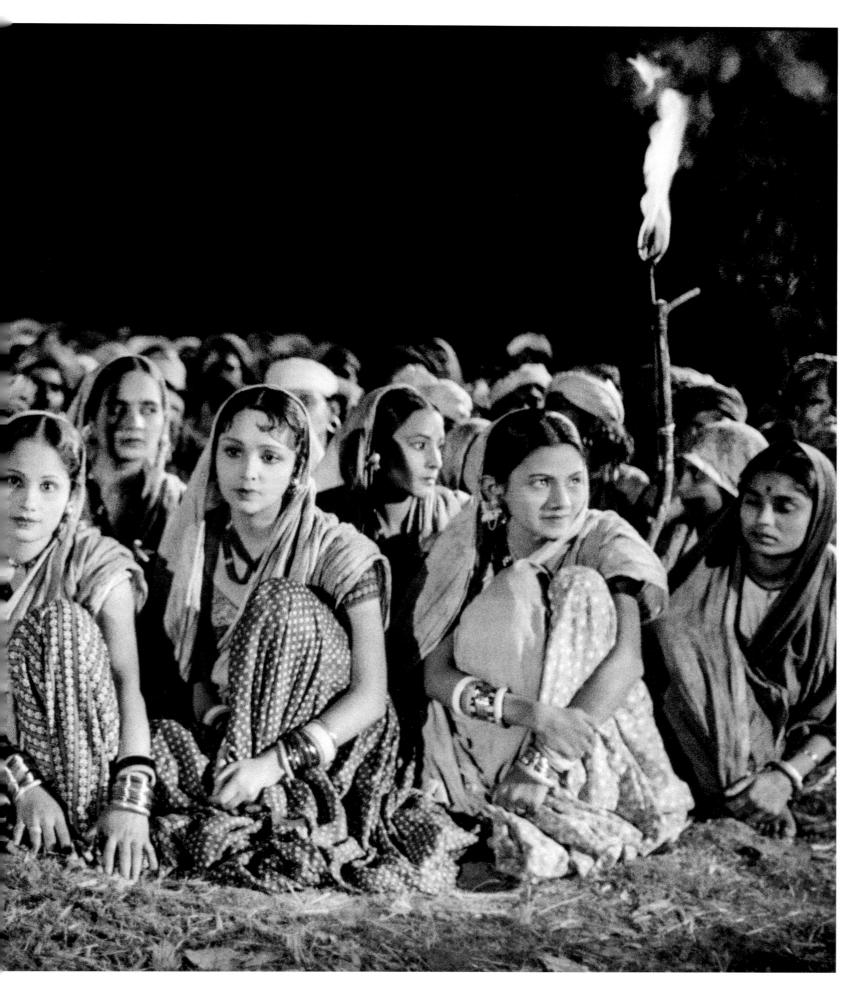

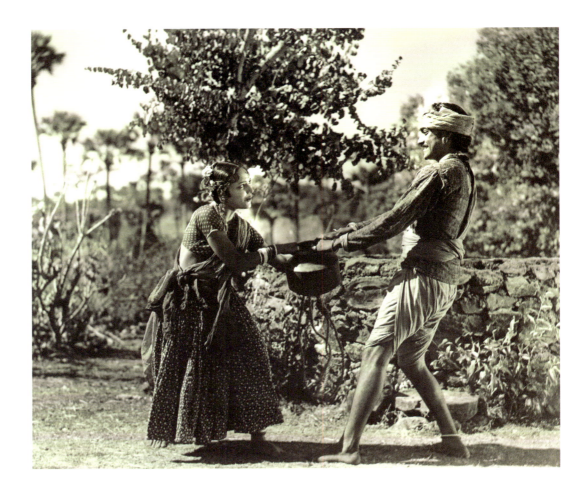

This insight can be put into productive alliance with Barthes's elaboration of cinema's obtuse meaning. Barthes also shifts focus away from cinema's reproduction of reality to cinema's technologization of perception in the first instance, and to its tools for transforming the profilmic into filmic space in the second. For Barthes, Eisenstein's commentary on aristocratic posturing is embedded within the film's dramaturgy, visually haunting the actor's gestures and bodily positions. As viewers, our consciousness of this obtuse meaning is a sensation (in a Humean sense) that the film enables us to experience via its images.

The Wirsching photographs, unlike the Barthesian stills, are not frozen images from a film, even if some of them may have been used for *Izzat*'s publicity. Rather, the Wirsching photographs were taken before, after, or during the actual filming of *Izzat*, and this is a crucial distinction. Including the Wirsching images in an analysis of the film *Izzat* diminishes the significance of determining the precise boundaries and blurs between a film's still and its moving images (explored by Barthes and in expanded ways by Beckman and Ma 2008), turning us instead to the *event* of filming and to the profilmic *gestures* of the actors. The photographs accompanying this essay capture some of the micro-gestures at the filming event, which are never fully captured on the film screen. Based on these photographs, we see that Rani's cinematic image suppresses her winking and smoking persona. It also reveals slight shades of difference between the instructions Rani was given

FACING PAGE
FIG. 10 *Izzat*
1937, Bombay Talkies, d. Franz Osten
Lobby Card (Gelatin Silver Print),
241 x 304 mm
JWA/ACP: 2020.01.0047

ABOVE
FIG. 11 *Izzat*
1937, Bombay Talkies, d. Franz Osten
Lobby Card (Gelatin Silver Print),
248 x 304 mm
JWA/ACP: 2020.01.0045

on set, as opposed to her performance for the film. In the shot of her rehearsal with Osten (see, figure 2a), for instance, she holds her left hand above her right hand, unlike him, mirroring her director but never precisely duplicating him.

Angel: The patterned blouses and pencilled moustaches fool no one. They breathe fire and ash and show their gold. Demigods now in dust.

Old men and women with crumbling teeth and bread, whose bodies tell of scraping, dying, hiding, rocking, fighting, kneading, cleaning. They cackle under trees and in the corners of their mouths at these men and women whose arms and ankles are heaving with counterfeit bracelets. They have seen more brilliance and more silence

The Knot 99

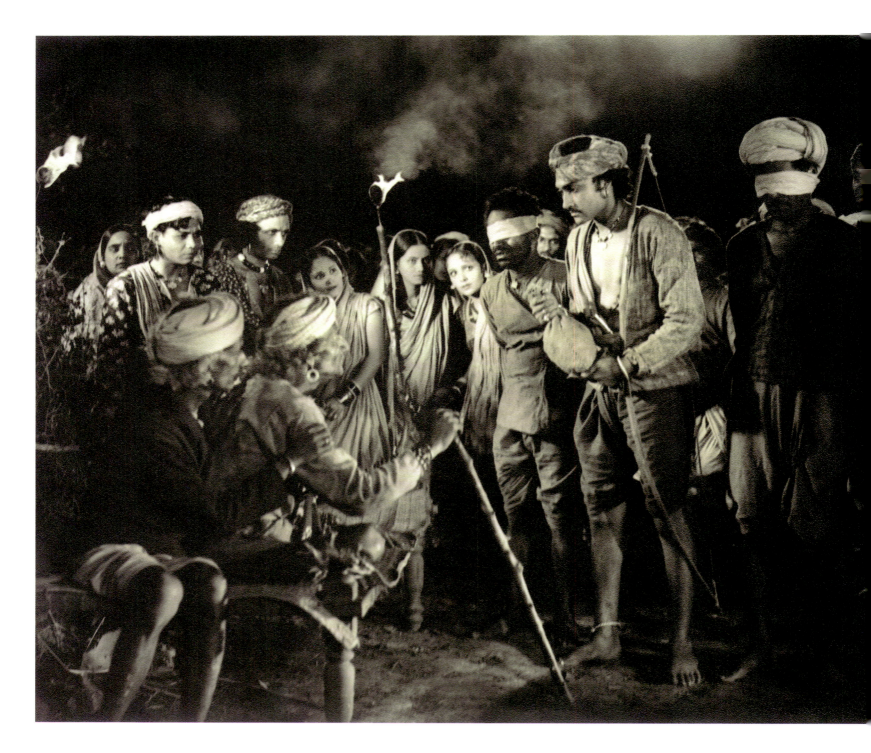

FIG. 12 *Izzat*
1937, Bombay Talkies, d. Franz Osten
Lobby Card (Gelatin Silver Print),
246 × 302 mm
JWA/ACP: 2020.01.0046

even if they are now and forever in shadows. Invisible mandibles working on clay and soft filth to make fragile homes rise up and touch the stars. See here the haven of blowflies and palaces to white-rot fungus. Mandibles grinding on past the silence of the Kolis and past the silence of the Bhils and past the thorny hurt of scrubs and the memories of water and new carbon-arc lamps and the litter of plastic shacks with cracked pink toys in three feet of fetid breath. The old, tattered man and his unseen, weary wife are right to laugh. They see the coming wasteland.

Scholar: Glancing from the film *Izzat* to photographs of the creative team in its profilmic space, we become aware of Devika Rani and Ashok Kumar adopting the facial expressions and bodily gestures of their characters. Wirsching reveals the processual nature of the profilmic as he goes beyond the margins of the cinematic frame both spatially (giving us a broader sense of the space by including those standing around, in figure 5) and temporally (giving us a photograph of what is yet to be filmed, in figures 2a–c). Collectively, Wirsching's photographs are close to the filmic images but they also slide apart from it, to reveal how and where the filmic and profilmic are dissimulations and disguises of each other. The photographs allow the profilmic to take on a density of its own, and teach us something about the filming environments and filmed bodies that the film itself cannot convey. Such photographs carry the promise of giving us a peek into something unseen on screen. They seem to cut the Gordian knot of an archive that holds secret material on the lives, experiences and records of early filmmakers, but remains hidden in shadowy corners of our past. Finally, we feel, here is some visual evidence that will expand what little we have learnt from the few surviving films and scarce film biographies of this era.

For instance, contrary to the narrative build-up that Kanhaiya receives in *Izzat*, the actor Ashok Kumar is unpolished on screen. This is unsurprising given his sudden move from the laboratory to the front of the camera. His discomfort with acting during his early years in the business is reported on in a few extant biographies. Writing about *Jeevan Naiya*, Nabendu Ghosh notes that Devika Rani "was, in fact, older to Ashok, by five or six years. Ashok was unnerved by her proximity" (43). Sa'adat Hasan Manto reports, "When I saw Ashok for the first time at close quarters, he was quite different from what I had seen of him in movies. He was quite dark with rough and chubby hands, strong of body and semi-rustic in manner. He was also quite formal but in a tense, uneasy kind of way" (7). Characteristically colourful, Manto informs us that "Devika Rani tried to have an affair with him but he rebuffed her rather brusquely" (4). If the film *Izzat* constructs a Kanhaiya who is the heartthrob of the Bhil women—much like Krishna the deity is irresistible to Vrindavan's *gopi*s (female cowherds)—Wirsching's photographs show us a more contained Ashok Kumar, rarely looking up at the camera, as opposed to Devika Rani's impish flirtation with the lens and stolen cigarette breaks.

In immediate ways, the photographs supplement biographical reports by showing a behavioural and power differential on set. Some of this disparity is evident in the film *Izzat*,

where Kumar's young voice has not yet settled into its characteristic pauses between rapid exhalations of speech and breath in imitation of naturalistic rhythms of conversations, which he would adopt as an older actor. Rani's voice, however, has already reached the cadences of speech heard throughout her career in front of the camera. The photographs supplement and extend what we see of this difference between the two actors on screen. They show us the difference between Devika Rani's postures adopted for her screen image, as against the ones she comfortably takes on during her rehearsals on location. She is not in the position of demure recoil adopted for the film's publicity. Her expression changes drastically when she makes faces at the camera, as opposed to when she is rehearsing her scene as a bound damsel with Osten. The photographs are laden with information that can be called "profilmic plus" or extra-profilmic material, to coin awkward terms, because they contain details that do not register on film. Following Giorgio Agamben's suggestive claim that "cinema leads images back to the homeland of gesture," (2000, 56) which, for Agamben, is imbued with a nostalgic sense of cinema's attempt to recapture what civilization loses with its mechanization, we can say that we witness, in these photographs, a transformation of idiosyncratic personal gestures into cinematic gestures in ways that we cannot witness on screen.

However, the idiosyncratic personal gesture adopted by actors in the film's profilmic setting is still shaped by a sense of the cinematic. When Rani winks at the camera or when she turns away from the camera to smoke, she is not *un*conscious of the act of being recorded. The environment is designed for the camera and the human body is poised for action, even during its break from filming, because the outdoor landscape is brought under the purview of the studio's production unit after being scouted, scoured, cleaned, lit and shot. Though looking away from the camera, Rani is still lit, accidentally or intentionally, in cinematic ways, with the workers blurred in soft focus around her. In other words, these photographs are not quite candid. The photographs remain defined in relation to what will become the filmic through inclusion or exclusion.

To recall an earlier observation, the cinematic is not just that which pertains to cinema. More expansively, it describes the transformation of our perceptions and sensations of the world, and our gestures towards the world, through a technological form that promises a greater proximity to or heightened experience of reality, while always remaining at a remove from it. We may add that cinema alters not only our perception of reality, but also our sense of *proprioception*. Proprioception, the body's sense of itself and its awareness of its boundary and placement in relation to other objects, is essential for its functioning in a world inhabited by other people and objects. The recognition that there is a technology that can record and archive our movements alters our proprioception. Cinema expands us by extending our movements beyond human capacity. At the same time, this enhancement is not free of the submission of our bodies to the camera's tools of recording and surveillance. The dialectic of cinema as an instrument that makes the subject incorporeal or virtual, while at the same time operating as a technology of

recording and controlling the body—assimilating it into a perceptual apparatus and shaping it by a subject's knowledge (and increasingly, ignorance) of being recorded—is writ small in these photographic images. Our revelatory pleasures of catching a clandestine glimpse of Devika Rani being cheeky to the photographic camera, and the erotic pleasures that the film *Izzat* builds around its heroine bound up in knots of cloth, remind us of this eternal duality of cinema.

> **Angel:** *I am the only eternal. What endears, what endures, in these fragments of dust, words, fabric and plastic? They come to naught.*

Notes

1. Patel and Naik are caste names as well as titles.
2. I viewed the film on the Indiancine.ma site and on YouTube, and the film skips over significant portions of the story in both: https://indiancine.ma/CIF/player; https://www.youtube.com/watch?v=RMucvCreL3c&t=143s
3. For two divergent approaches to *bhakti* as an undisciplined and disruptive force throwing the socio-religious dictates of patriarchy, matrimony and Hinduism into disarray, see Sangari (1990) and Subramaniam (2014). In particular, consider this Bhakti poem by Narsinh Mehta (a thirteenth-century male poet speaking as Radha), translated by Keki Daruwalla and Meena Desai: "To the foot of the bed I'll fasten your arms/with flower-ropes shameless. /Who will free you from the temple of my body? /Rivals? What can they do but flame in anger?"
4. This plea has become a cliché of Indian cinema, where women are repeatedly shown being assaulted by male lovers in jest, and by male villains with criminal intent.
5. The *punctum*, developed later, is not the same as the obtuse meaning of an image in Barthes, but the ideas of "The Third Meaning" look forward to that which punctures the image, in that it is "outside (articulated) language while nevertheless within interlocution." Obtuse meanings seem more tethered to the image as well as the referent than the *punctum*.
6. Beckman and Ma also refer to this Barthes essay in the introduction to their anthology, "*Still Moving*" (2008).

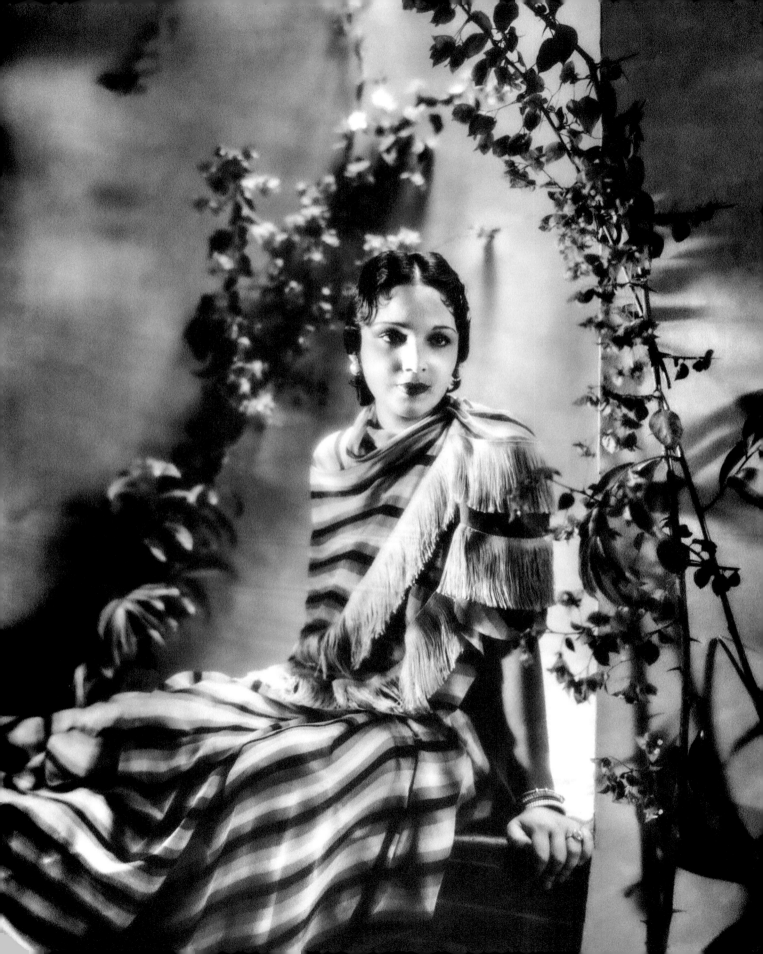

A German Eye on Indian Beauty

Josef Wirsching's Portrayal of the Female Star in Hindi Film

■ Rachel Dwyer ■

Josef Wirsching (1903–1967) spent over half his life in India, becoming a key figure in the history of Indian cinema. Trained in Germany, he helped to shape the aesthetics of Indian cinema, particularly in his use of exotic and dreamlike images, revealing a romantic side to his understanding of his craft.

Wirsching clearly loved India, capturing the everyday alongside the staged images of films presented in this collection. His photos show him and his fellow Germans, including Franz Osten, as well as the stars and scenes from the films they worked on. These reveal what Wirsching saw as the essence of the image captured on film, presenting us with stills of the greatest stars in Hindi cinema, both on screen and off. Cast and crew members of the studio are seen on the sets, indicating their working relations, whether engaged in technical matters or relaxing. Many of the photographs are staged but they still reveal what was going on behind the scenes.

In this essay, I connect the stills with the films and explore how Wirsching created the defining images of three of the greatest stars of Indian cinema and ideals of Indian beauty and femininity: Devika Rani (Devika Rani Chaudhuri, 1908–94), Madhubala (born Mumtaz Jahan Begum Dehlavi, 1933–69) and Meena Kumari (born Mahjabeen Bano, 1933–72). Wirsching's dramatic style of shooting the stars, with his Expressionist use of light and shadow, made their faces iconic, capturing their idealized beauty, which helped smooth their on-screen roles as disruptive women, and their off-screen, sometimes scandalous, star images. Their films are mostly romances featuring strong, often remote, women alongside powerless men.

FIG. 1 *Jeevan Naiya*
1936, Bombay Talkies,
d. Franz Osten
Gelatin Silver Print,
294 × 243 mm
JWA/ACP: 2019.01.0035

Devika Rani wears a stylish tasselled sari in this portrait photo, lit to emphasize mood.

Given Wirsching's early films, such as *Achhut Kanya* (1936) and *Kangan* (1939), were with Bombay Talkies and he continued working with the studio's personnel, I focus on the aesthetics he developed at Bombay Talkies, and trace this style to his later work such as *Dil Apna aur Preet Parai* (1960) and *Pakeezah* (1972).

Wirsching's first visit to India was for *The Light of Asia* (also titled *Die Leuchte Asiens* or *Prem Sanyas*, 1925), where he shows himself accomplished in his handling of outdoor and indoor shots of landscapes, architecture, bodies and faces. In keeping with the Orientalist aspects of the film, Seeta Devi (Renée Smith) is exoticized, draped in jewellery and cloth, but with Western make-up, including lipstick and mascara, her eyebrows finely plucked. Perhaps she was cast for her Anglo-Indian looks to appeal to Indian and Western audiences. She also appeared in the other two silent Indo-German films of Osten and Rai—*Shiraz* (*Das Grabmal einer grossen Liebe* in German) (1928) and *A Throw of Dice* (*Shicksalswürfel* in German and *Prapancha Pash* in Hindi) (1929)—not filmed by Wirsching, confirming their choice of feminine beauty as an exotic Western vision of an "Oriental" woman.

FIG. 2 *Achhut Kanya*
1936, Bombay Talkies, d. Franz Osten
35 mm Negative
JWA/ACP: 2019.01.0055

A local fisherwoman hanging up "Bombay Duck" fish for drying at the Versova beach fishing village. Such images taken by Josef Wirsching were maintained by him as an ethnographic store of images that could potentially be used as locations for future films.

Himansu Rai and Devika Rani made *Karma* (1933), a bilingual film in English and Hindi, with a mostly English team. However, when they set up their studio, Bombay Talkies, in 1934, they invited the Germans to work with them in India (Halsall 2016; Manjapra 2014; Mukherjee 2015). Germany having the most advanced film technology at the time, the idea was that their technicians would not only work with the studio but also help train the next generation.

In the 1930s, Bombay—at least in some areas—was a glamorous city (Kidambi et al. 2019). Work on the Art Deco Marine Drive began in the 1920s, giving the city a modern cosmopolitan look, while the suburbs were growing as transport links improved. The city was truly global in outlook on account of its trading links, an industrial centre with a growing workforce and a wealthy business elite. All Bombay Talkies films are in Hindi, or Hindustani, a language whose origins lay in Delhi and so is associated with northern Indian culture even though it was a *lingua franca* in urban centres of western and central India as well. Hindi and Urdu writers in Bombay who were members of the Progressive Writers' Movement, such as Sa'adat Hasan Manto and Ismat Chughtai, were writing modernist short stories as well as working in the film industry. One of Manto's short stories, "A Woman for All Seasons," barely conceals the identities of Devika Rani and Himansu Rai (Manto 2008).

Bombay Talkies' productions show a sharp move away from the earlier work of Rai and Osten's Orientalist films into presenting India as a modern country. They barely discuss India's glorious past, religion or spiritualism, but instead concern themselves with social reform, querying issues such as caste. They interrogate what it meant to be modern in India, what new roles there could be in this world, in particular for women, and the issues that confronted them in early twentieth-century India. Thus, Bombay Talkies created a cinematic modernism as a response to historical modernity, eschewing British aesthetics and ideas of empire. Instead it opted for a type of realism, tempered by Expressionism, thereby forging a new kind of nationalist aesthetics (Jaikumar 2006, 195–198). Most Bombay Talkies films are set not in the city but in villages and small towns, reflecting the thinking of the time that India *was* its villages, offering a different view of India than the Presidency city of Bombay.

The blend of influences and aesthetics that manifests itself in the films' mise-en-scène drew on pre-cinematic aesthetics as well as those of Hollywood

ABOVE
FIG. 3 *Shiraz*
1928, UFA-British Instructional Films,
d. Franz Osten
Publicity still
Courtesy: Deutsche Kinemathek,
Filmmuseum Berlin

Seeta Devi, née Renee Smith, plays the scheming Princess Dalia in this fictionalized story of the Taj Mahal.

BELOW
FIG. 4 Letter from Himansu Rai to Fritz Lang
20 February, 1932
Courtesy: The Dietze Family Archive

In 1932 Himansu Rai was actively looking for European co-producers to help him complete his ambitious but cash-strapped English-language talkie film, *Song of the Serpent* (*Karma*, 1933). This is one of several prospecting letters sent out by the Himansurai Indo-International Talkies Ltd (HRIIT).

A German Eye on Indian Beauty 107

and European films. Rani and Rai, though deeply anglicized, were also exposed to Bengali culture, in particular its recent flourishing associated with Rabindranath Tagore. Rani was related to Tagore, and Rai had spent time at Santiniketan. Like other elite Bengalis, they were also familiar with European culture. Art Deco and Bauhaus were fashionable at this time although Gothic also influenced their films; costume, hairstyle and make-up choices included Western influences to create a hybrid costume that was aesthetically pleasing rather than realistic.

Wirsching learnt technical camerawork in German studios and his Expressionism is plain for all to see. The mise-en-scène of films such as *Mahal* (1949) shows his emerging style in his use of light and darkness to create strong contrasts and textures in shooting sets, a depth of field which is seen also in location shots alongside naturalism, and his use of realism and surrealism. He developed his own style of cinema working alongside Osten and the "film architect" Karl von Spreti.

During this period of Hindi cinema, romance and melodrama enabled the postcolonial shift from the feudal family to the bourgeois subject (Prasad 1998). Wirsching adjusted his Western training to fit the melodramatic requirements of the Bombay Talkies screenplays, where inner feelings and repressed emotions were externalized, the best example being *Mahal*, where the mise-en-scène is focused on the emotional drama of the film. A key feature of the Hindi melodrama was the focus on the star, particularly the female star, on whom were framed questions of modernity and Indian nationalism, through their behaviour, their looks, their environs and their star image (Majumdar 2009).

FIG. 5 *Mahal*
1949, Bombay Talkies,
d. Kamal Amrohi
Film Poster
Courtesy: Osianama Research Centre, Archive & Library, India

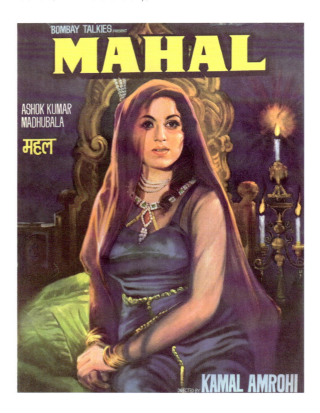

In the 1950s, the social film frequently featured a hero who struggles to bring love into the family and uphold the nation. In Bombay Talkies' films, it was frequently the woman who fell in love with a man with whom marriage was prohibited for reasons of caste or class. Bombay Talkies challenged the cinematic trope of the *adarsh bharatiya naari* ("the ideal Indian woman"), who struggled against all odds to keep her family together. During his career as a cinematographer in India, Wirsching often shot female protagonists who disrupt patriarchy and respectability through their love—an "Untouchable" woman (*Achhut Kanya*, 1936), a gardener's daughter (*Mahal*, 1949), a nurse (*Dil Apna aur Preet Parai*, 1960) and a courtesan (*Pakeezah*, 1972). Yet their disruption is limited: they all aspire to marriage, and all but one has to die. Nearly all the movies of Devika Rani were filmed by Wirsching, as was Madhubala's first film as the lead actress, and two of Meena Kumari's films, including her celebrated swan song, *Pakeezah*. Wirsching was the first cameraman to shoot with Devika Rani and Madhubala; his work with Meena Kumari creates a very modern image of the star in *Dil Apna aur Preet Parai* and returns to an Orientalizing or exoticizing image in *Pakeezah*.

Devika Rani

Bombay Talkies set out to be respectable, counting many notables on its board of directors, yet Devika Rani was a scandalous figure for much of her career on account of her "Western" habits, rumoured relations with men, and known elopement with co-star Najmul Hussain.

Josef Wirsching's first Hindi film, *Jawani ki Hawa* (1935), was also Bombay Talkies' debut feature. The film was a thriller with guns—mostly set on a train—as a couple elopes and the girl's father is murdered. Bombay Talkies had to deal with objections from the local Parsi community to the employment of two Parsi women in the film: Khorshed Homji, who composed the songs using the screen name Saraswati Devi, and her sister, Manek Homji, who took the name Chandraprabha. However, more serious was that life imitated art, and Devika Rani eloped to Calcutta with her co-star, Najmul Hussain. She returned but Hussain was dismissed and Ashok Kumar, then a laboratory assistant, became the lead star, appearing in most of Wirsching's films. Thus, Devika Rani cemented her star image as having an innocent face but a scandalous life (Mukherjee 2015).

FIG. 6 *Nirmala*
1938, Bombay Talkies, d. Franz Osten
Gelatin Silver Print, 127 x 165 mm
JWA/ACP: 2020.01.0066

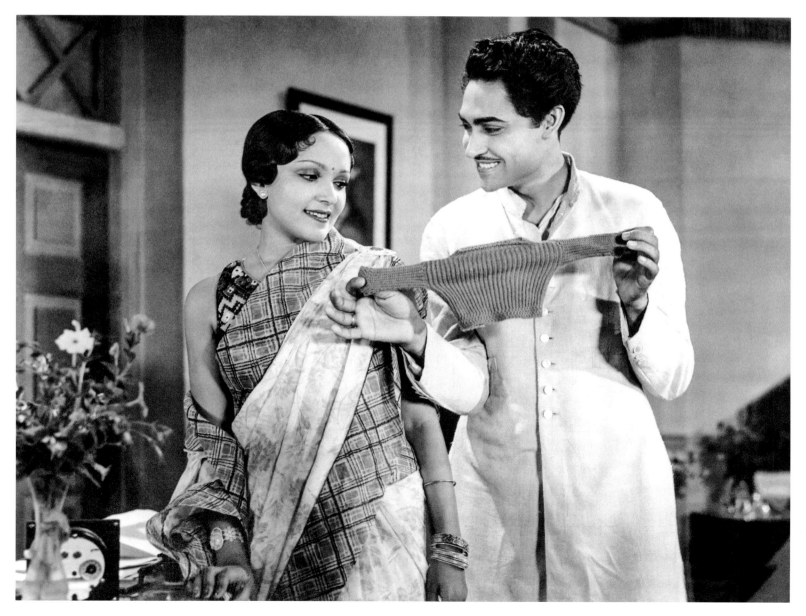

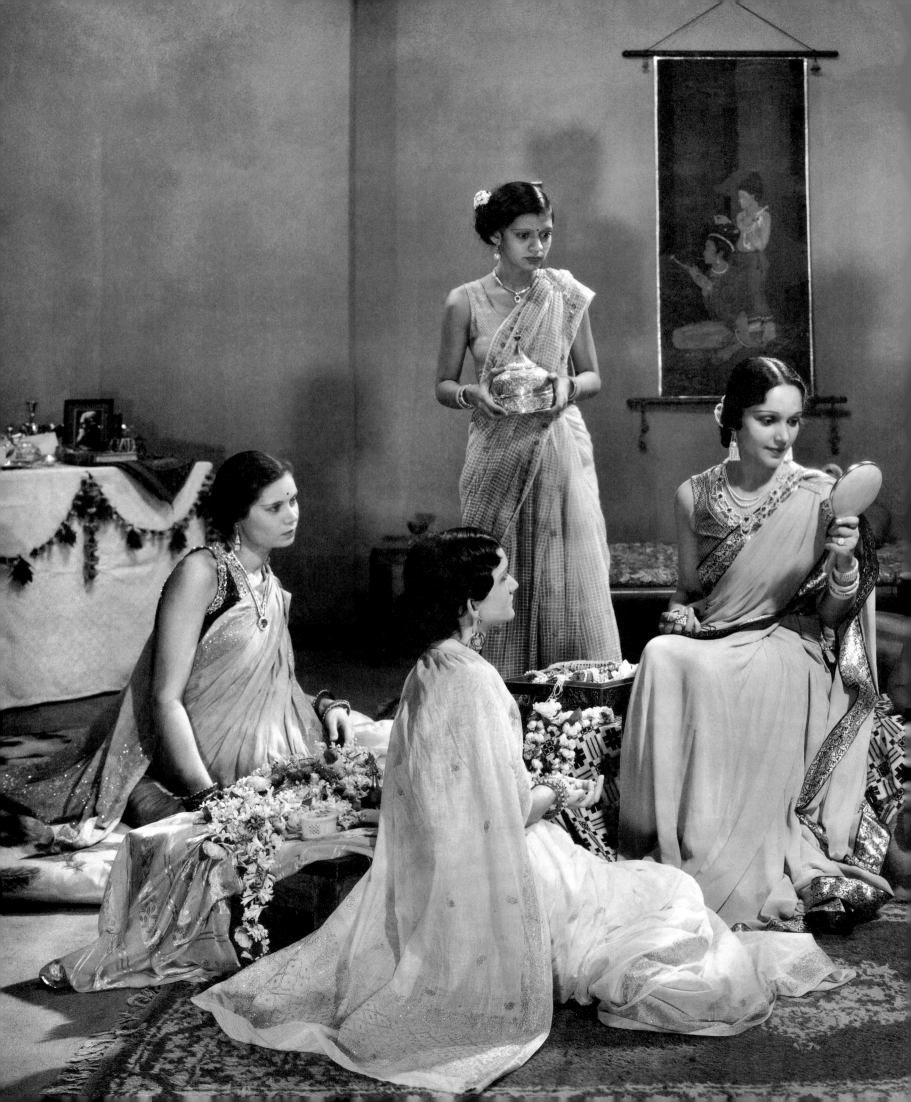

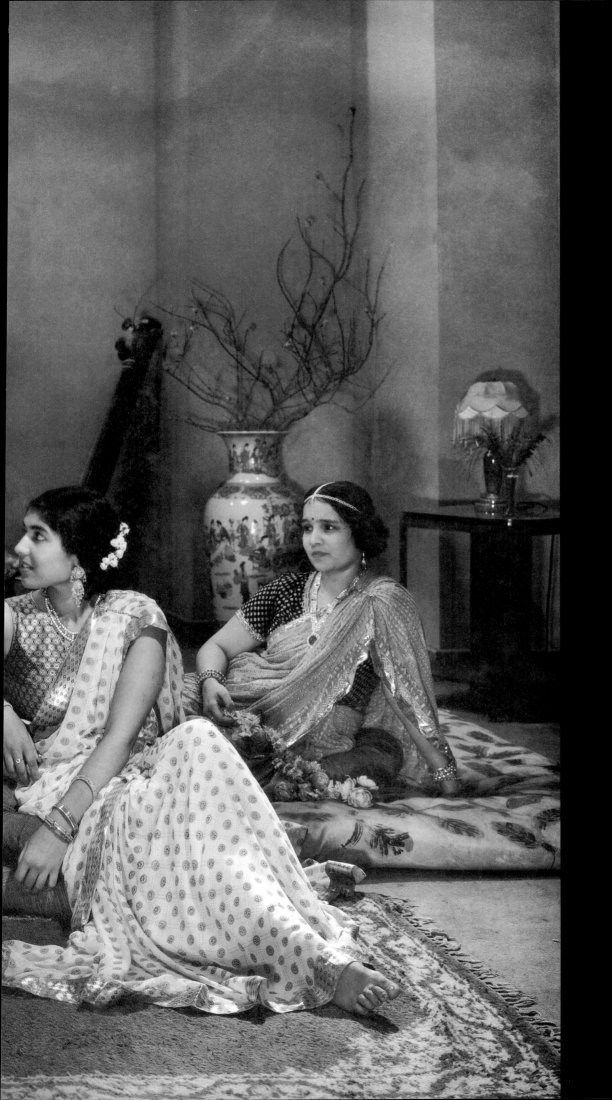

FIG. 7 *Jawani ki Hawa*
1935, Bombay Talkies, d. Franz Osten
Lobby Card (Gelatin Silver Print),
248 x 294 mm
Josef Wirsching Archive

Devika Rani and supporting female actors in a beautiful tableau composition created for a publicity still. This scene occurs early in the film, just before Devika Rani's character Kamala elopes with her childhood sweetheart on the night of her wedding.

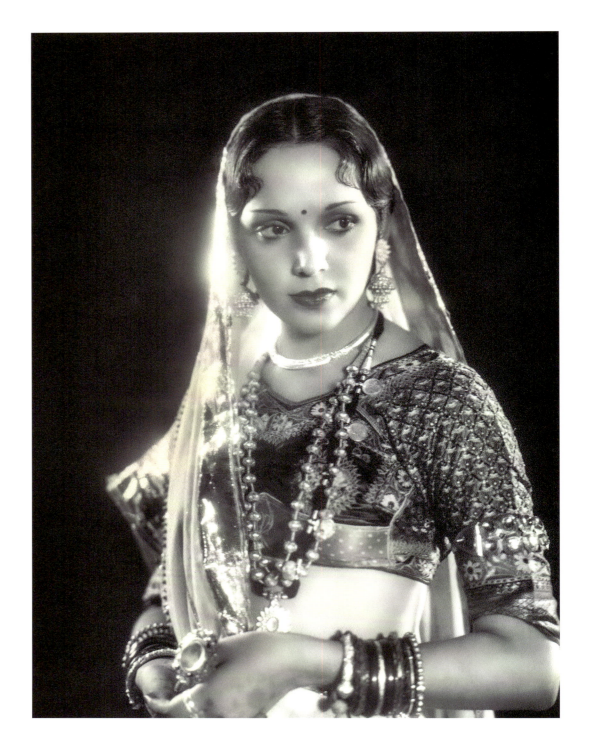

FIG. 8 *Achhut Kanya*
1936, Bombay Talkies, d. Franz Osten
Gelatin Silver Print, 294 x 243 mm
JWA/ACP: 2019.01.0036

Devika Rani poses for a publicity still in costumes designed by H. K. Khosla. Wirsching makes use of a dramatic rim light to glamorize this portrait and separate the figure from the pitch-black background.

FACING PAGE
FIG. 9 *Jeevan Naiya*
1936, Bombay Talkies, d. Franz Osten
Lobby Card (Gelatin Silver Print),
305 x 241 mm
JWA/ACP: 2020.01.0052

Perhaps the most famous of the Bombay Talkies films was *Achhut Kanya* (1936), based on Niranjan Pal's short story "The Level Crossing" and said to have been screened for Joseph Goebbels in Germany. Wirsching helped to create the star image of Ashok Kumar with this film, the Brahmin boy who falls in love with a Dalit girl. He displays a gentle masculinity and elegance, thought to be typically Bengali, an image he retained through much of his career.

Yet there was no doubt that Devika Rani was the film's major star. Her portrayal of a rural Dalit girl is totally unconvincing, in part for her accent, but mostly for her styling. Wirsching

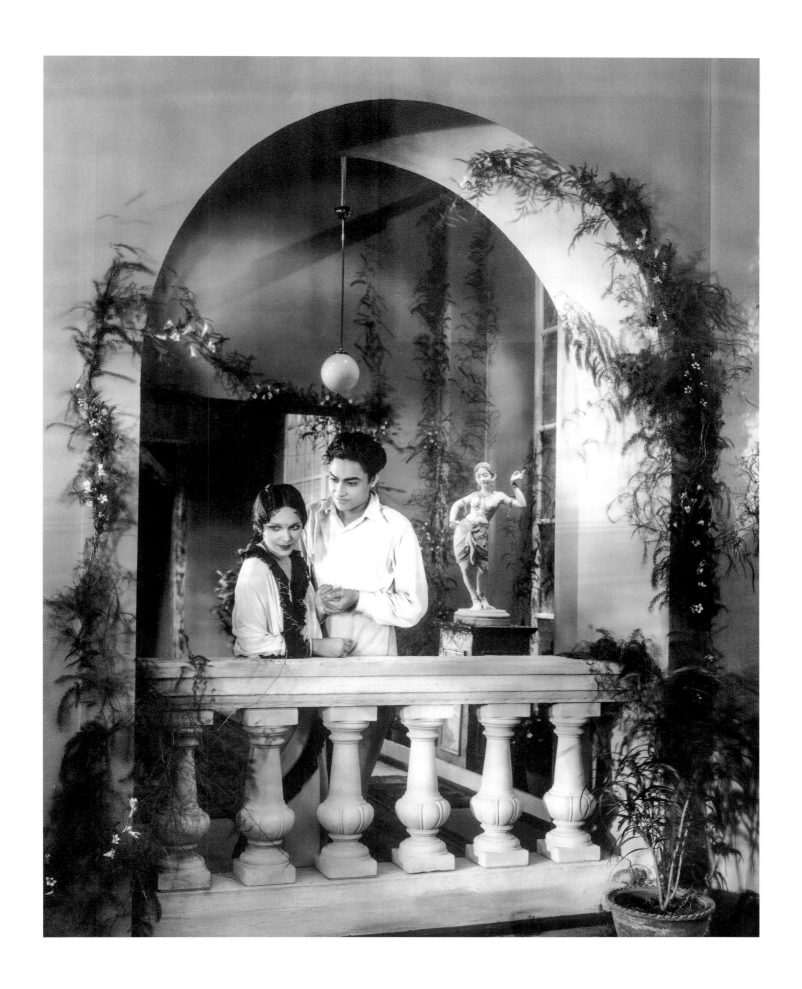

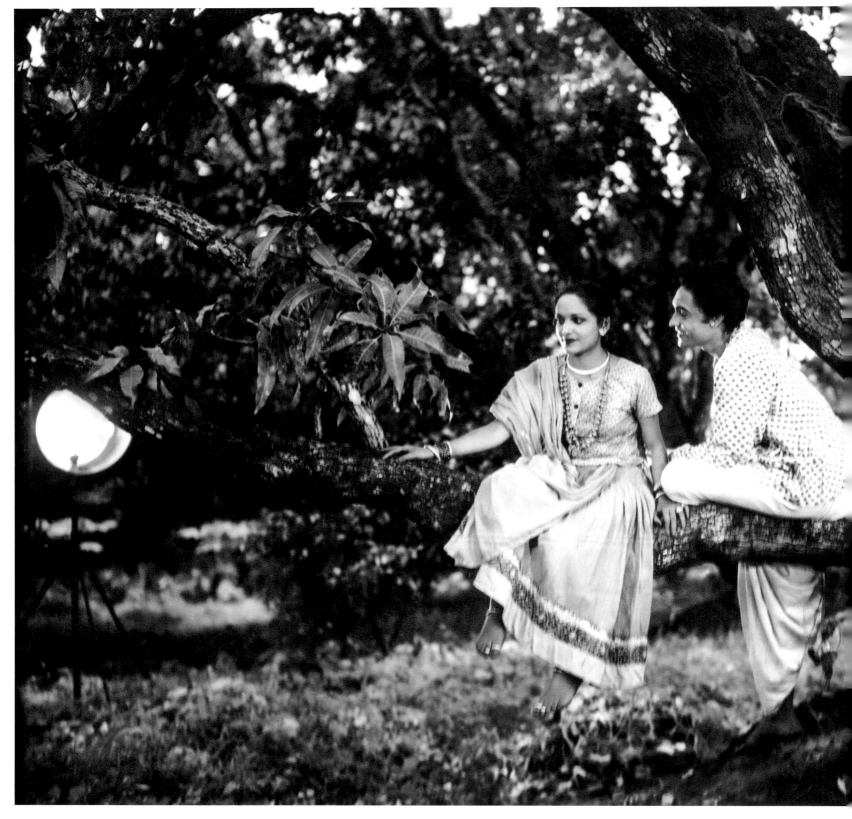

FIG. 10 *Achhut Kanya*
1936, Bombay Talkies, d. Franz Osten
Gelatin Silver Print, 86 x 119 mm
JWA/ACP: 2019.01.0093

Devika Rani and Ashok Kumar rehearse the film's famous song "Main ban ki chidiya" (I am a bird of the forest).

FACING PAGE
FIG. 11 *Nirmala*
1938, Bombay Talkies, d. Franz Osten
35 mm Negative
JWA/ACP: 2020.01.0031

Devika Rani lights up a cigarette on the balcony of the Bombay Talkies office building.

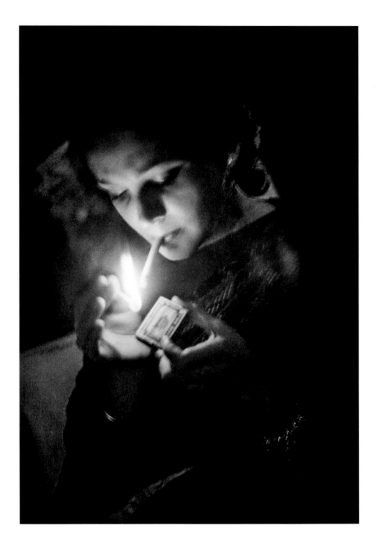

lights Devika Rani in the glamorous style of Greta Garbo and Marlene Dietrich, as can be seen in figure 8. Not only is there little effort to modify Rani's appearance to play a village Dalit, there is also clear use of European styles of the 1930s that make her face iconic.

The problem of an elite star playing a Dalit character is problematic whether in the 1930s or more recently, by Saif Ali Khan in *Aarakshan* ("Reservation," 2011). The image of the star exceeds that of the character. Devika Rani was a strange choice for the role but perhaps this film, celebrated as one of the few to address caste, could succeed only by having such a star play the role. By deploying the star images of the two Bengali actors, the film focuses on transgressive love, involving sacrifice, as something true to the Indian soul and the alleged purity of its women. This hybrid style was seen in all of Devika Rani's films, and many considered Bombay Talkies to be a Westernized studio, lacking an Indian sensibility. Prabhat Studios even featured a spoof of Devika Rani in the bilingual Marathi-Hindi film *Manoos* (*Aadmi* in Hindi) (1939), underscoring this point. A popular song from *Achhut Kanya*, "Main ban ki chidiya," is caricatured in *Aadmi*, where the female lead removes her sari at the end of the song to reveal Western dress as she lights a cigarette (Jaikumar 2006, 228–30; Majumdar 2009, 86–89).

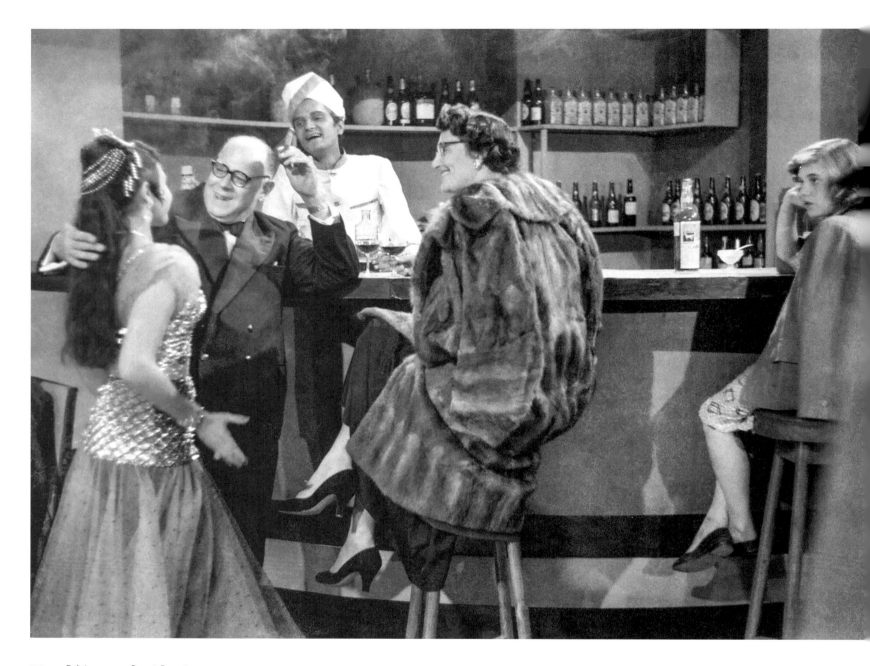

FIG. 12 *Dil Apna aur Preet Parai*
1960, Mahal Pictures, d. Kishore Sahu
35 mm Negative
JWA/ACP: 2020.01.0001

Josef and Charlotte Wirsching play walk-on parts in the cabaret song "Itni badi mehfil aur ik dil" (I have just one heart on offer in this large gathering).

FACING PAGE
FIG. 13 **Madhubala**
Unknown Photographer; Ram Siddhartha's Collection (stamp on verso)
Gelatin Silver Print, 1950, 118 x 86 mm
Courtesy: Rahaab Allana Collection

116 Rachel Dwyer

In *Kangan* (1939), Wirsching shot Leela Chitnis, famed as a great beauty and the first Indian star to advertise Lux soap. Shortly afterwards, Wirsching was interned in a camp for German nationals. R. D. Pareenja took over as cameraman in Wirsching's absence, working on films such as *Kismet* (1943), which has the iconic nationalist song "Dur hato ae duniyawalon, Hindustan hamara hai." There followed many upheavals in the studio: Himansu Rai died in 1940 and soon a breakaway group, including Sashadhar Mukherjee and Ashok Kumar, left Bombay Talkies to form Filmistan in 1943. In 1945, Devika Rani married the Russian artist Svetoslav Roerich and quit the studio, after which Ashok Kumar and Savak Vacha returned to Bombay Talkies as producers in 1947.

Madhubala

After the dust settled, Bombay Talkies produced *Mahal* (1949), where Wirsching created a strong Expressionist Gothic style. The film's melodrama and Expressionism link to the Gothic in literature which explores emotion, the anti-rational and non-scientific to oppose or haunt the rational and the modern as part of an eighteenth-century reaction to the Enlightenment (Eisner 1969; Carroll 1990; Dwyer 2011). The film has a striking absence of religion and any moral code, showing Gothic features including disguise, mistaken identities, feudal authority and the haunted house. The romance contests feudalism as the daughter of the gardener seeks to be the mistress of the house, enchants the hero by suggesting they were a couple in an earlier birth and makes ghostly connections, leading him to ignore his wife. The camera focuses on the house itself, its clock, its staircases and swinging chandeliers, while the ghostly heroine moves through its underground passages.

The mise-en-scène, particularly the lighting of the film, disrupts any attempt at realism. Darkness and moonlit shots create a dream world, its ghostliness intensified by the deep field of vision. Even at the film's end, when a trial reveals the hoax, many features are left unexplained, such as why in the song "Aayega aanewale" the chandelier is swinging, or whence the portrait of the earlier owner who looks like the

present one (Ashok Kumar). This portrait introduces the uncanny, combining the image and disembodied voice at the heart of the haunting elements of the film. The hero is a man who rejects courtesans as well as his wife as he is in love with Asha, a ghost he hardly sees, a ghost played by one of the most beautiful women in the history of Hindi cinema—Madhubala.

Madhubala had acted in Bombay Talkies' *Basant* (1942) as a child actor named Baby Mumtaz. *Mahal* was her first film as an adult, where her beauty is part of her magical presence. Yet she was also a great comedienne, in films like *Chalti ka Naam Gaadi* (1958) with the three Kumar brothers, and Guru Dutt's *Mr and Mrs 55* (1955), as well as a tragic heroine in *Mughal-e-Azam* (1960), where she played Anarkali, a courtesan loved by the Mughal prince Salim (the future Jahangir) and condemned to death for her transgression.

It is said that Savak Vacha persuaded Wirsching to mess up the trial shoots for *Mahal* so that Kamal Amrohi wouldn't replace the actress Suraiya with Madhubala (Deep 1996, 38). Yet, it was Wirsching who created Madhubala's star image as an exquisite beauty in this film. The young Madhubala is so ethereal that she often vanishes, leaving behind a disembodied voice. The first time we hear her, we don't even see her. She arrives at the mansion on a boat in the moonlight—a ghostly image, simply dressed, making her striking beauty, with Western hairstyle and eyebrows, even more haunting. The steady pace of the beautiful songs gives Wirsching time to develop his dramatic images, especially those at night on the river that flows by the mansion. "Dil ne phir yaad kiya" has silhouetted buildings, a clock tower, cupolas, and a moonlit river, while Madhubala appears on the boat in close-up, the moonlight shining on her face. She walks up the stairs and along an arched corridor, wearing a black sari, with transparent long sleeves, her hair open, looking like a ghostly vision. There is similar use of the riverside buildings in "Mushkil hai" and "Ek tir," but the latter is much more static, with strong winds blowing around a seated Madhubala, the long shots of arches giving a feeling of space to be travelled.

The ghostly character of Madhubala's Asha is contrasted to other women in the film; the courtesans sing "Ye raat phir" with high-angle shots of the harp and somewhat confusing movements for the dancers followed by the camera, while Ashok Kumar is often in half close-up, not quite the only audience for the song. The neglected wife, on the other hand, sings "Main woh hasi," her face half-covered before she applies make-up with great care, then lights a candle to focus on close-ups of hands and jewellery—a decorated married woman in contrast to the presumably virginal "ghost."

Meena Kumari

After *Mahal*, Bombay Talkies finally closed and Wirsching made documentaries, before returning to make two more films with Kamal Amrohi's production company—*Dil Apna aur Preet Parai* and then *Pakeezah* (1972). Both films starred Meena Kumari, to whom Amrohi was married for a time.

FACING PAGE
FIG. 14 *Dil Apna aur Preet Parai*
1960, Kamal Pictures, d. Kishore Sahu
35 mm Negative
JWA/ACP: 2019.01.0109

Meena Kumari leaning on a piano in a dramatic scene from the film. Note the use of chiaroscuro lighting, magnified shadows on the textured drapes, and the way the edges of the frame merge into total darkness.

Meena Kumari, like Madhubala, took up acting at her father's direction. She was already a major star when she became Amrohi's third wife. Again, like Devika Rani, Meena Kumari was seen to have an innocent face—innocent enough to be the *pakeezah* (pure) of the title though brought up in a courtesan's house—while also being accused of being sex-obsessed (catalogued at length in Deep 1998). Her beauty, her acting, her elegance and her voice, as well as her skills in poetry (Kumari 2014), made her the "Queen of Melodrama," and a woman who suffered off-screen as much as she did on-screen (Mehta 2013). She died at the age of forty from cirrhosis caused by her alcoholism.

More than ten years after *Mahal*, *Dil Apna aur Preet Parai* was Wirsching's return to the camera. In one scene, where Helen performs an adapted Harry Belafonte song, Wirsching himself is seen at the bar in the club, alongside his wife, Charlotte (figure 12).

The style of the film is not Gothic like *Mahal* and less Expressionist but still retains many features of Wirsching's dramatic black and white style. There are Gothic moments in the crisis when Raj Kumar and Meena Kumari drive to the village in the night and seem to turn into villagers, before a nightmare with chiming clocks and visions of storm and rain, but the overall feeling is of a romantic melodrama rather than a Gothic drama.

ABOVE
FIG. 15 *Achhut Kanya*
1936, Bombay Talkies, d. Franz Osten
Lobby Card (Gelatin Silver Print),
241 x 305 mm
JWA/ACP: 2020.01.0044

BELOW
FIG. 16 *Dil Apna aur Preet Parai*
1960, Kamal Pictures, d. Kishore Sahu
Gelatin Silver Print, 116 x 162 mm
JWA/ACP: 2019.01.0068

Kamal Amrohi, Josef Wirsching, and Meena Kumari pose with the Cinemascope camera, one of the technological innovations that Amrohi was determined to try out in the film.

FACING PAGE
ABOVE
FIG. 17 *Dil Apna aur Preet Parai*
1960, Kamal Pictures, d. Kishore Sahu
Gelatin Silver Print, 127 x 165 mm
JWA/ACP: 2020.01.0076

Kishore Sahu, Meena Kumari, Josef Wirsching and Kamal Amrohi rehearse a shot.

BELOW LEFT
FIG. 18 *Dil Apna aur Preet Parai*
1960, Mahal Pictures, d. Kishore Sahu
35 mm Negative
JWA/ACP: 2019.01.0066

Meena Kumari (left), Charlotte Wirsching (centre) and Helen (right) enjoying a light moment during a tea break.

BELOW RIGHT
FIG. 19 *Izzat*
1937, Bombay Talkies, d. Franz Osten
35 mm Negative
JWA/ACP: 2019.01.0024

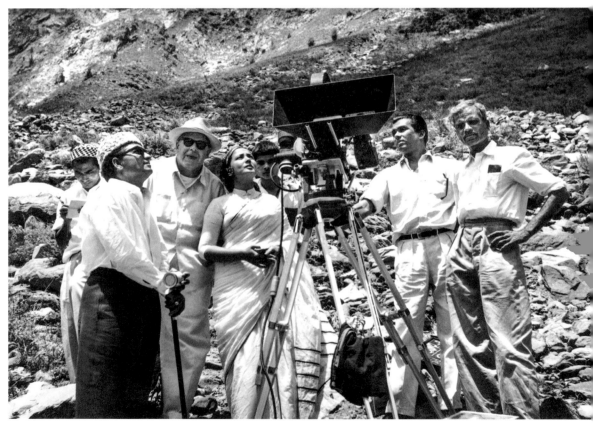

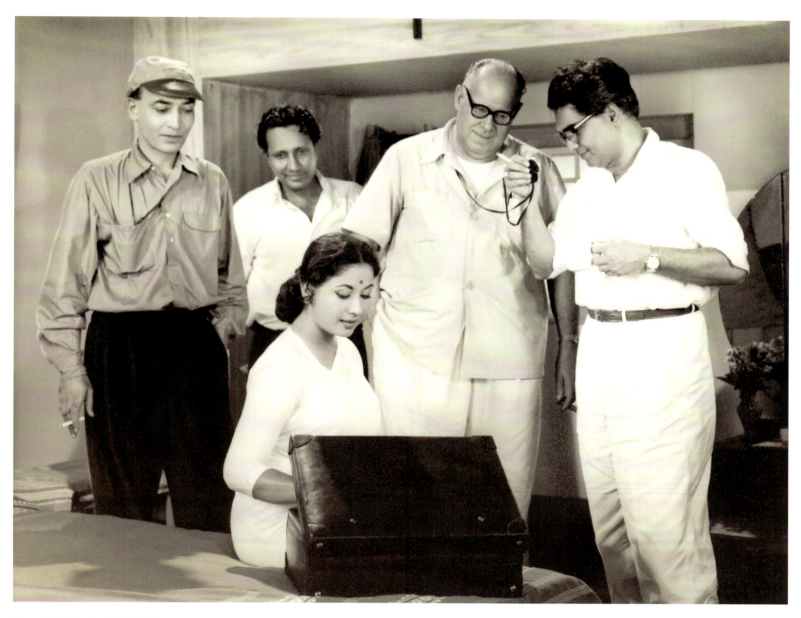

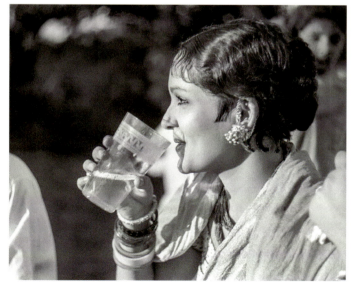

A German Eye on Indian Beauty

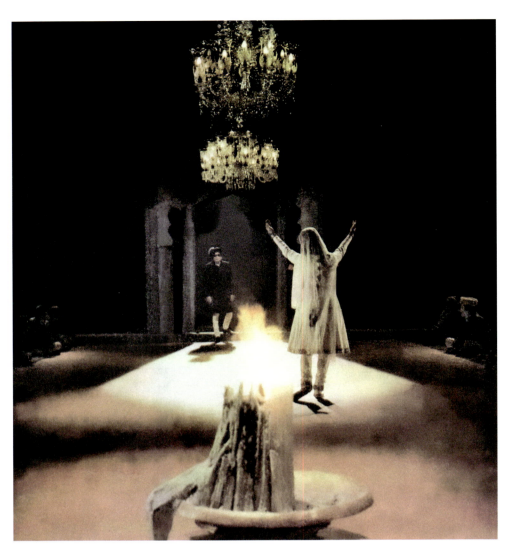

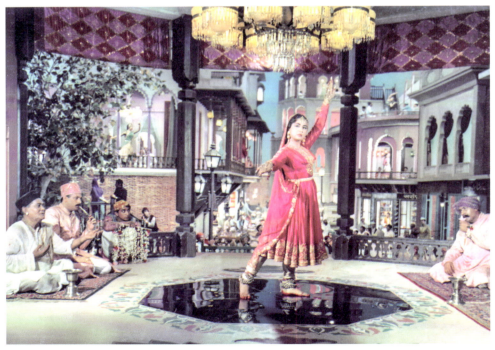

ABOVE
FIG. 20 *Pakeezah*
1972, Mahal Films/Kamal Pictures,
d. Kamal Amrohi
Publicity still
Courtesy: Debashree Mukherjee

BELOW
FIG. 21 *Pakeezah*
1972, Mahal Films/Kamal Pictures,
d. Kamal Amrohi
Publicity still
Courtesy: Kamat Foto Flash

Sahibjaan (Meena Kumari) sings "Inhi logon ne" (These very people) at her first public performance in the courtesan's suite. She is dressed in red, suggesting fertility or a wedding.

FIG. 22 *Pakeezah*
1972, Mahal Films/Kamal Pictures,
d. Kamal Amrohi
Publicity still
Courtesy: Kamat Foto Flash

The second and final film that Wirsching made with Meena Kumari was Amrohi's *Pakeezah*, one of the most loved films in the history of Hindi cinema. He had worked with much of the cast before: Meena Kumari, Ashok Kumar, Raj Kumar and Nadira. Filming began in 1956 and the film was initially to be shot in black and white. It was later reshot in colour. The movie was abandoned after Meena Kumari and Amrohi separated in 1964 but they came together to finish the film in 1969, with many changes to the cast, such as the replacement of Ashok Kumar, now too old to play a lead hero, by Raj Kumar. Although this film lacks the element of the uncanny, it is associated with death, not just through the cemetery at the beginning or Pakeezah's claim that she is a living corpse, but also because it is a film associated with the end of a marriage, the deaths of Meena Kumari, Ghulam Mohammed and Wirsching himself.

Wirsching was the cameraman on the first shooting schedule in the early 1960s but he died before the second schedule. Several other cameramen took over but it's not clear which scenes each man shot. Sometimes it is easy to tell that Wirsching shot some sequences because of Meena Kumari's age. Meghnad Desai convincingly argues that Meena Kumari's main songs—"Inhi logon ne," "Chalte chalte" and "Thare rahiyo"—were filmed by Wirsching in the first schedule while the romantic scenes were shot later. The later parts were filmed by Jal Mistry and V. K. Murthy. Fali Mistry is said to have helped and R. D. Mathur finished the film (Desai 2013, 48-50).

It seems strange that Amrohi wanted to work with Wirsching to create the images of a nostalgic film of a courtesan in an Islamicate milieu. Amrohi was famous for his dialogues and use of language, while Meena Kumari was a poet in Urdu, but Wirsching had little knowledge of the language. In addition to the new theme, *Pakeezah* was also Wirsching's first colour film. It is shot in Eastmancolor and also in Cinemascope. The brightness of the colour is quite shocking, a dazzling, if not gaudy, updating of the genre of the Islamicate courtesan film, very different from *Mughal-e-Azam*, another film which took more than a decade to complete and which was mostly shot in black and white with some portions in Technicolor. It would be fascinating to know how Wirsching approached shooting the elaborate dance sequences, as he undoubtedly created a classic look in one of the best examples of the courtesan film ever made.

The song sequences are breathtakingly spectacular, with elaborate sets and costumes, and a camera that focuses on Meena Kumari's face, not the body of the woman who saw herself as a *zinda lash* (living corpse). "Inhi logon ne" is shot on a massive set with multiple dancers positioned in different buildings to show the spectacle of the courtesan's district, the *bazaar-e-husn* (figure 21). The camera is always mobile. Meena Kumari appears from the background in red in mid-long shots, moving around the dance areas, as the camera closes in on her to give the song further subjectivity. It seems likely that Wirsching shot "Thare rahiyo," given Meena Kumari's relatively youthful appearance. It is one of the most dramatic songs in the film, not least for its camera work, featuring a very mobile camera

A German Eye on Indian Beauty

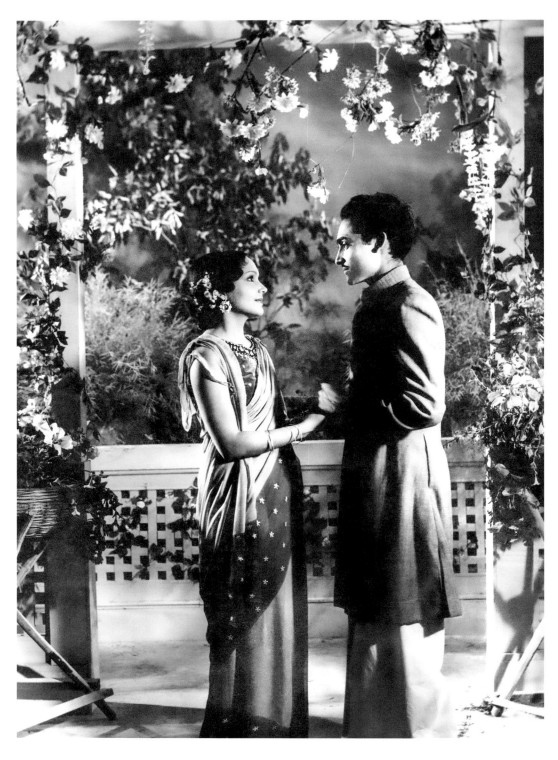

FIG. 23 *Nirmala*
1938, Bombay Talkies, d. Franz Osten
Gelatin Silver Print, 165 x 127 mm
JWA/ACP: 2020.01.0069

Nirmala (Devika Rani) and Ramdas (Ashok Kumar) sing a romantic duet, "Bolo sajni bolo," in an easy conversational style. Wirsching's cinematography in this song sequence is remarkable, and the sequence ends with the transition from night to early dawn in a single tracking shot.

that tracks in and out, mixing close-ups and mid-shots with many long shots. The effect of movement heightens the drama of this song sequence.

One of the most loved songs in *Pakeezah* is "Chalte chalte," a song of a chance encounter on the road. Meena Kumari wears an orange and gold costume, which is as much an iconic part of the mise-en-scène as the chandeliers, the carpet, the cushions or the architecture with the cypresses and fountains further back. She is shot in close-up at the start of the

song. In a symmetrical shot, two dancers enter and then she gets up to join them. As she sings, the camera tracks back through a fountain to look at Meena Kumari from across the courtyard. She looks at the outside world, singing to the sky. The camera now moves around, behind the *nawab* (aristocrat or person of high status) for whom she is performing. There is an extreme close-up of her eyes and the eyes of the *nawab*. The camera cranes up to the chandelier, and when the train whistles, the camera moves to the fountains, whose gently arcing water pipes then subside and come to a stop.

Conclusion

Wirsching's legacy lives on in his films, to which he brought a high level of professionalism and technical competence to create star images, in particular, female ones. These three great stars, Devika Rani, Madhubala and Meena Kumari, all had star images where their complicated and often tragic personal lives were at odds with the demure roles that they played on screen. They lived, or tried to live, outside the norms of society, choosing their own partners and challenging the norms of the day while acting as more conventional heroines. While Devika Rani moved away from Bombay to live a life perhaps more suited to her origins in the cosmopolitan elite, both Madhubala and Meena Kumari died young. While the latter two are celebrated today for their star images, not least in LGBTQ circles, where they are favourites of drag artistes, Devika Rani is little known. Wirsching was able to show these three extraordinarily beautiful women in their on-screen and off-screen roles as innocent, typical film heroines while also allowing their personalities and their glamour to shine through, especially in his portraits. Sometimes, he even allows hints of their personalities on screen, even if the film text itself emphasizes their innocence and the deep ambivalence in showing a Dalit who romanced a Brahmin boy; a servant who dreamt of being the mistress of the house; and a courtesan who wanted marriage and respectability. Wirsching's ability to capture these dynamics is an overlooked part of the creation of these three stars.

The legacy of Bombay Talkies is only just being assessed but its output undermines the idea of the Hindi film industry as a weird, exotic form and encourages the idea of it as an evolving one where individual talents and teams worked together. Its influence was spread by the people who worked with the studio, including actors Ashok Kumar and Dilip Kumar; writers K. A. Abbas and Sa'adat Hasan Manto; editor and director Bimal Roy; and writer and director Kamal Amrohi.

As Ashish Rajadhyaksha argued in his study of D. G. Phalke, the hybrid nature of Hindi film is not just a result of Indian stories and aesthetics meeting Western technology but something much more (1987). Wirsching himself worked for many years in this vernacular and popular form, mixing Indian and German sensibilities. He was a cinematographer who ultimately aligned himself with the West in terms of style but whose legacy shaped Indian cinema, adding to its hybridity and its endless ability to absorb and make outside elements its own.

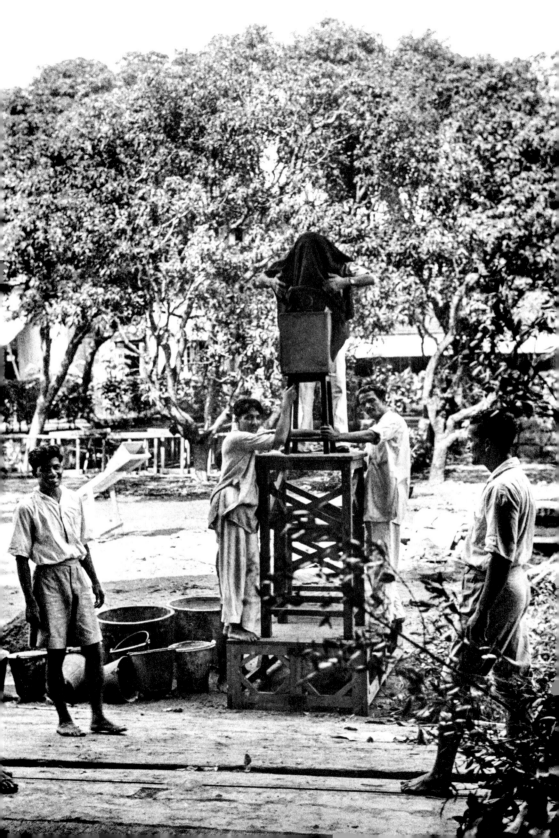

Between the Studio and the World
Built Sets and Outdoor Locations in the Films of Bombay Talkies

■ Debashree Mukherjee ■

Cinema is a form that forces us to question distinctions between the natural world and a world made by humans. Film studios manufacture natural environments with as much finesse as they fabricate built environments. Even when shooting outdoors, film crews alter and choreograph their surroundings in order to produce artful visions of nature. This historical proclivity has led theorists such as Jennifer Fay to name cinema as the "aesthetic practice of the Anthropocene," that is, an art form that intervenes in and interferes with the natural world, mirroring humankind's calamitous impact on the planet since the Industrial Revolution (2018, 4). In what follows, my concern is with thinking about how the indoor and the outdoor, the world of the studio and the many worlds outside, are co-constituted through the act of filming. I am interested in how we can think of a *mutual* exertion of spatial influence and the co-production of place and space by multiple actors.

The most ambitious film studios and filmmakers of pre-Independence India were intent on crafting a new kind of cinema for an emergent nation. What was this collectivity that comprised the nation? Who were its people? And what did it look like? Bombay Talkies studio, set up by a group of Bengalis who had spent formative years of their adulthood in Europe, took up this project of imagining an ideal nation space through a series of filmic experiments with built architecture and actually-existing geographies. Framed by the camera, nature becomes a set of values (purity, regeneration, unpredictability), as does the city (freedom, anonymity, danger). The Wirsching collection allows us to examine these values and their construction by keeping in view both the filmed narrative as well as parafilmic images of production. By examining the physical and imaginative worlds that were manufactured in the early films of Bombay Talkies—built sets, painted backdrops, carefully calibrated outdoor locations—I pursue some meanings of "place" that unfold outwards from the film frame.

FIG. 1 *Vachan*
1938, Bombay Talkies,
d. Franz Osten
35 mm Negative
JWA/ACP: 2019.01.0084

R. D. Pareenja under a black camera blind during a daytime shoot in the lawns of the Bombay Talkies studio.

I examine how certain spatial imaginations announce themselves as placeholders of the urban, the modern, the natural or the Indian. By asking what spatial meanings Bombay Talkies brought to bear on a particular built environment, I also ask what the actually existing geography of the Bombay region brought to the cinema of Bombay.

Bhabhi (1938): Crafting the Generic Indian City

All over the world, as film production grew in prominence, scale and popularity, the city came to represent the distillation of cinematic modernity. Not only were the earliest film studios located in and around big cities but city life was also often the main attraction of the movies. Urban architecture, modern technologies, mass transit systems, fashion and commodity culture, and the emergence of the modern working woman were some essential features of the cinematic city of the 1920s and 1930s. If Berlin became a cinematic icon of modernity in Germany, represented on film through location shooting as well as elaborate sets, in France it was Paris that dominated the filmic aesthetic of modernity. Social films made in Bombay also participated in this transnational fascination and often showcased the city's architectural attractions, such as Hanging Gardens, Victoria Terminus (now the Chhatrapati Shivaji Maharaj Terminus) and the Gateway of India.

Bombay Talkies' earliest films are either set in Bombay or feature Bombay in certain scenes—*Jawani ki Hawa* (1935) prominently features Horniman Circle and the *Mumbai Samachar* newspaper offices; *Always Tell Your Wife* (1936) has extensive scenes at and around the Gateway of India; and *Jeevan Naiya* (1936) begins with a long shot of Marine Drive as viewed from Hanging Gardens. *Prem Kahani* (1937) has rare travelling shots of Bombay: Victoria Terminus; streets crowded with pedestrians, cars, and carriages; stores

FIG. 2 *Izzat*
1937, Bombay Talkies, d. Franz Osten
35 mm Negative
JWA/ACP: 2019.01.0062

Josef Wirsching lights up an exterior night scene.

selling "readymade clothes"; ubiquitous advertising and signage; single and double-decker trams; and the Orient Hotel.

Soon, however, Bombay Talkies veered sharply away from a particularly Bombay-brand of transnational modernity to a more diffused form of middle-class urbanism that vaguely signified something "Indian" without specifying a particular place. Films like *Achhut Kanya*, *Izzat* and *Durga* were set in villages, and a large majority, such as *Janma Bhoomi*, *Prem Kahani*, *Jeevan Prabhat*, *Nirmala*, *Bhabhi*, *Kangan* and *Azad* were set in unnamed semi-urban locales. In *Bhabhi* (1938), a large outdoor set was built to simulate a narrow street in an urban residential neighbourhood.[1] Neither the dialogue nor the publicity materials specify which city the film is set in and the only place name we see is the name of the street—Hanuman Lane—indicating a predominantly Hindu demographic. These two-storeyed cement homes, with their geometrically patterned wooden balconies and shuttered windows, represent a modern middle-class architectural standard that was ushered in with the growing availability of Indian-made cement since 1914 (Tappin 2002, 82).[2] Hanuman Lane was thus a generalizable middle-class space that could stand in for many such neighbourhoods across the major towns of early twentieth-century India. The decision to choose unnamed and undefined towns as filmic milieus speaks to Bombay Talkies' growing desire to transcend geographic boundaries and address an imagined pan-Indian audience with light, socially instructive entertainment.

Bhabhi is a film about regressive social values and the toxicity of gossipy, middle-class morality. In fact, the original title of the Bengali story by Saradindu Banerjee, which served as the basis for the screenplay, was "Bisher Dhuan," titled in English as "Poison Smoke." The hero, Kishore (played by P. Jairaj), promises a dying friend that he will take care of his young widow. Kishore and the widow, Bimla (Maya Devi), become good friends and live together in Kishore's city home as siblings. Kishore refers to Bimla as his *bhabhi* (sister-in-law). Their living arrangements, however, become a thorn in the side for various people, culminating in a social scandal that prompts Kishore's father to publicly disown him. In the meantime, Kishore falls in love with a charming neighbour, Renu (Renuka Devi), but again, various malicious forces intervene to keep the couple apart. The film aligns with its young lovers and their conspicuous modernities—Kishore is a scientist and professor, while Renu is a confident woman who freely speaks her mind, with a social circle that includes male friends—and deploys urbanized interiors and exteriors to convey life in a generic Indian city.

Built sets play a major role in the narrative action of *Bhabhi*. The elaborate outdoor set of Hanuman Lane serves as a kind of public square where characters meet and separate, and learn trust and caution. Figure 4 depicts a lighting rehearsal for a comic scene of misunderstanding where Renu's father, Benoy Babu, flees in fright from Kishore, who has been described to him as a dangerous street ruffian. Josef Wirsching uses a mix of natural light, artificial lights and reflectors for this scene, heightening the look of the dappled sunlight that filters through the set (note the foliage in the image). In the film, this

FIG. 3 *Jeevan Naiya*
1936, Bombay Talkies, d. Franz Osten
35 mm Negative
JWA/ACP: 2019.01.0087

Ashok Kumar and Devika Rani in an outdoor nighttime party scene set up on the Bombay Talkies lawns. The studio's central office building features prominently in the background.

scene lasts a full two minutes, including one long shot of Benoy Babu walking down the lane through pedestrian and cycle traffic. He soon bumps into Kishore, who lives next door. Kishore is holding a bottle of spirits, and, prejudiced by poisonous hearsay, Benoy Babu assumes that Kishore is an alcoholic. Panicking, he runs home and sees an old and respected friend at his doorstep. The friend reveals that Kishore is a college professor and the spirits are for the chemistry experiments that he conducts in his private laboratory at home. Contrite, Benoy Babu now invites Kishore home and the love plot between Renu and Kishore develops. The spatial proximities and parallel anonymities of the urban thus play a key role in the development of the plot.

Benoy Babu is played by the famous comedian V. H. Desai, in his first film for Bombay Talkies. In a short biographical sketch, Sa'adat Hasan Manto refers to Desai as "God's clown" (2008). Desai, a former lawyer, turned to acting after a period of poor health. Manto recounts that Desai was notorious in film circles for being unable to remember his lines during a shoot. Take after take would be reshot while Desai misremembered or misplaced words. However, he was a huge hit with paying audiences and the studio hung on to him as their comic mascot. Speaking of *Bhabhi*, Manto says, "What torture the staff and technicians of Bombay Talkies suffered during the making of that movie, it is not possible to describe. Many times, they almost gave up on him but persisted because they saw it as a challenge" (2008, 467). How many rehearsals and retakes did this scene in Hanuman Lane require? Does figure 4 carry traces of the tired bodies of the crew as they rehearse with a legendarily forgetful actor? Does it carry traces of an actor's struggle with a learning disability? Set design, as Mark Shiel points out, is "anthropomorphic and customized for different clients" (2015, 58). The actor's body and the set must, in a sense, "fit" each other, and in a studio where actors were full-time employees, necessarily the sets were designed with prior knowledge of the actors who would perform in them. Hanuman Lane may not have been calculated according to Desai's physical dimensions but his presence, the movement of his body during rehearsals and retakes, even the movement of the dirt on the ground as it is unsettled by the production crew, leave imprints on the set as traces of human labour. The actor, the crew and the set exert mutual pressures on each other, affecting the final image registered by the camera and projected on the screen.

Several different ideas about set design were at play in the interwar years, and the Bombay Talkies team had been exposed to some of these debates in Europe. Around 1928 or 1929, about five years before Bombay Talkies was established, Himansu Rai was employed at Germany's legendary UFA studios.[3] German cinema in the 1920s was renowned for

Between the Studio and the World 131

its spectacular set design, most notably represented in the acme of Expressionist film style, *The Cabinet of Dr. Caligari* (1920). By the time Himansu Rai and Devika Rani joined UFA, set design had come to dominate debates on the differences between the two most prominent filmmaking nations of the world—Germany and the United States. The precedence of narrative over sets was deemed American, with critics arguing on both sides for greater or lesser emphasis on design and architecture. In 1929, Erich Pommer, "probably the most noteworthy of all producers the world over," (Collier 1929, 38) started his own production unit at UFA and ushered in a production strategy that retained spectacle and the affective appeal of melodrama but introduced a strict spatial economy of a "restricted number of locations" (Bergfelder, Harris, and Street 2007, 118). This was the year that Pommer's unit produced such canonical films as *Asphalt* and *Blue Angel*. Devika Rani has claimed in interviews that Rai and herself worked with Pommer, and this might partially explain Bombay Talkies' economical and non-flamboyant use of sets (Malik 1958, 35). Indeed, there is little that is epic or spectacular in the constructed sets of early Bombay Talkies.

Rai, Osten, Wirsching and Rani were amply familiar with the world of epic filmmaking fashionable in the Weimar Germany that they had left behind, but they were either uninterested in or financially ill-equipped to replicate that aesthetic in Bombay. The spectacular backdrops of their pre-Bombay Talkies silent films were largely possible because films like *The Light of Asia* (1925) and *A Throw of Dice* (1929) were shot on location in the existing palaces and forts of Rajasthan and elsewhere. Bombay did not offer such medieval architectural splendours. Besides, the Bombay Talkies vision had moved beyond the fashionable Orientalism of Indian Players' silent films, focusing now on reformist pictures for a self-consciously modernizing India. These were to be modest films about ordinary characters that Indian viewers could identify with, made on modest budgets. Bombay Talkies films remain focused on plot and character, with an overriding insistence on moral and social messaging. Sets are largely functional and sustain the plot, valued more as environments that enable a certain kind of sociality or community or, conversely, threaten social bonds. Set design, though elaborate and detailed, does not serve as a seductive spectacle in the visual world of Bombay Talkies, but as an environment or *medium* to carry bodies and emotions.

Hanuman Lane features prominently in *Bhabhi*, returning again towards the end of the film, this time as a space of public violence. After a period of forced separation from Renu and much romantic resentment, Kishore returns to a city that is engulfed by riots. Again, neither the city nor the causes of mob violence are named, but the dialogue and visuals draw on audience familiarity with the phenomenon of urban crowd violence and police deployment. Sounds of rioting and men's raised voices are heard off-screen as Kishore ventures out in the midst of chaos to fetch a doctor for Benoy Babu. We are not shown any violent confrontations but we see the aftermath of the riots as Hanuman Lane is strewn with debris and Kishore returns all bloodied and faint with injury. Bombay audiences were

FACING PAGE
FIG. 4 *Bhabhi*
1938, Bombay Talkies, d. Franz Osten
Gelatin Silver Print, 81 x 106 mm
JWA/ACP: 2019.01.0098

An elaborate lighting set-up for an outdoor scene shot on a constructed set. Bombay Talkies' popular comedian V. H. Desai can be seen rehearsing a scene in which he mistakenly flees from the good-natured protagonist, played by P. Jairaj.

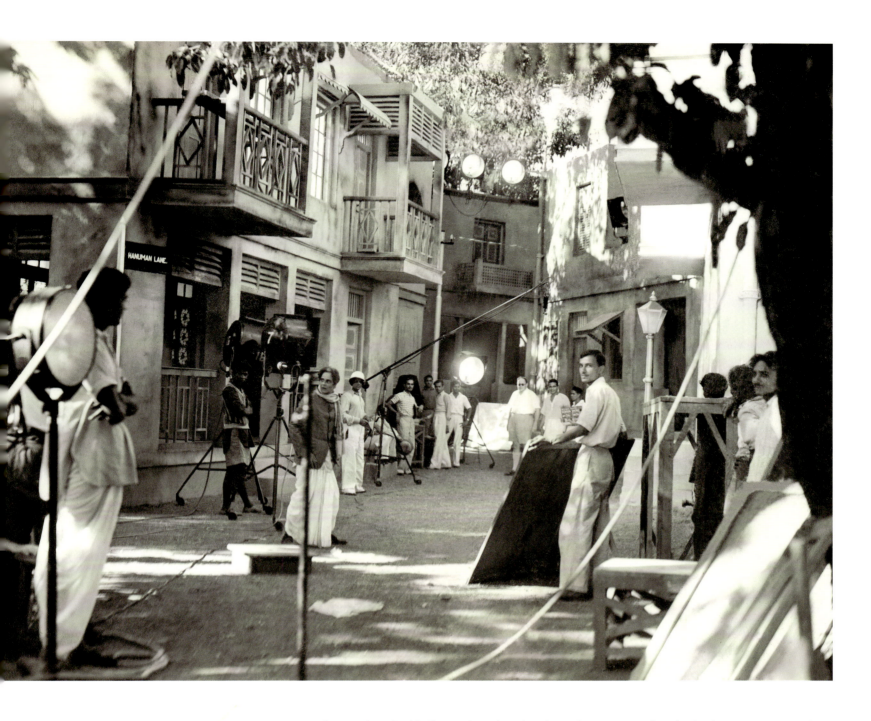

well acquainted with the codes of such urban phenomena; the city had seen communal riots take place at an alarming frequency in preceding years. Curfews, shuttered shops and expanded police presence had become a familiar reality. But riots were not a phenomenon isolated to Bombay. In the 1930s, Hindu-Muslim riots were widely reported on from cities such as Calcutta, Benares, Lucknow, Madras, Karachi, Poona (now Pune), Lahore and Hyderabad. By 1938, a film could therefore reference mob violence and police curfews with the assurance that urban audiences would be able to fill in any gaps in the storytelling with their own personal experience or knowledge from newspaper reportage. Just as urban proximity was diegetically mobilized to further the plot, current socio-political crises were also utilized towards narrative resolution. Though Bombay city itself was a prime venue

FIG. 5 *Bhabhi*
1938, Bombay Talkies, d. Franz Osten
Gelatin Silver Print, 94 x 119 mm
JWA/ACP: 2019.01.0100

A shot of the same outdoor set (on previous page) which is now lit up for a night sequence. In this sequence, Renuka Devi and Meera say their goodnights to Rama Shukul as he drops them home after a night at the movies.

FOLLOWING PAGES
FIG. 6 *Bhabhi*
1938, Bombay Talkies, d. Franz Osten
Gelatin Silver Print, 91 x 119 mm
JWA/ACP: 2019.01.0097

In this final song sequence from the film, the camera is trained on the romantic lead—P. Jairaj and Renuka Devi. Note the artificial rain produced by the upturned sprinklers overhead, and the cityscape behind, enlarged from a recce photograph shot by Wirsching himself.

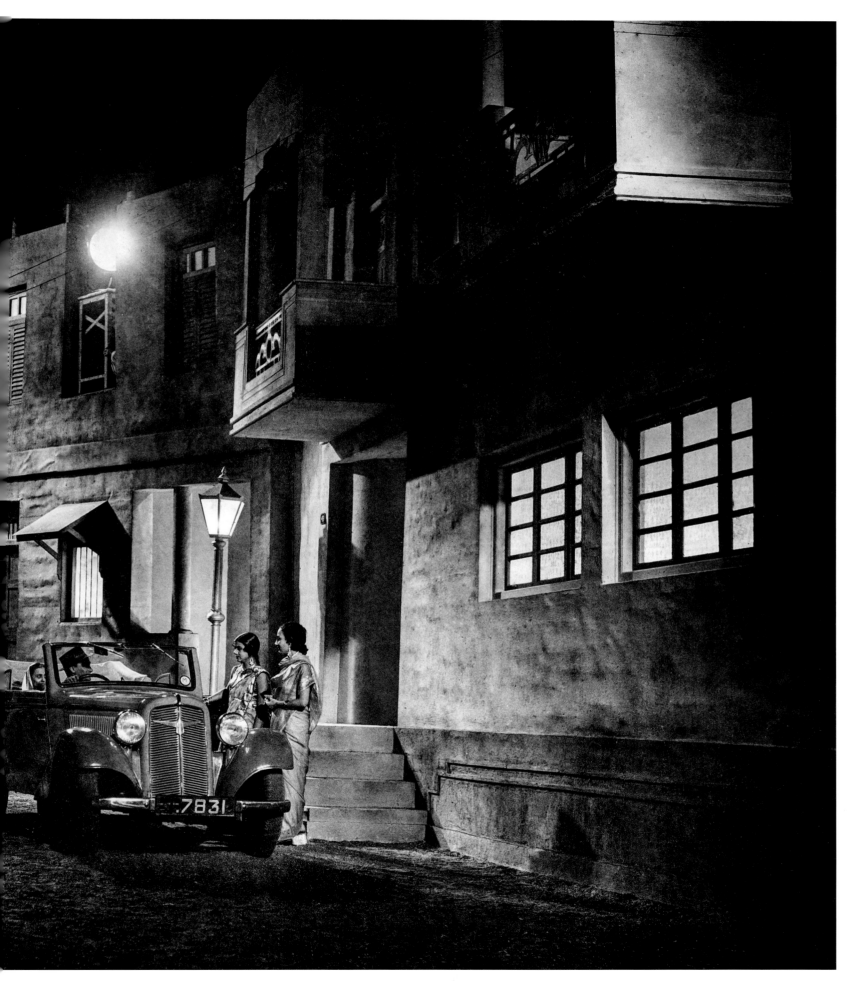

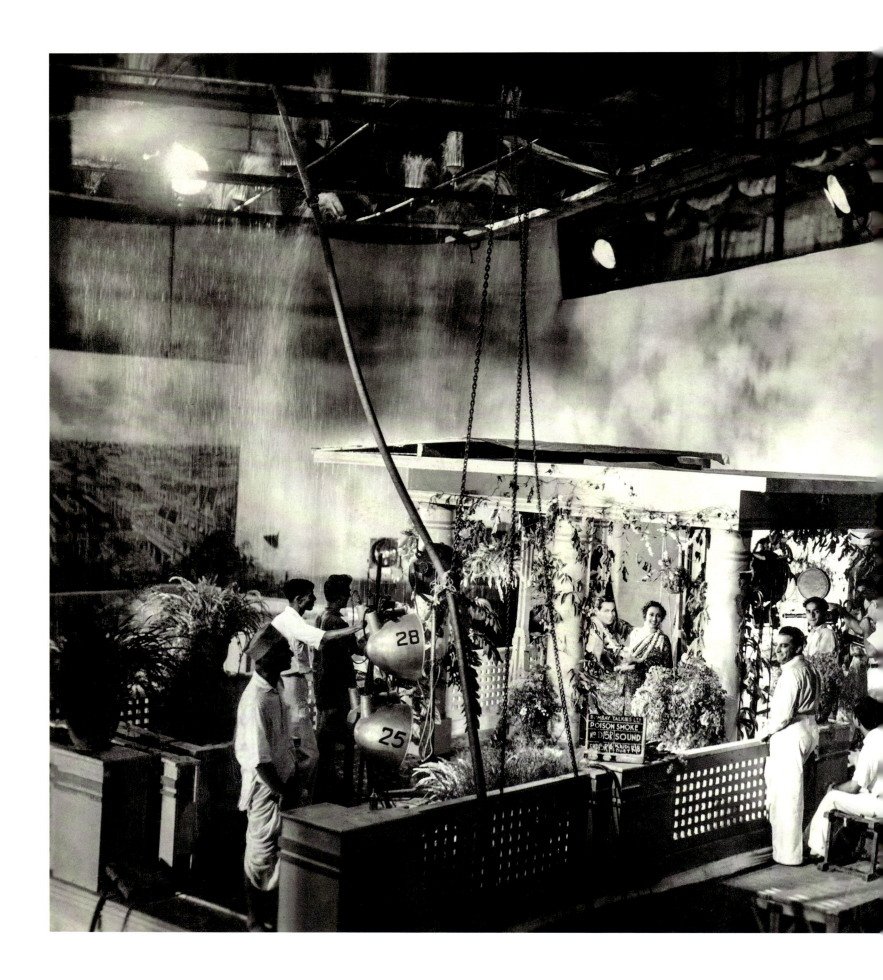

of communal riots, the ambiguous nature of the built urban sets served to open up the meaning of an unspecified violent "disturbance" (*gadbad, maar-kaat*) to render riots as a generic feature of the modern Indian city. Architecture, off-screen sound, and verbal cues combine to make Hanuman Lane a cinematic metonym of urban experience, one that was increasingly marked by violent mass agitations.

Bombay Talkies had three sound stages, or soundproofed studio floors. Figure 6 provides an insider's glimpse of the use of indoor sets to create a filmic milieu of lived life. This densely crowded image gives us a synoptic view of the elaborate assemblage of the mechanical and the manual, the technological and the human that constitutes the world of film production. Occupying the bulk of the frame is a built set of a terrace, with a gazebo structure wherein Kishore and Renu enjoy their final reunion. The film ends with the song "Hum qaidi" (We are prisoners) as the couple garland each other with flowers and reiterate that love is a consensual bond of commitment that arrests lovers in a mutual form of capture.[4] The terrace set is built on a raised platform decorated with potted plants and hanging creepers. Lights illuminate the painted background and the protagonists and a system of water sprinklers overhead produces artificial rain. A thick water hose and sturdy metal chains vertically cut through the image, highlighting the tenuous and temporary nature of this environment held aloft by pulleys and links. This photograph shows the filming of a make-believe world, but as Siegfried Kracauer remarked about his own visit to UFA studios, "there is nothing false about the materials: wood, metal, glass, clay. One could also make real things out of them…" (1995, 286)

One of the reasons why images like this strike us as remarkable is that they starkly confront us with the many spaces of cinema that were never intended to be filmed. Two catwalks cut horizontally across the very top of the photo, designed for nimble human bodies to adjust lights, water faucets and pulleys, lowering and raising, turning on or off the machinery behind the illusion. These are spaces thought of as the *space of production*, not the space of representation. The objects, equipment and humans that inhabit these spaces are similarly outside the purview of a filmic canon of images, a history of the visible. Production stills in the Wirsching collection pull these unintended spaces and bodies into a history of cinema.

The film crew is concentrated on the lower right of the image, huddled behind the camera, which is facing the characters and the painted backdrop on the wall behind them. This painted backdrop, visible on the left edge of the photo, depicts an aerial view of multi-storeyed residential buildings arranged in a grid-like pattern. It features prominently in several scenes in *Bhabhi*, noticeable through windows and on terraces. Based on a photograph taken by Josef Wirsching as a location reference (according to the Wirsching family), the meticulously painted backdrop creates a sense of spatial depth and grounds the film in a recognizable architectural milieu that signifies modern urban India. It is both particular and general, as the urban vista does not carry any specific architectural landmark

Between the Studio and the World 137

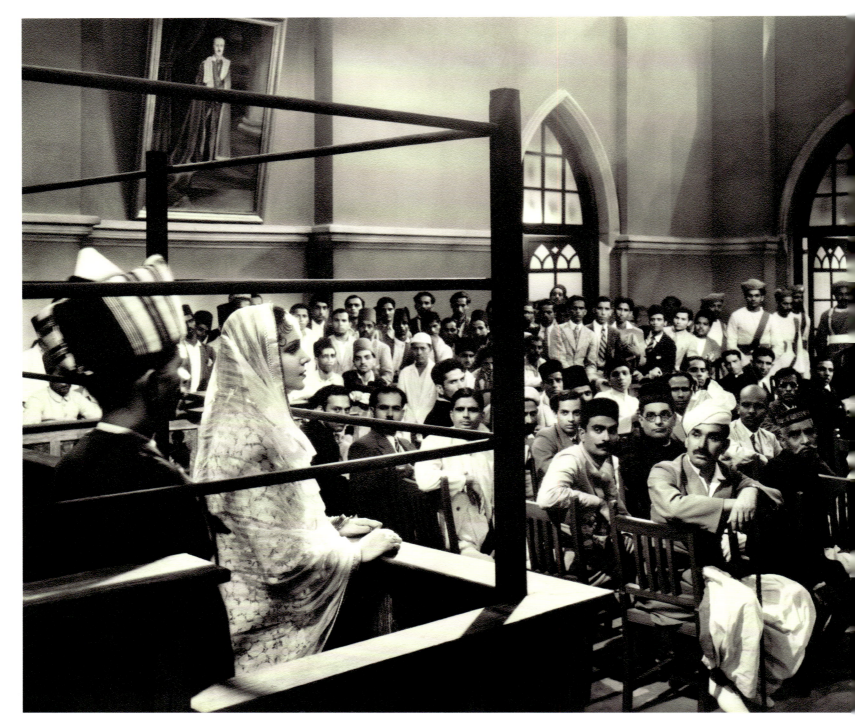

FIG. 7 *Mamta or Mother*
1936, Bombay Talkies, d. Franz Osten
Lobby Card (Gelatin Silver Print),
243 x 294 mm
JWA/ACP: 2020.01.0059

Devika Rani plays Swarup Rani, a dancing girl who is accused of murder.

FACING PAGE
ABOVE
FIG. 8 *Jeevan Prabhat*
1937, Bombay Talkies, d. Franz Osten
Gelatin Silver Print, 84 x 114 mm
JWA/ACP: 2019.01.0123

A classic behind-the-scenes moment as Devika Rani and Kishore Sahu rehearse an outdoor song sequence. The entire set-up for the scene, including camera, microphone, crew and props, such as a gramophone player, can be seen in the frame.

BELOW
FIG. 9 *Jawani ki Hawa*
1935, Bombay Talkies, d. Franz Osten
35 mm Negative
JWA/ACP: 2019.01.0118

Franz Osten and others inside the compartment of the Great Indian Peninsula train during an outdoor shooting sequence. The camera is positioned to shoot a receding landscape and train tracks.

138 Debashree Mukherjee

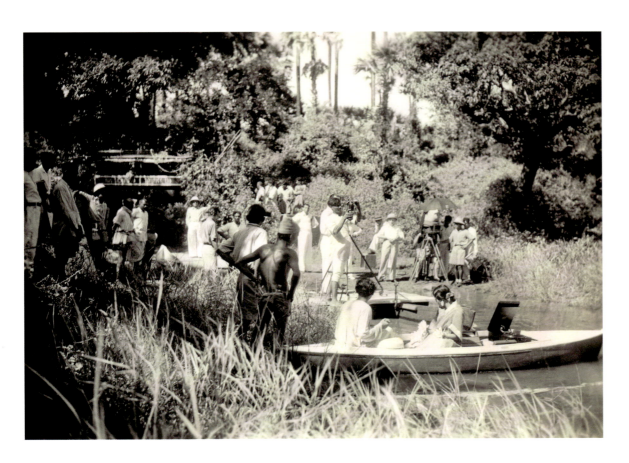

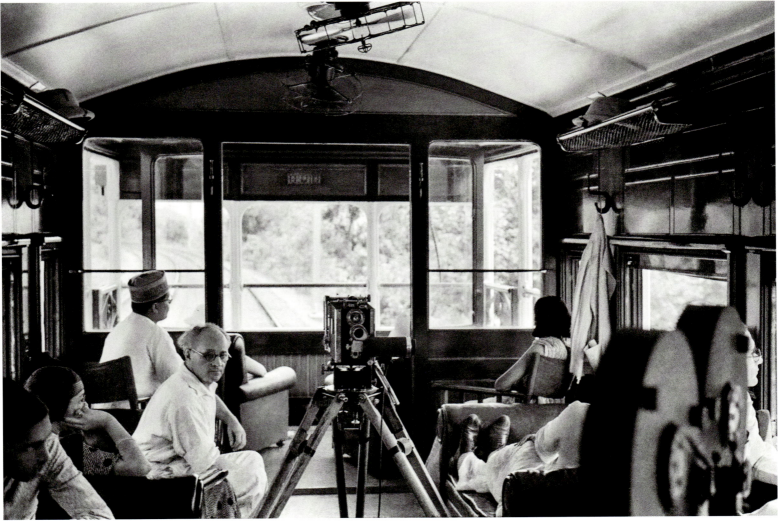

Between the Studio and the World 139

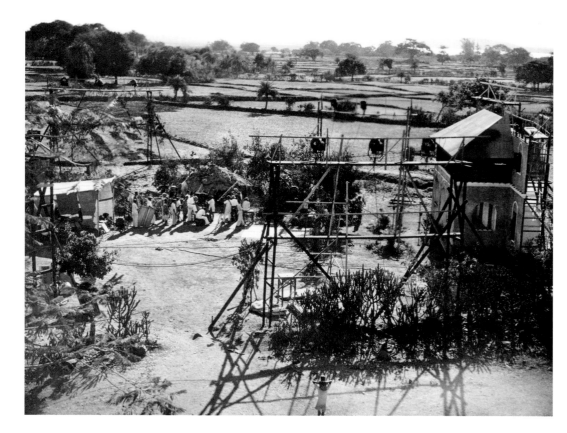

LEFT
FIG. 10 *Jawani ki Hawa*
1935, Bombay Talkies, d. Franz Osten
Lobby Card (Gelatin Silver Print),
246 x 300 mm
Josef Wirsching Archive

An outdoor set of a train station built for the climactic scene of the film. The station is given the fictitious name of "Dadishet Station" as an inside joke referencing BT's studio address—Dadishet Road, Malad.

ABOVE
FIG. 11 *Achhut Kanya* [Attribution]
1936, Bombay Talkies, d. Franz Osten
Gelatin Silver Print, 111 x 83 mm
JWA/ACP: 2019.01.0088

An elaborate lighting set-up for outdoor nighttime filming. Note the two artificial built sets constructed for this outdoor schedule: the first one, a thatched hut, is being filmed for a daytime scene, while the second building, to the right, awaits a later shooting date.

that would code it definitively as a Bombay vista. Bombay Talkies' drive to establish itself as a modern studio for a modernizing India was materialized in its set design, its built exteriors and painted backdrops, which remain purposefully ambivalent so as to encourage identification by a wide swathe of urban viewers.[5]

But there was another less ideological and more immediately pragmatic value to setting films in generic Indian townscapes or villages. The Bombay Talkies studio complex was far from the city centre and its well-known visual features. Most studio employees lived on or around the studio premises. Built on a sprawling eighteen-acre property in rural Malad, Bombay Talkies had to draw upon its immediate physical environment to construct its spatial vision of India.

In the early 1930s, when Himansu Rai, Devika Rani and Sir Richard Temple were strategically thinking about the logistics of their proposed new studio in Bombay, they initially settled on Chembur as their preferred site as it was close to the hub of film production, Dadar, known in those days as "India's Hollywood" (Wagg 1946, F2). Bombay Talkies was finally built on the property of F. E. Dinshaw, a member of Bombay Talkies' board of directors, who offered the use of his summer bungalow and large estate in Malad. Malad was, at this time, connected to the main city by train and the Malad train station was barely a kilometre away from Dinshaw's mansion. Prasad Shetty notes that the studio complex was part of the land comprising Chincholi village and in the "lands beyond were paddy fields, betel nut groves, and orchards of vegetables and fruits" (online, 2012). This mix of rural and agricultural milieu offered a new topographical imagination to the filmmakers and gradually made its way into almost every film produced by Bombay Talkies in the 1930s and early 1940s. If legendary film studios like UFA and MGM drew on their extensive backlots stuffed with new and old sets of all kinds, then Bombay Talkies drew on what was abundantly available in its *backyard*—a quiet rural countryside. Though far from the iconic sites of colonial, downtown Bombay city, this landscape was also Bombay.

Savitri (1937): Framing Nature as a Cinematic Medium

In 2010, I came across an intriguing artefact while looking through some of Bombay Talkies' extant studio papers: a colour plate torn out of a Bengali magazine. It lay inside a box of documents pertaining to the shooting of the film *Savitri* (1937). Saved amidst fragments of shooting scripts, dialogue scripts and assorted pre-production paperwork, this artefact struck me as unusual. I was in Melbourne, Australia, studying Devika Rani's personal collection of studio papers, which are now preserved and maintained by Peter Dietze, Himansu Rai's grandson. Unlike the Wirsching collection, the Dietze archive is mainly textual—dominated by letters and correspondence, pre-production paperwork and fragments of screenplays. This torn piece of paper arrested my attention, introducing a different kind of visual stimulus in the middle of a jumble of words and documents. Filed amidst papers pertaining to *Savitri*, the image was most likely meant to be a "visual reference," a placeholder to express a director or producer's vision for the final look of a

FACING PAGE
ABOVE
FIG. 12 *Bonobhojon* (Picnic)
Shrishanti Guha
Prabasi magazine, July–August 1937
Courtesy: Debashree Mukherjee

BELOW
FIG. 13 *Savitri*
Ravi Varma Fine Art Lithographic Press
Oleograph, c. 1898,
500 × 350 mm
Courtesy: Collection of Hemamalini and Ganesh Shivaswamy, Bengaluru/The Ganesh Shivaswamy Foundation

scene, setting, or character.⁶ I was intrigued by the foliage, the length of the tree trunks and the shape of the women's faces and necks. What made this image such an important visual reference for the film *Savitri*, and what were the spatial itineraries encoded within it?

Savitri is Bombay Talkies' only mythological film. It is based on a story from the Hindu epic *Mahabharata* that narrates the devout love of the princess Savitri for her husband, Satyavan, a man destined to die within a year of wedlock. The story is remarkable for its staging of female vocality in an epic tale wherein a woman's insistent speech is rewarded, indeed legitimized, though framed within patriarchal ideas of wifely devotion. In the climactic sequence of the tale, Savitri embarks on a verbal test of wills with Yama, the God of Death, who is so impressed with her wisdom, wit and persistence that he returns Satyavan to life. As a tale of female exceptionalism, the Savitri story was told and retold in early Indian cinema since the silent era, with the heroine Savitri embodying an idealized Indian femininity. It made sense for the tale to be revived in the talkie era, given the centrality of dialogue in the high-stakes scenes between Yama and Savitri.

A large portion of the story takes place outdoors as Savitri and her ladies-in-waiting roam the countryside, in search of a suitable partner for her, and then later, after marriage, when Savitri and Satyavan retire into a forest. Popular representations of the story therefore highlight landscape itself as a critical environmental protagonist. Two extant silent film adaptations of the story, *Sukanya Savitri* (Kohinoor Film Co., 1922) and *Sati Savitri* (Maharashtra Film Co., 1927), stage the critical scene of Yama's arrival in a manner reminiscent of Raja Ravi Varma's iconic interpretation of the moment. The filmmakers borrow the gestural language of Varma's characters as well as their costumes and choreography. Moreover, located as both film companies were in Maharashtra, the landscape they use is firmly rooted in the region's environmental specificity, similar to Varma's own invocation of the hilly topography and lush vegetation of monsoon-fed forests in the Deccan. This landscape is ever-present in Bombay Talkies' outdoor shots, and, as noted earlier, Bombay Talkies shot outdoor locations extensively rather than stay confined to the controlled environment of the studio. What use, then, was a visual reference of a stylized painting in a Bengali magazine? If the location itself was not a necessary point of reference, what work was the image meant to do?

The torn colour plate was from the 1937 monsoon issue of the popular illustrated Bengali-language periodical *Prabasi*. Published by Ramananda Chattopadhyay, this monthly magazine was widely patronized by Bengali-speaking urban middle-class readers dispersed across India. Its specific address was to the *prabasi*, or "one who lived in foreign lands (outside of Bengal)." This address had

Between the Studio and the World 143

FIG. 14 Devika Rani/*Achhut Kanya*
1936, Bombay Talkies, d. Franz Osten
Lobby Card (Gelatin Silver Print),
244 x 302 mm
Josef Wirsching Archive

FACING PAGE
FIG. 15 *Achhut Kanya*
1936, Bombay Talkies, d. Franz Osten
Lobby Card (Gelatin Silver Print),
246 x 294 mm
Josef Wirsching Archive

Ashok Kumar, Devika Rani, P. F. Pithawala and Kusum Kumari pose for a publicity still. This set, a grocery store run by Ashok Kumar's father in the film, is the target of mob violence and arson in a climactic scene.

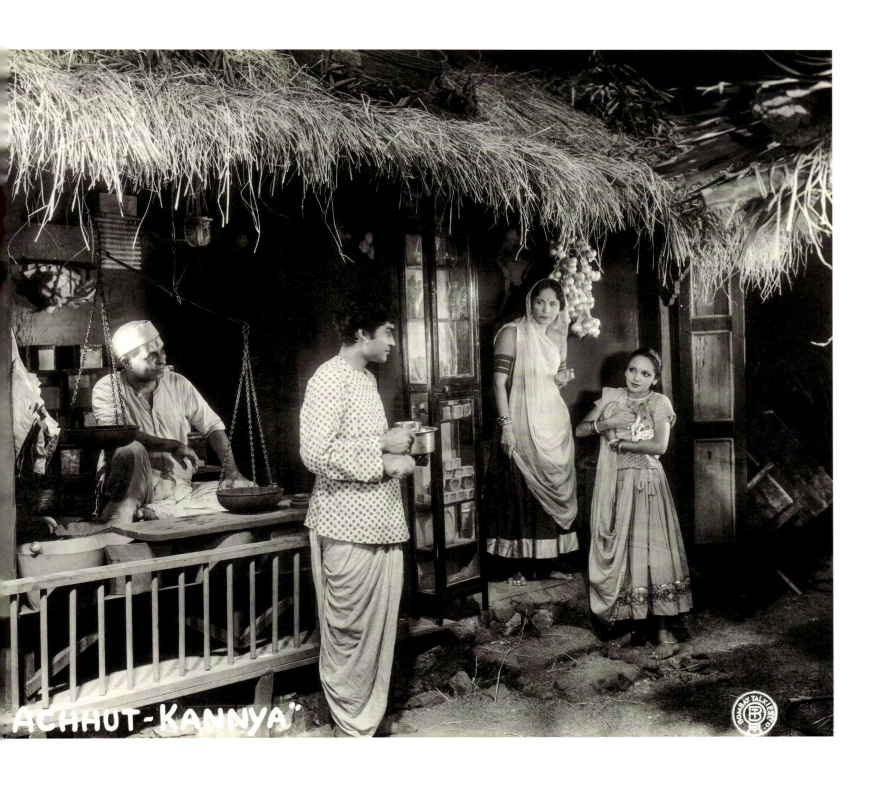

become necessary in the early twentieth century as "Bengali professionals… started moving to other parts of the subcontinent" along the colonial administration's "vast civil, medical, educational and military networks" and further, across the seas for higher education (Mitra 2013, 219). Since its inception in 1901, *Prabasi* consciously took on a pedagogical role to cultivate "the aesthetic taste of its readers" (225). To that end, the magazine published both established and emerging visual artists and actively promoted the new Bengal school of art inaugurated by Abanindranath Tagore and others. The colour plate illustration played a major role in this aesthetic project. Tagore's *Bharat Mata* was first printed in the pages of *Prabasi* in 1926. Apart from the new "Indian style" of painting, the magazine also published reproductions of Ajanta Cave frescoes and Mughal, Pahari and Rajput miniatures. Samarpita Mitra argues that *Prabasi* tried to "shape a modern literary community as a new form of solidarity wherein the imagined nation could be actualized" (205). One can go further and argue that in its selective curation of, on the one hand, contemporaneous artists who were deeply engaged in crafting an indigenous style for modern Indian art, and on the other, of archaeological digs, ancient cave sculptures and medieval miniatures, *Prabasi* produced a visual repertoire for imagining the nation as aesthetic space.

It is not surprising, then, that Devika Rani should come to own a copy of *Prabasi* magazine and even use it as a visual reference for her film. As a properly *prabasi* Bengali herself, who had journeyed long and far from the Bengali homeland, and who represented the elite, educated Bengali aesthete, Devika Rani was the magazine's ideal reader. At the same time, there was a shared texture to the aesthetic project of *Prabasi* and the cinematic agenda of Bombay Talkies. The story of *Savitri* allowed Bombay Talkies to cinematically represent a diverse and mythic topography of an ancient "land of wells and gardens, far in pleasant woods and jungles, unto *ashram*s, hermitages, *tirtha*s and temples" as Savitri set out on her quest to find a suitable husband (*Savitri* song booklet, 1937). This mythic landscape of the past (notably a Hindu past) was eminently suited to the studio's experiments in manufacturing the nation as a visual space, simultaneously identifiable and non-specific.

Here I want to bring in another cultural imagination, this time from Germany—of the *Heimat*. The word *Heimat*, loosely translated as "home," has been theorized as a fundamentally spatial concept, a concept that mediates between place and space, the local and the national, to suggest an idea of a homeland and, with it, difference from the foreigner (Moltke 2005). Franz Osten's brother Peter [Ostermayr] was known for his early "place films," featuring local landscapes, which prefigure the *Heimatfilm* of the 1930s and beyond. The conception of *Heimat* itself, which predated the cinema, can be seen as a cultural project that allowed the young German nation to develop a topographical imagination for the homeland, an aesthetic space defined by the particularities of landscape. As Johannes Von Moltke points out, "*Heimat* facilitated a double view of the local as possessing both a concrete experiential dimension and a more abstract metaphorical function," (9) underlining a "belief in the singularity of local identity and in the capacity of the *Heimat* idea to represent the singularity and to reconcile it with

FIG. 16 *Yama-o-Savitri*
Nandalal Bose
Kokka Japanese Woodblock Print,
late 1900s, 341 x 205 mm
Courtesy: Osianama Research Centre,
Archive, Library & Sanctuary, India

a notion of Germanness" (Confino 1997, as cited in Moltke 2005, 9). In some ways, this iconographic imagination has affinities with the Bengali nationalist visual imagination of the early twentieth century, where landscape and the particularities of place start to lend themselves to the production of a pan-Indian national space. Where *Heimat* uses topography to create a sense of spatial authenticity from the specificity of certain locales like Alpine peaks, the visualization of India in *Prabasi* draws on natural landscapes as well as man-made cultural sites where an Indian civilizational past can be said to inhere— such as archaeological digs, temples and cave paintings—as well as the active production of landscape as identity.

At the same time, there is a fundamental ambiguity to the artistic project of defining India as a place: first, due to the sheer heterogeneity of subcontinental geography, and second, due to the diversity of cultural influences that layer the artistic production of landscape in the 1930s. The style of representation in *Bonobhojon* closely resembles the style of Nandalal Bose, a pupil of Abanindranath Tagore and principal of Kala Bhavan, the art school at Santiniketan. Bose was deeply influenced by the Ajanta frescoes, and the facial contours, depiction of flora, and colour scheme in this painting are definitely reminiscent of that mode. But here is the curious thing. Nandalal Bose also painted his own version of the Savitri story, this time drawing on the techniques of Japanese painters such as Okakura Kakuzo, and the water-dripping techniques of Yokoyama Taikan and Arai Kanpo (Inaga 2009).[7] This image was not the one chosen by Devika Rani, likely because it offers little by way of locational grounding. The Japanese water-dripping technique was known as the *mōrōtai* (vague style) technique, and yielded ethereal, floating backgrounds. Imagistic focus was confined to the beauty and emotions of the human figures, while their environments blurred away. On the other hand, Shrishanti Guha's composition firmly *emplaces* its human characters. If, as I have suggested, Bombay Talkies was interested in the co-construction of identity and place, the real and the representational, then we can understand *Bonobhojon* as a reference for the hybridity of idealized places. This is a stylized landscape, drawing more on ancient iconography than on geographical authenticity. Further, it is the mutuality of the women and their milieu, the aesthetic integration of person and place that serves as the point of reference, rather than the particularities of shape and form. As with *Bhabhi*'s use of built sets of the generic city, *Savitri* uses nature as a cinematic medium to carry and choreograph bodies and emotions.

In figure 17, we see Savitri and her ladies-in-waiting carefully positioned within a lush environment dynamized by a roaring waterfall in the background. Dressed in the imagined clothes of a mythic past, the actors are cradled by a vision of nature as eternal. The temporality invoked here is of a geological time, recorded in the formation of rocks and mountains, the seasonal rhythm of waterfalls. Yet, as cinema is wont to do, this scene also signals a certain contemporaneity. The actors are known to the viewers and the film

FIG. 17 *Savitri*
1937, Bombay Talkies, d. Franz Osten
35 mm Negative
JWA/ACP: 2019.01.0081

Devika Rani and others rehearse against the backdrop of a waterfall.

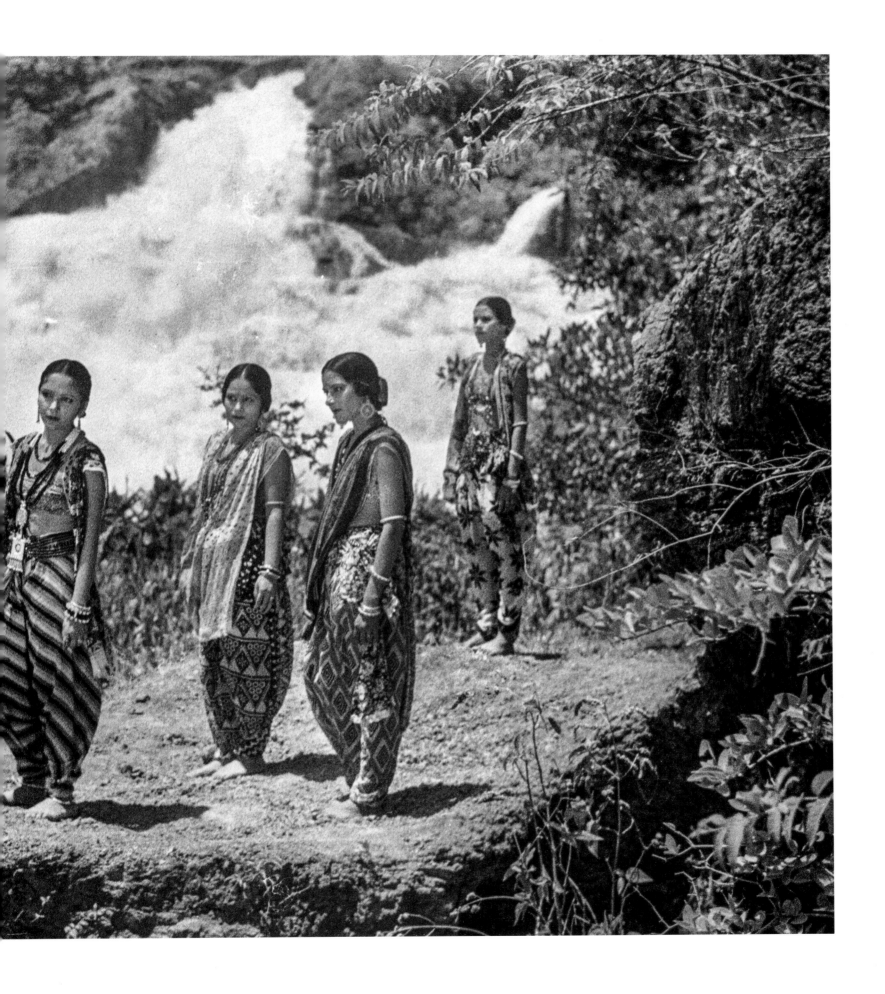

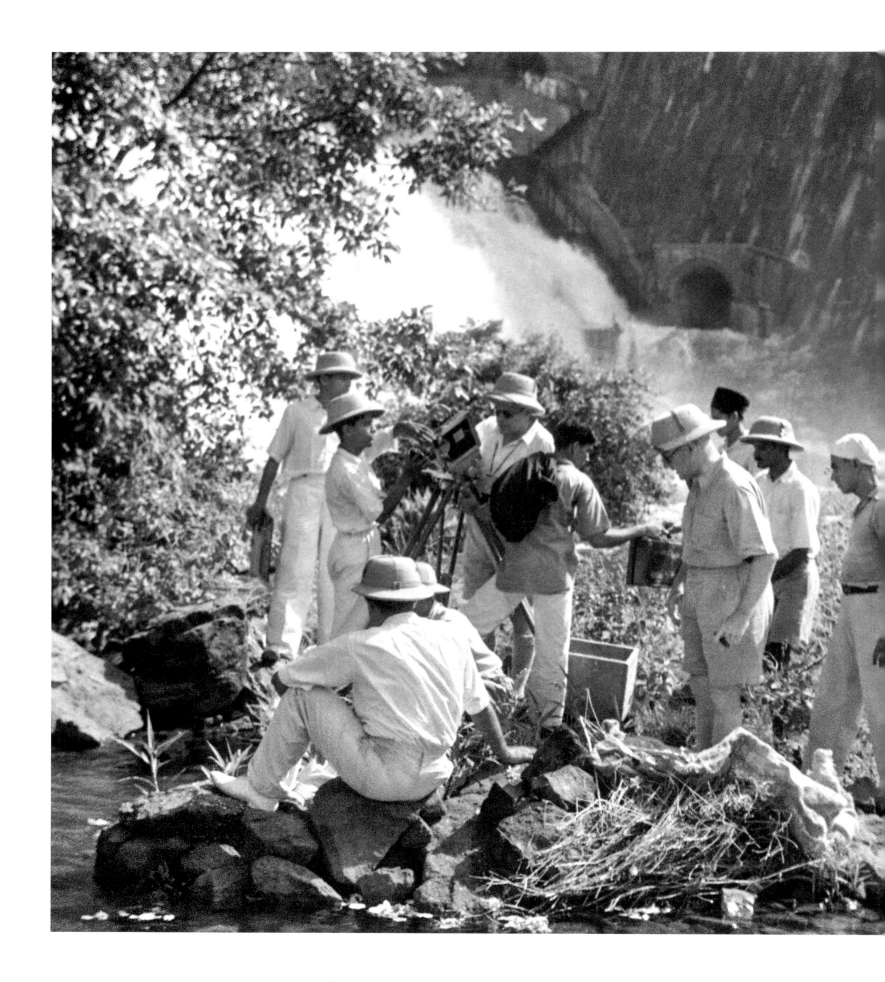

FIG. 18 *Savitri*
1937, Bombay Talkies, d. Franz Osten
35 mm Negative
Josef Wirsching Archive

Between the Studio and the World 151

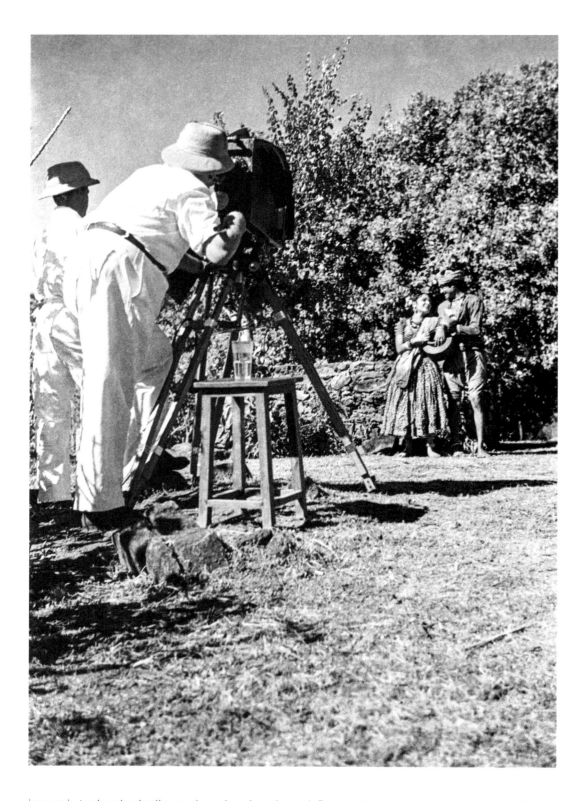

FIG. 19 *Izzat*
1937, Bombay Talkies, d. Franz Osten
35 mm Negative
JWA/ACP: 2019.01.0073

Josef Wirsching seen behind the camera as Devika Rani and Ashok Kumar rehearse an outdoor scene. Also visible in the far left of the frame is Franz Osten.

image is technologically produced and projected. Beyond this basic understanding of the layered nature of reality and temporality in cinema, the Wirsching collection offers another startling insight. We learn that several outdoor scenes for *Savitri* were shot at a dam, and that the volatile waters in the background were generated by man not God. Indeed, even an outdoor "natural" place can be as artificially engineered as an indoor set.[8] Once again, Wirsching's photos of sets and locations dismantle reassuring partitions of the natural and

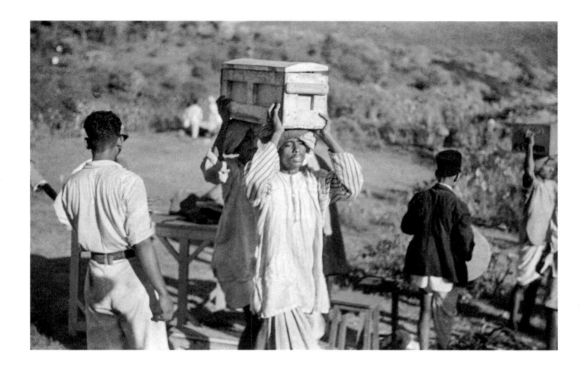

FIG. 20 *Izzat*
1937, Bombay Talkies, d. Franz Osten
35 mm Negative
JWA/ACP: 2019.01.0075

Porters carrying equipment boxes after a day of outdoor shooting. All the film equipment, from cameras and tripods to lenses and raw stock, was expensive and imported.

the artificial. In showing us the material relations between filmmaking and its geographical ground, these images show us how climate and topography, engineering and human intentionality enter and inform the space of nature in aesthetic production.

Consider another image from the *Savitri* shoot, this time of an indoor set (see figure 25).

A wooded forest has been fabricated inside the studio, complete with trees and fallen leaves. But, as Sudhir Mahadevan asks in his essay in this volume, who is to say that the trees are artificial? They were likely brought in from the outdoors to recreate nature on the studio floor. Pushing further on the question of the artificial, we may rephrase the question to ask not if the trees are real but if our separation of the inside and outside itself needs to be questioned. The Bombay Talkies studio in Malad was surrounded by agricultural land cultivated by humans and determined by regimes of commerce, technology and property. This *outside* was also complicit in a project of human world-making, if to a different degree from the work of cinema that took place inside the studio.

Let us look next at the painted backdrop on the right-hand wall of the studio, which depicts a tranquil landscape with water, land, vegetation and sky. Based on a separate location reference photo, this simulated vista carries something of the actual place and time of photographic capture. The flat plains and rocky valleys of the Deccan, with vegetation that comes to life and bursts into colour during the monsoon, offered Bombay Talkies the material reality from which to forge an aesthetic vision, and its particularity is inescapable. Just as architecture can be mobilized to be generic rather than specific, landscape can force itself into a historical moment with its particularity. Between the studio and the world, there is a kind of movement that confounds our need to partition reality.

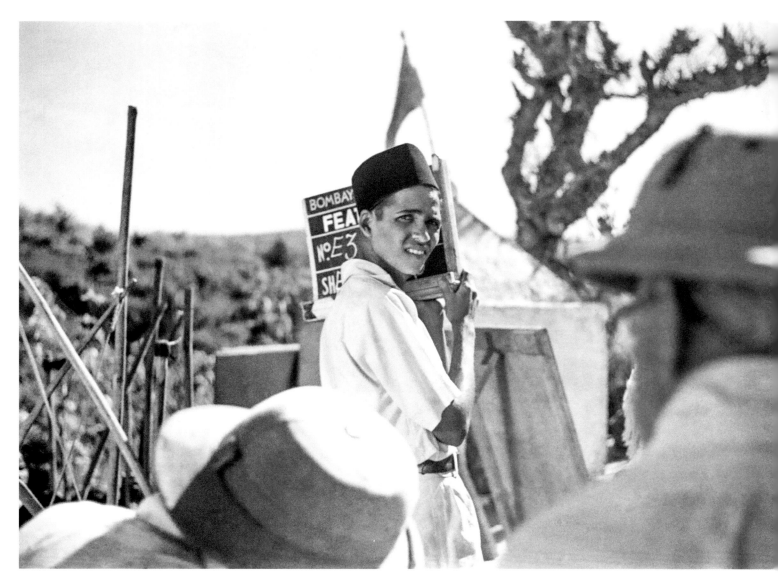

FIG. 21 *Izzat*
1937, Bombay Talkies, d. Franz Osten
35 mm Negative
JWA/ACP: 2019.01.0074

FACING PAGE
ABOVE
FIG. 22 *Jeevan Prabhat*
1937, Bombay Talkies, d. Franz Osten
35 mm Negative
JWA/ACP: 2019.01.0086

Bombay Talkies had its own outdoor vans to transport cast, crew and equipment for location shoots.

BELOW
FIG. 23 *Izzat*
1937, Bombay Talkies, d. Franz Osten
35 mm Negative
JWA/ACP: 2020.01.0014

Sashadhar Mukherjee and Savak Vacha record sound on location.

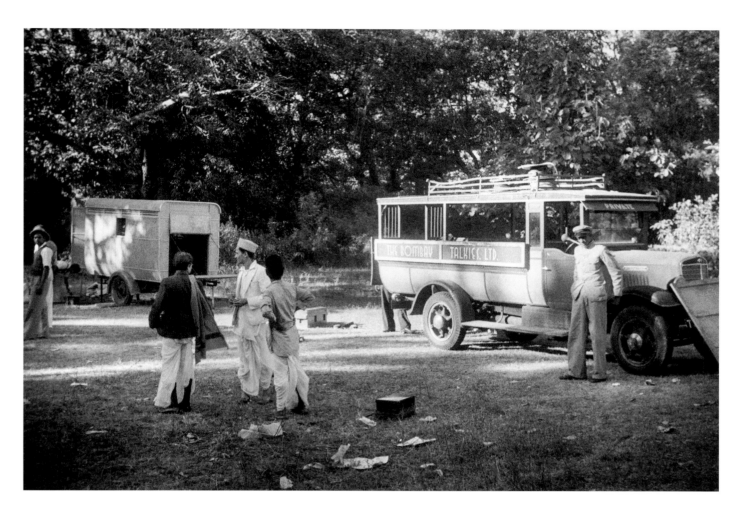

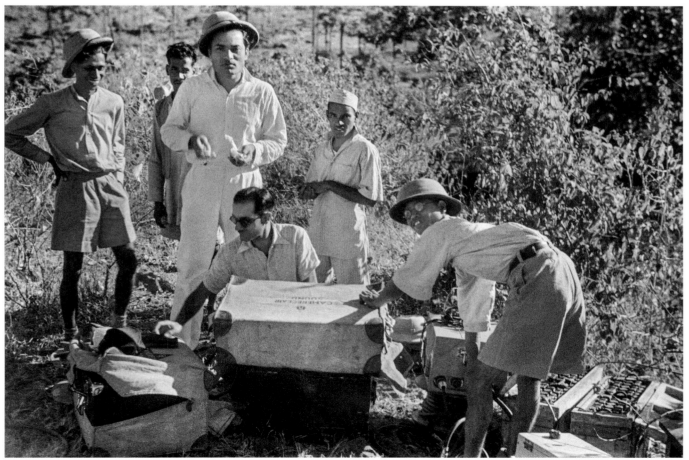

ABOVE
FIG. 24 *Savitri*
1937, Bombay Talkies, d. Franz Osten
35 mm Negative
Josef Wirsching Archive

BELOW
FIG. 25 *Savitri*
1937, Bombay Talkies, d. Franz Osten
Gelatin Silver Print, 86 x 116 mm
JWA/ACP: 2019.01.0099

Savitri and Satyavan, played by Devika Rani and Ashok Kumar, converse in a forest recreated inside the studio.

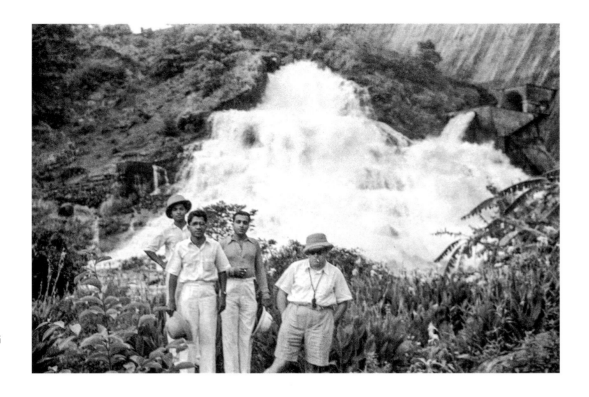

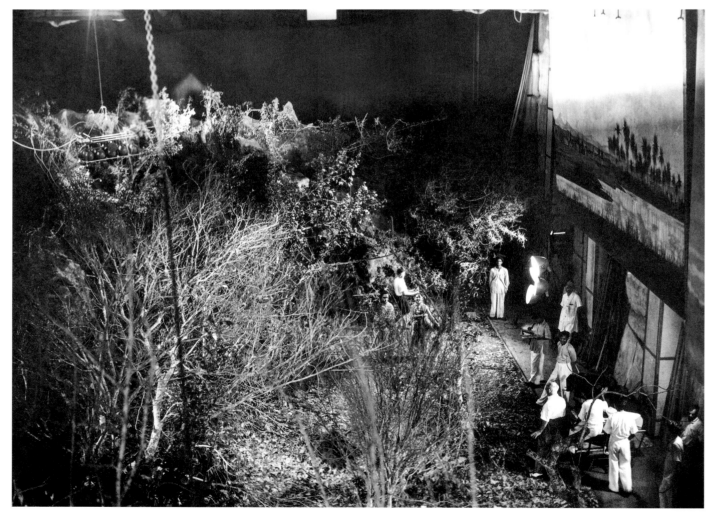

156 Debashree Mukherjee

The scene of production, made intimately available to us in Josef Wirsching's photographs, is a site of world-making. To ask if those worlds are genuine or false is to miss the point. Cinema orders and arranges the relations between people, materials, objects and landscapes, crafting realities that seep through the permeable borders of the studio and the world. Both Bombay as topography, and cinema as a popular mass cultural form, tempered the Bengali nationalist, the German-nostalgic, and the elite *bhadralok* search for an authentic national space. Layer upon layer of influences mark the making of *Savitri*, but in its topographical imagination of a mythic national space, the particular spills over.

Bombay Talkies' experiments with filmic space pull towards the non-specific, towards constructions of a generic urban and a timeless natural geography, all of which takes effort. Wirsching's location photographs and production stills perform a zoom-out function for the contemporary viewer, locating the image within a complex milieu of working bodies and cultural imaginations. They jolt us into a recognition of the temporal and topographical specificity of place and practice. Once you see these images it is impossible to unsee the artifice of a painted backdrop or a man-made dam. At the same time, as I have argued in this essay, such images urge us to consider that between the inside and the outside, the real world and the film set, the local and the national, the past and the present, there is a complex traffic of energies and histories that often defies boundaries. Between the studio and the world, there is a permeability of presence.

Portions of the section on *Savitri* have appeared in *Representations* 157, 2022, in the article "The Material and Aesthetic Force of Landscape in Cinema."

Notes

1. From 1935 to 1937 Bombay Talkies employed the German Karl von Spreti as its in-house set designer or "Film Architect." From 1938 onwards we see credit for "Settings" attributed to Y. E. Hate and N. R. Acharya. It is hoped that with the recent discovery of a hundred letters that Karl von Spreti wrote while in India, we will learn a little more about the early set designers and design conventions of Bombay Talkies.

2. The Indian Cement Company started producing cement in 1914 in Porbandar, Gujarat. A vast amount of cement was also imported (1,50,530 tonnes in 1914). The overall use of cement in India quadrupled in scale by 1929.

3. Archival records indicate that he was on the payrolls with the understanding that he would direct a film tentatively titled *Vasantsena* (likely based on Sudraka's ancient Sanskrit play *Mrichhakatika*) in collaboration with Franz Osten. Letter from Ludwig Klitzsch to Ernst Hugo Correll, December 16, 1929, Bundesarchiv.

4. Also see Priya Jaikumar's essay in this volume for a more detailed discussion of erotic capture.

5. For more information on the audiences of Bombay Talkies films, see Introduction.

6. The use of visual references is a mainstream production convention today, used in India and elsewhere. In Hollywood, for example, a collection of visual references is called a "lookbook."

7. Shigemi Inaga, "The interaction of Bengali and Japanese Artistic Milieus in the First Half of the 20th c (1901–1945)," *Japan Review*, 2009: 149-181.

8. Several dams were built in the Bombay region to supply water to the city, such as Tansa dam, completed in 1891.

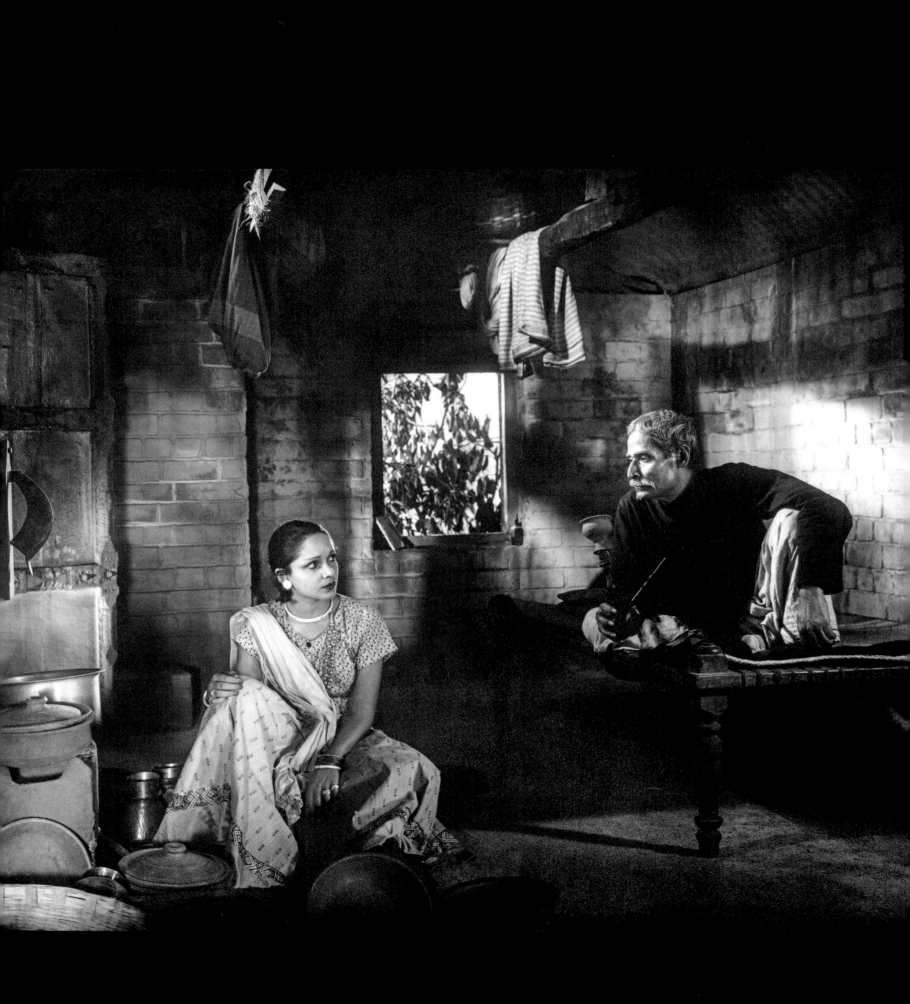

Re-Visioning Bombay Talkies: Restoring Parallaxes to an Image
A Conversation with Virchand Dharamsey

■ Kaushik Bhaumik ■

Kaushik Bhaumik talks with Virchand Dharamsey, a renowned historian of Indian cinema, about Bombay Talkies and its fortunes. This conversation has been edited for length and clarity.

Prologue

Kaushik Bhaumik: *Josef Wirsching is always talked about in terms of his connection with Bombay Talkies (henceforth BT) and then, over time, with* Pakeezah *(Kamal Amrohi, 1972). But I would say that there is another strand of history in which we can place Josef Wirsching, which is a very long history of people coming from outside India, especially from Europe, who have had a very direct connection with Indian filmmaking, production, acting and things like that. So, maybe the first thing will just be to place Wirsching in that context of Europeans and Americans who worked in South Asia in the silent period.*

Virchand Dharamsey: The first Indian filmmaker who came [here] from America was Suchet Singh.[1] He came to India and decided to just see what was going on and get some funding to form a company. He arrived with a cameraperson, Baron von Rayvon, and the latter's wife, Dorothy Kingdon.[2] She was quite a well-known actor at that point of time. So, these were the first people with an American background to enter Indian cinema. We can also gain an insight into this period through Madan Theatres's film *Bilwamangal* (Rustomji Dotiwala, 1919), which is now available.[3] We do not actually know who was involved in the making of this film, maybe [the Italian director] Eugenio de Liguoro[4] or someone else, but that's the film that is available and was surely shot by Europeans.

FIG. 1 *Achhut Kanya*
1936, Bombay Talkies,
d. Franz Osten
Lobby Card (Gelatin Silver Print), 241 x 305 mm
JWA/ACP: 2020.01.0043

This publicity still showcases Wirsching's artistry with lighting design. In the shot are Devika Rani (left) and Kamta Prasad (right).

KB: *It could have been Eugenio de Liguoro.*

VD: [The French director] Camille Le Grand was active between 1921 and 1922, as a cameraperson and director.[5] Charles Creed, too, started with the Madans as a cameraperson (with J. J. Madan's *Nurjehan* in 1923). He mastered sound technology with the advent of the talkies, going on to become chief technician with Shree Bharat Lakshmi Pictures in the talkie period.[6] So, we have the Europeans and Americans in the beginning.

KB: *Let's speak of [the Italian cameraperson] T. Marconi.*

VD: [The Italian writer] Count Angelo de Gubernatis had written a play called *Savitri*, which was subsequently performed in Bombay in 1883 by a Parsi theatre company.[7] A film based on it, *Savitri* (Giorgio Mannini, 1923), was made in 1922–23.[8] According to local publicity, it was a co-production between the Madans[9] and an Italian company, but the Italians have never said anything about the Madans. It's doubtful whether the Madans were really involved in the production of the film. Anyway, Marconi was around to observe the filming of *Savitri* in Rome and he became really interested in India. He came to India subsequently but we have no records of which films he was involved with—the first film for which we have a record of his name is *Kapal Kundala*, in as late as 1929—because the Madans never gave out any publicity, hardly any publicity.[10]

There is an interesting similarity between Wirsching and Marconi. Marconi also stayed in India through the Second World War and, because Italy was at war with Britain, he was in a POW camp, like Wirsching. After the war, Marconi continued to work for a

FIG. 2 Aga Khan III and Bombay Talkies Shareholders
1936
35 mm Negative
JWA/ACP: 2019.01.0051

Sir Sultan Mohammed Shah, the third Aga Khan, with Bombay Talkies shareholders at the premiere of the double bill *Mother* and *Always Tell Your Wife*. Prominently featured in a black suit is Rai Bahadur Chuni Lall, chief representative of Bombay Talkies' managing agents and father of the famous music composer Madan Mohan.

FACING PAGE
FIG. 3 *Nirmala*
1938, Bombay Talkies, d. Franz Osten
35 mm Negative
JWA/ACP: 2019.01.0016

Himansu Rai and others on the balcony of the Bombay Talkies studio office in Malad, overlooking a nighttime outdoor shoot.

long, long period in India. So it is interesting that both Wirsching and Marconi were from Axis countries during World War II and then lived for a long period in India.

I. The Founding of Bombay Talkies and Careers of Certain Key Personnel

KB: *And so it was with* Karma *(John Hunt, 1933) that Himansu Rai came to Bombay and Rai Bahadur Chuni Lall was the person really managing the show.*

VD: There are two very important persons in the early history of Bombay Talkies. One is Chuni Lall and the second is Richard Temple. I think these two people played a very important role. And then there was Framroze E. Dinshaw, who gave them some land he owned to set up a studio. Before that, in 1934–35, was the period when Maneklal Patel of Krishna Film Company had a very big studio in Andheri.[11] Himansu Rai wanted to buy it but Maneklal said no, i.e. he was not interested in selling the studio. And that's why they started looking for another place. Finally, they found Dinshaw's property, including its bungalow. I think the bungalow that we see [in the photographs], the Bombay Talkies office quarters, used to be Dinshaw's.

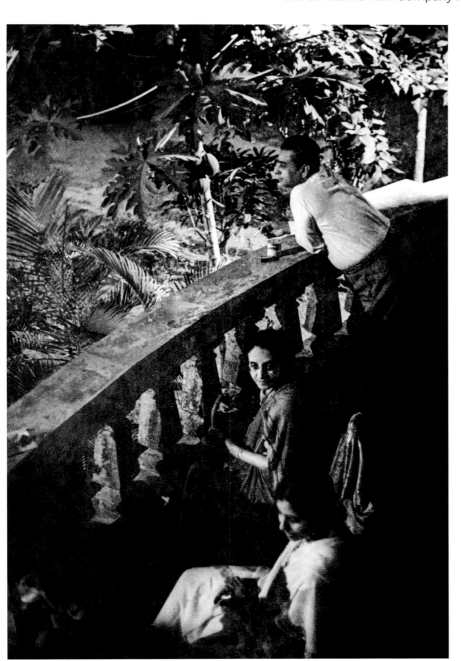

KB: *So that is then how Bombay Talkies came in.*

VD: And then they had to place a big advertisement in newspapers inviting applications for the post of the actor. They had a heroine [Devika Rani] but what about the hero? So a big ad was placed. And there were quite a large number of entries, I don't remember exactly how many. Najmul Hussain was selected from this pool. That was the first film he applied for and he was selected.

KB: *So now what we can do is have a look at the photographs and talk about some key personalities.*

VD: And another thing before that: among the photographs that are available here, you can see they feature a lot of Devika Rani. So one can understand the importance of Devika Rani for BT and Wirsching. But to begin with, there are two people I can talk about, Sashadhar Mukherjee and Savak Vacha. Now, both Sashadhar and Vacha joined as assistants to soundman Len Hartley. Vacha, I think, had a background in technology, too. So these are the first people

who trained at BT, who later became very important figures. Savak Vacha is not well known. So let us talk about him a little more.

Savak Vacha eventually quit BT to work in Filmistan with Ashok Kumar. But he came back with Ashok Kumar to BT when it was going through a big crisis. During this time, Vacha played a key role in production. Ashok Kumar definitely was a legendary figure but Vacha also played a very significant role in the survival of BT. He was a very important person, who started his career at Wadia [studio] but was later rooted in BT. He tried to save the company when it was going through huge losses.

KB: *So what did Savak Vacha do after BT?*
VD: He directed Filmistan's *Shikari* (1946) with Ashok Kumar. Following BT, Vacha also produced *Yahudi* (1958), which was made by Bimal Roy under the Bombay Films banner, the banner's name being an homage to Bombay Talkies.

KB: *So now we come to Sashadhar Mukherjee.*
VD: Basically, from the position of sound recordist he was promoted to look after production and general affairs at BT. He was a very key figure. And Himansu Rai must

have groomed him to be a very important figure in BT, to select and make films in the role of a producer. At BT Sashadhar Mukherjee became a more successful figure than anyone else.

KB: And of what did his success consist?

VD: You see, when *Kangan* (Franz Osten et al., 1939) was left unfinished due to the German team being in the POW camps during World War II, Mukherjee took over the production. He took important decisions, such as the selection of persons who would direct and complete the film. So there was a group decision while Himansu Rai was still alive. They elected N. R. Acharya and Najam Naqvi to complete *Kangan*. Najam Naqvi was, in this period, a continuity person and a dialogue writer as well. And together the group finished the film. *Kangan* turned out to be a highly successful film. Its songs became very popular. A new songwriter had been introduced—Kavi Pradeep.[12] From *Bandhan* (N. R. Acharya, 1940) onwards, the films—*Naya Sansar* (N. R. Acharya, 1941), *Jhoola* (Gyan Mukherjee, 1941) and *Kismet* (Gyan Mukherjee, 1943)—were basically produced by Sashadhar Mukherjee's team.

It is said that Ashok Kumar's films ran in Roxy [Cinema] continuously for seven years. Filmistan's, too, ran for long periods at the Roxy.

KB: *And Sashadhar Mukherjee had something to do with it.*

VD: Yeah, naturally, he had something to do with it. But above all, he was the man behind the changes taking place at BT from this period onwards. Ashok Kumar had definitely changed as an actor with *Naya Sansar*. Sashadhar Mukherjee played a role in grooming Ashok Kumar into his new persona. So Mukherjee and Kumar became the two important figures at BT from this point on.

KB: *So now a little bit about Pareenja.*

VD: R. D. Pareenja was Wirsching's first assistant cameraperson. He started with Wirsching with the very first BT film, *Jawani ki Hawa* (Franz Osten, 1935) and continued throughout Wirsching's tenure. But even before BT, I think he had already worked as a cameraperson in some independent films. Then he became an assistant director as well. Pareenja turned main cinematographer with *Bandhan*. *Naya Sansar*, *Jhoola* and *Kismet* were all shot by Pareenja. So, some say that from *Bandhan* onwards Pareenja became a full-fledged cinematographer for BT.

KB: *And R. D. Mathur joined straight as a cameraperson?*

VD: No, R. D. Mathur joined as second assistant cameraperson in *Vachan* (Franz Osten, 1938). He became a solo cinematographer later—for *Anjaan* (1941) and *Basant* (1942). And then *Char Aankhen* (Sushil Majumdar, 1946). Later on, he became an independent cameraperson. He was the one who shot *Mughal-e-Azam* (1960). So these are the two important cinematographers of Bombay cinema who came through Wirsching's team.

FACING PAGE
LEFT
FIG. 4 Richard Temple
Gelatin Silver Print, 336 x 238 mm
Josef Wirsching Archive

Signed portrait of Lt. Col. Sir Richard Temple used as a holiday print for friends and family. Temple was instrumental in helping Himansu Rai secure funds from Bombay's capitalists in the 1930s and was on Bombay Talkies' board of directors.

RIGHT
FIG. 5 Savak Vacha/*Nirmala*
1938, Bombay Talkies, d. Franz Osten
35 mm Negative
JWA/ACP: 2019.01.0012

Trained in Paris, Savak Vacha was a sound recordist at Bombay Talkies and a key member of the core technical group. Vacha joined a few others in 1943 to break away from the studio and form Filmistan. Around 1945, after the departure of Devika Rani, Savak Vacha and Ashok Kumar returned to try and revive Bombay Talkies.

FIG. 6 *Vachan*
1938, Bombay Talkies, d. Franz Osten
35 mm Negative
JWA/ACP: 2019.01.0029

Devika Rani and Meera share a scene in BT's *Vachan*, a film about Kshatriya valour and honour written by Aga Jani Kashmiri.

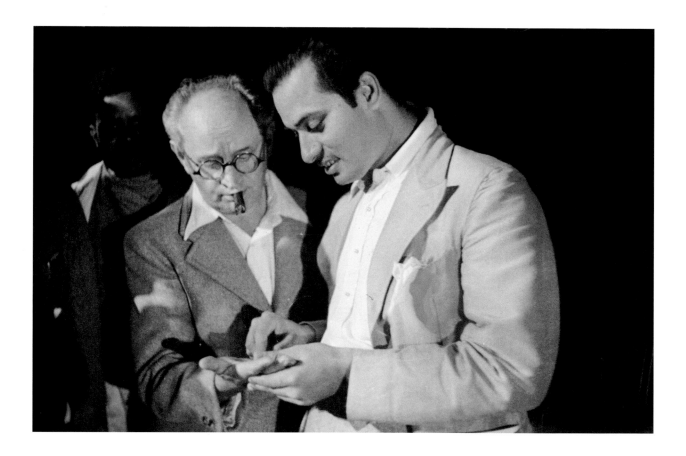

FIG. 7 Sashadhar Mukherjee/*Izzat*
1937, Bombay Talkies, d. Franz Osten
35 mm Negative
JWA/ACP: 2019.01.0017

Sashadhar Mukherjee (1909-1990), Bombay Talkies' production manager, reads Franz Osten's palm. Mukherjee was one of the co-initiators of Filmistan and later founded his own studio, Filmalaya, in the 1950s.

KB: *What about Najam Naqvi?*

VD: Najam Naqvi was a continuity person. *Punar Milan* (1940) was his first film as a director. He left BT at some point and made some films with P. K. Atre's Navyug Chitrapat.[13] He came back to BT and made *Nateeja* (1947) with them. After that he joined Filmistan,[14] where he directed a few films.

KB: *Let us discuss the scriptwriting.*

VD: In the early period, Niranjan Pal wrote the story and script in English and J. S. Casshyap would adapt these to Hindustani. Casshyap was also the dialogue coach for the actors and he wrote songs as well. But over time he became a dialogue writer in his own right. Pal stayed with BT until *Jeevan Prabhat* (1937), mostly as a storywriter, except for *Izzat* (1937), where I think he has a screenplay credit.[15]

KB: *What about Saradindu Banerjee[16] and other writers?*

VD: Saradindu joined BT with *Bhabhi* (Franz Osten) in 1938 and continued afterwards. He also worked with Casshyap to adapt scripts into Hindustani. Saradindu was one of those who received a monthly salary. That was in 1938–39. But then you can see the whole thing changing with *Kangan* and *Bandhan*. *Naya Sansar* was basically a story by K. A. Abbas.[17] And Abbas at that period of time was a very famous film critic of Bombay cinema, writing in *Bombay Chronicle*. But the script [for *Naya Sansar*] came from Gyan Mukherjee, although Abbas has also been credited. Casshyap wrote the dialogues.

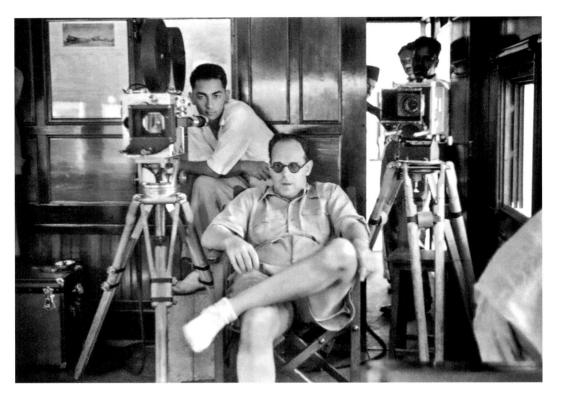
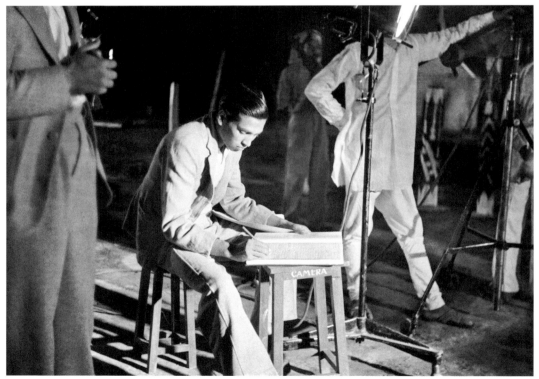

FACING PAGE
ABOVE
FIG. 8 *Jawani ki Hawa*
1935, Bombay Talkies, d. Franz Osten
35 mm Negative
JWA/ACP: 2019.01.0119

Josef Wirsching and assistant cameraperson R. D. Pareenja pose for a still photograph inside the Great Indian Peninsula train.

BELOW LEFT
FIG. 9 Najam Naqvi/*Izzat*
1937, Bombay Talkies, d. Franz Osten
35 mm Negative
JWA/ACP: 2019.01.0013

Najam Naqvi (1913-1982) was born in Muradabad and joined Bombay Talkies as continuity supervisor and occasional actor. Naqvi directed several films in the 1940s and continued to make films after migrating to Pakistan in the 1950s.

BELOW RIGHT
FIG. 10 Niranjan Pal/*The Light of Asia*
1925, Emelka Films and Great Eastern Film Corporation, d. Franz Osten
45 x 60 mm Glass Plate Negative
JWA/ACP: 2019.01.0014

Niranjan Pal (1889-1959) met Himansu Rai while writing for the London stage. Son of the nationalist leader Bipin Chandra Pal, Niranjan's screenplays brought a strongly reformist tone to Bombay Talkies' early films.

KB: *And what about the famous relationship of Manto[18] with BT?*

VD: No, that was with Ashok Kumar at Filmistan. That was nothing to do with BT. After Filmistan, Ashok Kumar became good friends with Manto. So, when Ashok Kumar came back to BT, Manto may have come with him but I don't have evidence for Manto in film credits or advertisements for BT films. So, he had his connection with Filmistan, where he wrote and starred, I think, in *Aath Din* (D. N. Pai, 1946). But Manto never succeeded in film writing even though he was a great literary short-story writer of the Indian subcontinent. There were exceptions, like *Mud* (1940) and *Mirza Ghalib* (1954). He had some connection with Imperial [Film Company] but is not remembered for that.[19] Later, he was a storywriter with Saroj Movietone and its associate companies.[20]

II The Two Major BT Stars—Devika Rani and Ashok Kumar

KB: *So, now we can talk about the two major figures—Ashok Kumar and Devika Rani—who defined this era for BT. And also, in terms of the percentage of photographs in the Wirsching collection, they receive maximum representation.*

VD: Let me tell you, there are very few portrait photographs of Ashok Kumar in the collection. On the other hand, there are a number of such photographs of Devika Rani. So there is a big difference in Wirsching's point of view towards Devika Rani and towards Ashok Kumar. The two are totally different. At this point in time Ashok Kumar was just an actor for Wirsching because he was not aware of the Ashok Kumar of 1941, the future movie star. Ashok Kumar became a star only after the German crew left in 1940.

KB: *We can start with his career and how he starts [at BT].*

VD: Ashok Kumar joined BT around 1936–37 and, until 1939, he was not an important actor in the film industry as such. I have read so many things about that period but I could hardly find a mention of Ashok Kumar. They mention the name of several actors, but we don't find the name of Ashok Kumar in such lists. They mention Motilal as a great actor.[21] Why did this happen? Maybe because Ashok Kumar himself was not very positive about the way he entered the film industry. He wanted to be a cameraperson and to go and learn cinematography in Germany. Not at BT. But Sashadhar [Mukherjee] was Ashok Kumar's brother in-law, because of which his relationship with Himansu Rai was not like that between a boss and his employee. Usually, if one wanted to meet Himansu Rai one had to take an appointment. But this was not the case with Sashadhar. So then Himansu Rai said, "We have all the German technicians here. So where is the need to go to Germany?" And then Kumar was asked to stay there in BT as a laboratory man, training as a cameraperson and such things. And during that period, for a short time, BT had no hero.

KB: *Najmul Hussain... that issue of Devika Rani eloping with him after* Jawani ki Hawa *had happened.[22]*

VD: And Devika Rani was a big, big name, more than any other actor, except maybe Sulochana.

Re-Visioning Bombay Talkies: Restoring Parallaxes to an Image 167

FIG. 11 *Izzat*
1937, Bombay Talkies, d. Franz Osten
35 mm Negative
JWA/ACP: 2019.01.0033

KB: *You said that maybe Himansu Rai did not want any outsider to act opposite Devika Rani.*

VD: I am coming to that. BT did not want a repetition of the Najmul incident. So then they said, "We have this boy [Ashok Kumar]." They asked Ashok Kumar but he was not happy—he cut his hair, shaved his head. But they said they were willing to wait. And thus Ashok Kumar started as an actor.

KB: *Franz Osten wasn't happy.*

VD: No, he was not happy with this kind of thing. He did not like Ashok Kumar as an actor. But there was no other alternative. The next actor who debuted as a BT hero was Kishore Sahu in 1937, with *Jeevan Prabhat*.

KB: *Yes, there were quite a number of films between* Jawani ki Hawa *and* Jeevan Prabhat.

VD: After the Najmul Hussain incident BT produced two short feature films, *Mamta* and *Miyaa Biwi* (Franz Osten, 1936), both without any hero. The two films were billed together and J. S. Casshyap played important roles alongside Devika Rani and H. Masih played a minor part.

KB: *So, then Ashok Kumar gradually becomes important. His first major film was* Achhut Kanya.

VD: His first big film was *Achhut Kanya*, no doubt. But the way the roles were created, in the publicity and all other things... If you look at the ads in that period of time, Devika Rani's name was more prominent, it was two inches tall, while Ashok Kumar's name was only half an inch... always. That was the first time, even in the reviews, that the critics noticed Ashok Kumar. They said he was "okay-okay." And he was not considered good in mythological and historical roles either. But *Kangan* was the film where he established himself with the media, newspapers, with the public. And *Bandhan*, the next film, established him very strongly. Then, for the first time, in *Anjaan* (1941), Devika Rani and Ashok Kumar shared equal screen space in a film. *Anjaan* came after *Kangan* and *Bandhan*, two Ashok Kumar-Leela Chitnis starrers that were bigger hits than any Devika Rani starrer.

KB: *Was* Bandhan *more modern in a sense?*

VD: Yes, this was an equal role. Ashok Kumar played a schoolteacher, an idealistic headmaster who wants to change the world. Then there was, of course, the quality of his acting and the mass popularity of the songs of the film. His dress, a *jhabba* (loose tunic) and dhoti, became very popular, with a lot of college students copying the look. And the song "Chal chal re naujawaan," which he sings in the film and which is then again sung by the character of Suresh, a young boy, became very popular. So the question is what exactly integrates all these kind of things. These are the kinds of roles through which Ashok Kumar established himself, although not as a distinct actor. The real change in Ashok Kumar came with *Naya Sansar*. In *Kangan* and *Bandhan* he established himself but with *Naya Sansar* he became a star.

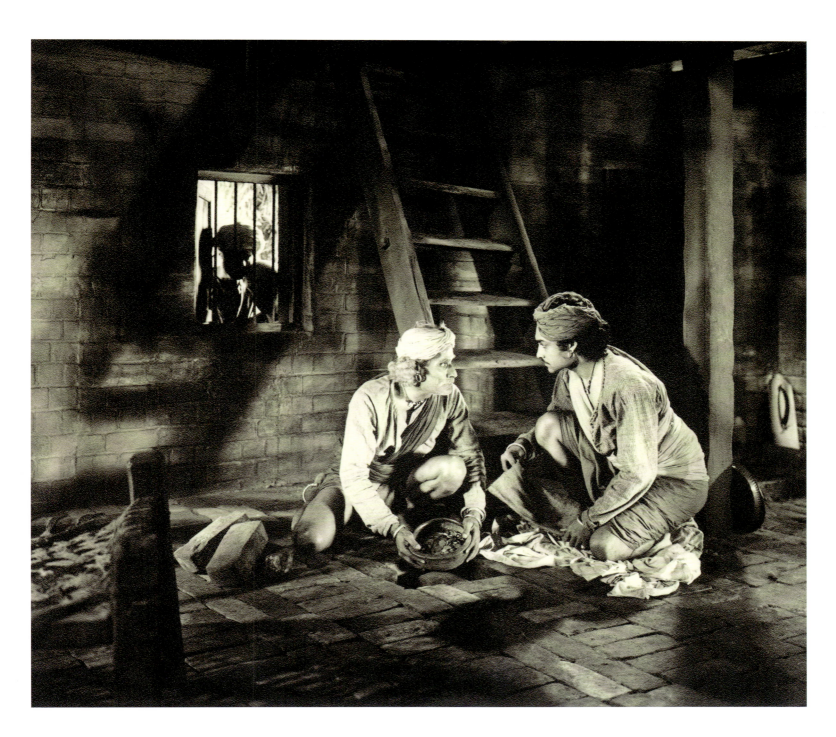

FIG. 12 Ashok Kumar and
Kamta Prasad/*Izzat*
1937, Bombay Talkies, d. Franz Osten
Lobby Card (Gelatin Silver Print),
244 x 295 mm
Josef Wirsching Archive

KB: *What was the difference?*

VD: In *Naya Sansar* he played a rebel journalist. The role, the courage of the character he portrayed, all those things contributed to the distinction of Ashok Kumar's performance in the film. Also, the way he characterized these things. I think the way the script was written by Gyan Mukherjee contributed as well. Khwaja Ahmad Abbas, a great newspaper editor, started using the phrase "naya sansar" in a lot of things. His company's name was Naya Sansar. Abbas wrote the stories for a number of films whose titles have the word *naya* in them. So, the film *Naya Sansar* must have been important enough for him to do such a thing.

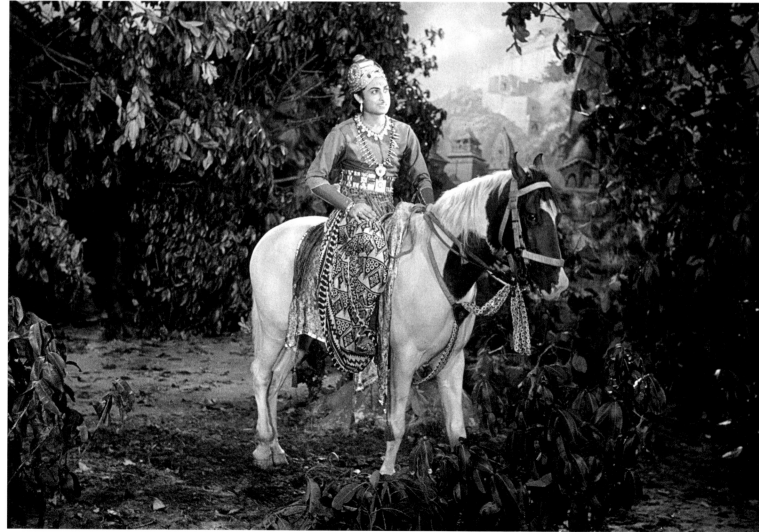

III. The Legendary Split in BT and its Slow Demise

KB: *So now we can talk about the major split in BT that happened after Himansu Rai's death and all its subsequent dynamics. It seems that people who were personally groomed by Himansu Rai [such as Sashadhar Mukherjee] were in one group and Devika Rani had her own team.*

VD: So, Amiya Chakrabarty, Himansu Rai's secretary, was not directly involved in studio production. But he must have had the urge to direct films and that could be one of the reasons why he may have sided with Devika Rani and/or because of his personal admiration of Rai and Rani. Whenever you have power and become popular, naturally you also start dominating [others]. So long as they were not in power the Sashadhar Mukherjee camp remained mild but when their films started to succeed, this group became stronger. *Kangan* was basically [managed] by this group. And then *Bandhan*, *Naya Sansar*, *Jhoola* and *Kismet*. These successes strengthened the Sashadhar Mukherjee camp against the Devika Rani-Amiya Chakrabarty camp. But, in practice, actors worked in films across the camps. Mumtaz Shanti acted in *Basant*, directed by Amiya Chakrabarty, and also in *Kismet*, directed by Gyan Mukherjee. Leela Chitnis acted in *Char Aankhen*, from the Rani-Chakrabarty camp, as well as *Jhoola* by Mukherjee. Pareenja shot films across the camps.

After the split, however, Ashok Kumar was not cast in the films produced by Devika Rani, which may also have been because she had by then discovered Dilip Kumar.[23] But when you read about Dilip Kumar, he doesn't mention the kind of rift which was going on in BT. He avoids mentioning it, or maybe he was not part of that inner circle… He basically just writes about how Ashok Kumar has influenced him. It must be noted that he also worked at Filmistan, where he did *Shaheed* (Ramesh Saigal, 1948).

By the way, *Jhoola*, *Naya Sansar* and *Kismet* were all scripted by Gyan Mukherjee. He was a master screenwriter and it was due to him that K. A. Abbas came into *Naya Sansar*. Then, with *Kismet*, he created a new kind of modern cinema and, with it, the image of Ashok Kumar. And, of course, *Kismet* had record success at the box office. So the Mukherjee pair (Sashadhar and Gyan) played a very key role.

KB: *It is interesting that BT had a long history, say, about twenty years' history, from the early 1930s to the 1950s. But it seems that, barring* Achhut Kanya *and* Kangan, *there were very few really successful films in the Osten period. And* Kangan *was not finished by Osten. As you have always argued, in that period films were not big hits, for the most part, in the way we understand hits today.*

VD: No, they did run but no one considered them as big hits. They were a moderate kind of hit. *Bhabhi* was a hit in Calcutta, though. In the 1930s, BT made only one or two hit films but their image as a big company has always endured, whatever the reason may be. When Bombay cinema [of that period] was discussed, people never talked about any other studio. We never heard about anyone else except Ranjit. People hardly talked about Ajanta, Krishna, Sagar or Saroj.[24] BT got all the media coverage.

ABOVE
FIG. 13 *Nirmala*
1938, Bombay Talkies, d. Franz Osten
35 mm Negative
JWA/ACP: 2019.01.0027

Devika Rani rehearses a scene in which the heroine, Nirmala, flees from her home during a stormy night.

BELOW
FIG. 14 *Vachan*
1938, Bombay Talkies, d. Franz Osten
35 mm Negative
JWA/ACP: 2019.01.0101

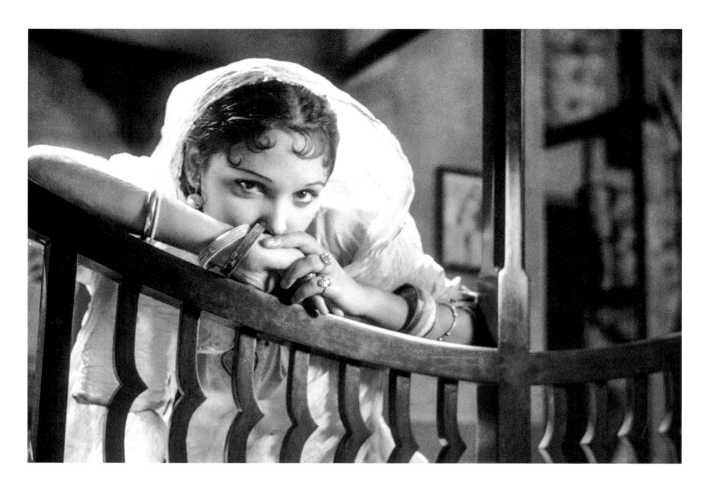

FIG. 15 *Mamta* or *Mother*
1936, Bombay Talkies, d. Franz Osten
35 mm Negative
JWA/ACP: 2019.01.0028

KB: *So, therefore, there is this rather interesting kind of thing when we talk about this archive that the biggest hits of BT were made after the Osten and Wirsching period. And you consider Gyan Mukherjee to be a very important person in that [dynamic]. Why do you say that?*

VD: The reason is the kind of films he wrote or made. *Sangram* (1950) had a dark existential anti-hero, which was remarkable. *Sangram*, which I consider to be a very, very important film, came after a long gap of six years after *Kismet*. So, in between those two, we don't know what exactly happened. I don't remember reading anything on Gyan Mukherjee [during this period]. After *Sangram* he made some films that were much below his standard. You cannot say that the same man made these films. But Guru Dutt[25] dedicated *Pyaasa* (1957) to Gyan Mukherjee.

KB: *But, as we were discussing yesterday, in this context it is also interesting that the period between 1941 and 1944 seems to be—*

VD: That was a dynamic period for Bombay cinema as a whole. Basically, whether it was New Theatres, or Prabhat, or Sagar, or even Ranjit, they did not consistently make good films but, from time to time, some important films did emerge from these studios. I think the big problem in Indian cinema in this period was finance. If two or three films failed you were without capital, and you would have to borrow. But interest rates were very high. Even in 1936, when Chimanlal Desai[26] delivered a lecture, he said that 30

per cent interest had to be paid on money borrowed from moneylenders. So you can imagine, 30 per cent interest!

But what exactly happened that led to BT's decline, especially after the success of all these films up till *Kismet*? And Amiya Chakrabarty-Devika Rani's hit film *Basant*?

KB: *Yeah,* Basant *was the biggest grosser in 1942, and, in 1943,* Kismet *was the biggest grosser.*

VD: BT more or less declined after that. Devika Rani left in 1945. And money being easily available on the market led to people coming in to BT who had no understanding of cinema, with the rare exception of those like Hiten Choudhury. So what happened was that after about two years, by 1945–47, the films were coming but only slowly. Choudhury was involved with *Milan* (1947), which he asked Calcutta-based Nitin Bose[27] to come and direct. For *Milan*, Bose did the camerawork as well and Radhu Karmakar[28] did all the lights. But this did not work either and it was at this point that Ashok Kumar and Savak Vacha came back to BT.

But I can tell you one thing: all the BT films from the Devika Rani period, with negatives, were mortgaged to Seksaria's Diamond Pictures.[29] This happened before Ashok Kumar

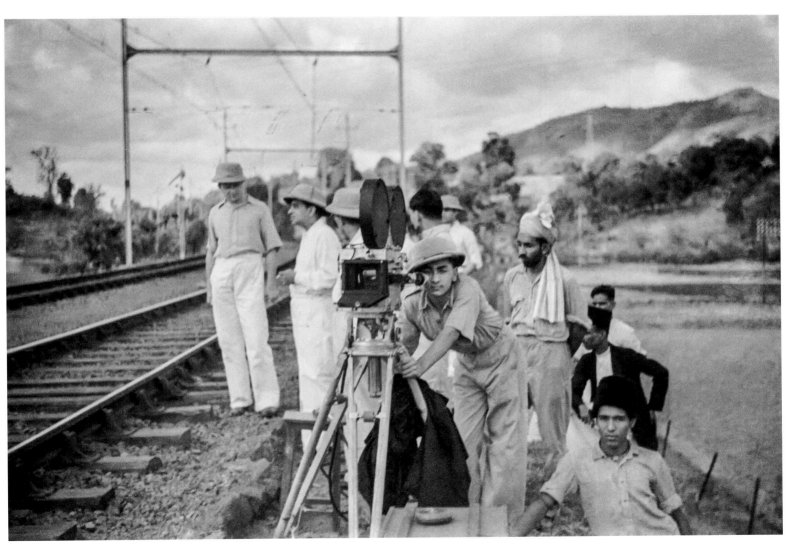

FIG. 16 *Jawani ki Hawa*
1935, Bombay Talkies, d. Franz Osten
35 mm Negative
JWA/ACP: 2019.01.0110

R. D. Pareenja operates the B-camera (second unit) while shooting a sequence with a speeding train. Also visible in the frame are Franz Osten and Himansu Rai (left).

FIG. 17 *Nirmala*
1938, Bombay Talkies, d. Franz Osten
Gelatin Silver Print, 127 x 165 mm
JWA/ACP: 2020.01.0070

Re-Visioning Bombay Talkies: Restoring Parallaxes to an Image 175

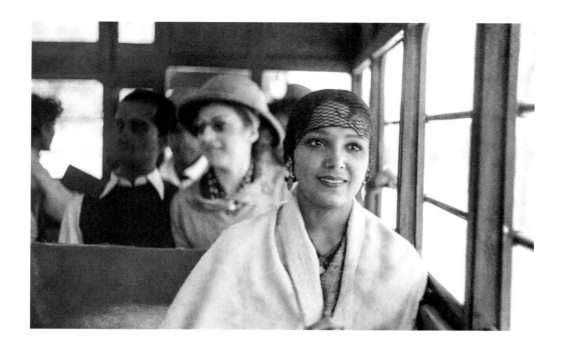

and Savak Vacha joined BT. Diamond then decided to make a new film, *Anyaya* (c. 1949) out of the mortgaged films, for which they invited Casshyap to write the story. And that film was almost ready, publicity and all such things were going on, when the actors filed a suit because they were not paid royalties. The film remains unreleased.

Gradually, BT started getting back its reputation, which was due to the Ashok Kumar-Savak Vacha team. This was a period when BT was trying to recover but the financial gap was so wide and the interest rates so high that the debts must have been increasing. There were other problems too. In terms of films, *Ziddi* (Shaheed Latif, 1948), which was Dev Anand's first major film, did not have any box office pull because Dev Anand[30] was not a well-known actor then. Kishore Kumar arrived, first as a playback singer for Dev Anand in *Ziddi*, and then began his acting career with *Muqaddar*.[31] Then S. D. Burman[32] worked at BT on *Ziddi* even though he had already worked at Filmistan. This was also the period when the actor Shyam started to achieve stardom with hits such as *Majboor* (Nazir Ajmeri, 1948).

But they persevered. They made *Muqaddar* (1950), which, again, was a small-budget film. Then they made the bilingual *Mashaal* (1950). After that they tried to make a small-budget film, *Maa* (1952), where Bimal Roy[33] was invited to come from Calcutta to direct it, and Bharat Bhushan, who was not yet a well-known actor, was cast in the lead, while Leela Chitnis played the mother's role. Lastly, there was *Tamasha* (1952), directed by Phani Majumdar, with a strong cast. All these films had a moderate run but no big success.

And then salaries had to be paid every month to the entire staff, including technicians. And BT had very good technicians who were well paid. *Mahal* (1948) had to be withdrawn in Bombay due to non-compliance with the censors' code.

FIG. 18 *Izzat*
1937, Bombay Talkies, d. Franz Osten
35 mm Negative
JWA/ACP: 2019.01.0025

Devika Rani with Savak Vacha and Madame Andrée in the background on the Bombay Talkies bus heading back to the studio after a day of outdoor shooting.

Epilogue

KB: *So, what is your final take on the BT legacy for Indian cinema?*

VD: Of course, in the early period, their professional set-up of the studio and the organized way in which they worked [were very significant]. Their films were polished, with generally a very high technical standard (see, figure 4, chapter 4). Towards the end of her career, Devika Rani discovered one of Hindi films' most original actors, Dilip Kumar. Unfortunately, at that juncture, she retired from filmdom. At one point in time, Ashok Kumar, Dilip Kumar and Raj Kapoor were all working in BT. The studio nurtured not only several writers, poets and of course directors, but also producers and a veritable galaxy of stars. All these traditions continued in different ways. Ashok Kumar and Savak Vacha continued the old legacy of BT, especially if we look at talented people such as Kamal Amrohi[34] coming to BT and making *Mahal*, which remains one of the landmark Gothic films of Bombay cinema. It built the career of Madhubala and Lata Mangeshkar. Moreover, it was the last film of Khemchand Prakash, the music composer. The studio went on producing small-budget films and continued to fight against mounting financial odds. Unfortunately, the financial gap kept widening and finally Ashok Kumar and Savak Vacha handed BT over to the workers to run. This, basically, was the sad end of Bombay Talkies.

Notes

1. Singh was a Sikh filmmaker who trained in the US and came back to India to found the Oriental Film Company in Mumbai in 1919. In 1920 he made *Shakuntala*, starring Dorothy Kingdon, which enjoyed considerable success, running for forty days in the cinemas.

2. The spellings of individual names mentioned here are based on published information circulating in contemporaneous sources in Mumbai media. However, there is some confusion on this question as other sources may refer to "Baron Van Raven." Dorothy Kingdon herself is referred to, variously, as "Baroness Van Raven," or "Dorothy van Raven," or "Dorothy Kingdon Van Raven." Camille Le Grand is also referred to as "Camille De Grand" or "Camille Legrand" in varying sources.

3. This film was recently "found" and twenty-eight minutes of footage, in digital copy form made off of the original nitrate print at the Cinémathèque Française, can now be accessed at the National Film Archive of India, Pune.

4. Eugenio de Liguoro was an Italian actor and filmmaker who worked with the Madans in the 1920s. Not much is known about his career there. He was involved with a number of Madan films, for example, *Dhruva Charitra* (1921) and the four-part serial film *Ramayan* (1922).

5. Camille Le Grand seems to have started his career as a cameraperson for Pathé in India. Again, as with many Madan personnel of the early silent period, we know next to nothing of his activities there, except the filming of plays by Madan's theatre company. Credits as cinematographer/director include *Shivarati* (1921), *Vishnu Avatar* (1921) and *Ratnavati* (1922).

6. Of unknown origin, Charles Creed came to India around 1921 and made a topical short, *Darjeeling*, after which he joined Madan.

7. Angelo de Gubernatis was a prominent Italian Orientalist. A professor of Sanskrit at Florence, he was nominated for the Nobel Prize in literature fourteen times.

8. *Savitri* is attributed to the Cines Film Company based in Rome. It starred Rina de Liguoro, a prominent actress of Italian silent cinema. She finished her career playing the Princess of Presicce in Luchino Visconti's *The Leopard* (1963).

9. Madan Theatres was the media behemoth of pre-Independence India. Functioning from Calcutta, Jamshedji Framji Madan ran a film company, theatre companies, and covered up to three-quarters of the film distribution trade as well as a substantial proportion of the exhibition sector in British India.

10. Not much is known of T. Marconi beyond bare traces of his work with Madan. In addition to his silent cinema work, he did the camera for Madan's talkie version of *Indrasabha* (J. J. Madan, 1932) and *Zehri Saap* (J. J. Madan, 1933). After that we find his name listed as cameraperson for the Tamil film *Vimochanam* (A. N. Kalyanarayan, 1939) and for the Telugu film *Raksharekha* (R. Padmanabhan, 1949).

11. Patel is a member of the legendary pantheon of founders of the Bombay film industry. He began his career as film exhibitor in Ahmedabad and in 1920, in partnership with Dwarkadas Sampat, founded the first commercially viable film studio of Bombay cinema with an all-India reach—the Kohinoor Film Company. He then founded the Krishna Film Company in 1924, an offshoot of the Krishna Film Lab.

12. Ramchandra Narayanji Dwivedi a.k.a. Kavi Pradeep was a very important lyricist of Bombay cinema. He is famous for having written the nationalist dirge "Aye mere watan ke logon" to mourn the fallen Indian soldiers of the Sino-Indian war of 1962. Sung by Lata Mangeshkar, the song is reported to have moved Prime Minister Jawaharlal Nehru to tears. Kavi Pradeep also wrote the nationalist anthem "Dur hato ae duniyawaalo" for Bombay Talkies' biggest hit, *Kismet*.

13. A monumental figure of Marathi cultural modernism, Prahlad Keshav Atre was a writer, poet, educator, scenarist and filmmaker. His film *Shyamchi Aai* won the first ever Golden Lotus award (the President's Gold Medal) for All-India Best Film at the National Awards for Indian cinema in 1953.

14. A breakaway film studio from BT, Filmistan, founded by Sashadhar Mukherjee, Ashok Kumar and Rai Bahadur Chuni Lall, produced a number of hits in the 1940s. The studio remains functional for shooting till date.

15. *Izzat* was based on a story by Dr. G. Nundy, reworked by his daughter J. Nundy.

16. The legendary Bengali novelist Saradindu Banerjee is most famous for his novels featuring the detective Byomkesh Bakshi, which have now been adapted multiple times for television, cinema and now as web series, making him probably the most timeless media detective in cultural history after Sherlock Holmes and Hercules Poirot.

17. Khwaja Ahmed Abbas was a pioneering film journalist. He is is famous for having written Raj Kapoor's *Awara* (1951) and for his long partnership with Kapoor.

18. Sa'adat Hasan Manto is considered a pioneer of Urdu literary modernism. Notorious for his run-ins with the law on charges of obscenity, Manto was famous for a cool beady-eyed look at the sexual hypocrisies of his society. He migrated to Pakistan during the partition of India.

19. The Imperial Film Company was one of the biggest film studios of the silent era of Bombay cinema. Helmed by Ardeshir Irani, the company has gone down in the annals of Indian film history for having produced India's first talkie film, *Alam Ara* (Ardeshir Irani, 1931).

20. For more on Manto's film career in Bombay see Debashree Mukherjee, "Tracking Utopias: Technology, Labour and Secularism in Bombay Cinema (1930s-1940s)," in Arvind Rajagopal and Anupama Rao eds. *Media and Utopia: History, Imagination and Technology*. Routledge, 2016.

21. Motilal Rajvansh is considered to be one of Bombay cinema's most underrated actors. Renowned for his versatility, he has since been acclaimed by later Bollywood stars, such as Amitabh Bachchan and Naseeruddin Shah.

22. For more on this elopement scandal see Debashree Mukherjee, "Scandalous Evidence: Looking for the Bombay Film Actress in an Absent Archive," in Julia Knight and Christine Gledhill eds. *Doing Women's*

Film History: Reframing Cinemas, Past and Future. University of Illinois Press, 2015.

23. Dilip Kumar, born Muhammad Yusuf Khan, was, along with Raj Kapoor and Dev Anand, one of a trio of iconic actors considered as the superstars of post-Independence Bombay cinema. Making his debut at Bombay Talkies with *Milan* (Nitin Bose, 1946), he is best known for his performances in *Shaheed* (1948), *Andaz* (Mehboob Khan, 1949), *Deedar* (Nitin Bose, 1951), *Mughal-e-Azam* (1960) and *Ganga Jamuna* (Nitin Bose, 1961), among many others.

24. Ajanta Cinetone, Krishna Movietone, Sagar Movietone, Saroj Movietone and Ranjit Movietone were pioneering studios of early talkie cinema in Bombay. Sagar and Ranjit were two of the silent-era studios that made the transition to sound successfully.

25. Considered the *poet maudit* of post-Independence Bombay cinema, actor-filmmaker Guru Dutt is known for his existential tragedies—*Pyaasa* and *Kagaz ke Phool* (1959). Early in his career he made some stylish noir films and breezy comedies such as *Baazi* (1951) and *Mr. and Mrs.'55* (1955), respectively.

26. Starting as a distributor for Bombay films in southern India, Chimanlal Desai went on to found Sagar Film Company along with Ardeshir Irani and Ambalal Patel in 1929. Amongst other things, Sagar is famous for having trained Mehboob Khan, who went to make the epic allegory on Indian nationhood, *Mother India* (1957).

27. Nitin Bose was an important filmmaker of early Indian cinema, making the transition to the talkies and then post-Independence cinema with considerable success. His early career saw pioneering work as cameraperson in Calcutta's New Theatres studio.

28. Radhu Karmakar was the legendary cinematographer for Raj Kapoor's films, including classics such as *Awara* (1951), *Shree 420* (1955), *Sangam* (1964) and *Bobby* (1973).

29. Govindram Seksaria was a Marwari business magnate of pre-Independence India. He was a member of the New York Stock Exchange and founded the Bank of Rajasthan.

30. One of the iconic acting trio of post-Independence Bombay cinema, along with Raj Kapoor and Dilip Kumar, Dev Anand had a long successful career in the industry as an actor, producer and director. Pioneering the noir film through many of his acting stints in the 1950s, he is best known for his performance in *Guide* (Vijay Anand, 1965). As a director he is best known for his take on hippie counterculture in India in *Hare Rama Hare Krishna* (1971).

31. Kishore Kumar, né Abhas Kumar Ganguly, a brother of Ashok Kumar, is one of the most prolific and acclaimed playback singers in Indian cinema history. He also had a very successful acting career through the 1950s and 1960s through films such as *Chalti ka Naam Gaadi* (Satyen Bose, 1958), *Half Ticket* (Kalidas, 1962), *Door Gagan ki Chhaon Mein* (Kishore Kumar, 1964) and *Padosan* (Jyoti Swaroop, 1968). He is considered one of the greatest comic actors of Indian cinema.

32. Sachin Dev Burman, a doyen of Bombay cinema's music direction, emerged out of the remarkable film-music stable at New Theatres in Calcutta, which housed music composers such as K. C. Dey, R. C. Boral and Pankaj Mullick. Burman is known for his long collaboration with the Anands at Navketan.

33. Bimal Roy broke into prominence as the cameraperson for the legendary New Theatres director Pramathesh Barua, doing the camera for *Devdas* (1935). After coming to Bombay, he became famous for directing the neo-realistic melodrama *Do Bigha Zamin* (1953), and romantic dramas such as *Madhumati* (1958) and *Bandini* (1963).

34. Kamal Amrohi was a notable filmmaker of Bombay cinema, responsible for *Mahal*, *Daera* (1953) and *Pakeezah*.

Josef Wirsching and the *Kreuzer Emden*

The Entangled Politics of the Interwar Period

■ Eleanor Halsall ■

As a metaphor for the triangular entanglements between India, Germany and Britain, the story of the battleship SMS *Emden* began on the evening of September 22, 1914, when the First World War was barely a few weeks old. The battleship unexpectedly targeted Madras, firing shells at oil tanks in the harbour, killing three people and injuring a further sixteen; an outrage that has become a colloquialism in the Tamil language (Henderson 1914).[1] Twenty-three years later, the trauma of this bombardment was perhaps partly redressed when, during a visit in 1937 by a subsequent incarnation of the *Emden*, its crew plucked thirty women and children from the waters of Bombay's harbour after their boat capsized, thereby saving their lives ("Drowning Women & Children Rescued," *The Times of India*, March 8, 1937, 14).

The connection with Josef Wirsching may at first seem tenuous, but Wirsching's relationship with India is entangled with that of the *Emden*. Caught in a nexus of political interests, the *Emden* might be seen as symbolic of the struggle between Britain and Germany, and the complicated relationship each nation had with India. The *Emden* also provides a frame within which one might discuss what the political conditions prevailing at the time meant to and for the average German.

At least eighteen films have been made about the *Emden*, the most recent being *Die Männer der Emden* ("The Men of Emden," Berengar Pfahl, 2012). Josef Wirsching was involved with four of these. The first, *Unsere Emden* ("Our Emden," Louis Ralph), was filmed in 1926, soon after Wirsching returned from India after filming *The Light of Asia* with Franz Osten in 1925. Wirsching was one of four cameramen under the cinematographer, Ewald Daub.[2] Produced by Emelka, *Unsere Emden* strove for realism: following the log of Captain Karl von Müller and using some of the original crew in the cast (Kester 2003, 165).

FIG. 1 **Josef Wirsching**
c. 1939
Gelatin Silver Print, 116 x 88 mm
Josef Wirsching Archive

A rare photograph of Josef Wirsching at the WWII internment camp for enemy aliens at Dehradun. According to the family, Wirsching is busy at work drawing a storybook for his young son, Peter, whose portrait hangs on the wall next to him.

The film's premiere was delayed by the German government, anxious that the film might harm the *entente cordiale*. It was nevertheless popular, appearing in Britain, Australia and the United States of America as *The Raider Emden*, and in Sweden as *Emden—Havens Fribytare* ("Film und Aussenpolitik," *Berliner Tageblatt*, December 22, 1926, 7). Caroline Lejeune described it as "the romance of gallantry; it belongs no more to Germany than to the whole world. It has no villains; it is the story of the clash of heroes, in which victor and victim share the honour, and no one can really say which has lost and which has won" (1927, 16).

The film *Kreuzer Emden* followed in 1932, also produced by Emelka. Wirsching worked on this film with Franz Koch in what was to be their penultimate film together. Once again directed by Louis Ralph, *Kreuzer Emden* pursued a different narrative arc. No longer a docudrama, it was a definitively masculinist film intended for a political landscape that was being increasingly shaped to the dominant trope of "the Fatherland." With its crude caricatures of Russian officers, it introduced a triangular love story, pitting two male heroes against one another and depicting the handful of female characters as duplicitous and disloyal. Combined with a fetishization of the semi-naked male body, echoing some of Leni Riefenstahl's early work, the overriding masculine aesthetic of *Kreuzer Emden* stands in sharp contrast to the films that Wirsching would soon be photographing at Bombay Talkies.

Mit Kreuzer Emden in die Welt ("Into the World with Battleship Emden," 1937) might be described as the *Emden*'s personal travelogue as it criss-crossed oceans, visiting strategic locations around the world, including Ceylon and Bombay. The film was produced by the Oberkommando der Kriegsmarine (Germany's Naval High Command) and directed, yet again, by Louis Ralph. Arguably a show of strength in the prelude to war, it suggests an object of propaganda for a home audience. A copy of *Mit Kreuzer Emden in die Welt* survives in the Bundesarchiv-Filmarchiv in Berlin but, tantalyzingly, it is not complete. This is particularly regrettable because, as becomes clear from the censor certificate, the missing footage includes the crew's visit to Bombay, where they also attended a screening at the Roxy Theatre to watch the Bombay Talkies' film *Izzat* (1937).[3]

Having already left for India in 1935, Wirsching was not involved in the photography of this film, but he was working at Bombay Talkies and it is likely that he operated the camera on a fourth *Emden* film—a newsreel produced by Bombay Talkies during the *Emden*'s visit in 1937 that was shown at Bombay's Opera House ("Emden film to be shown," *Bombay Chronicle*, March 17, 1937, 10).[4] If copies survive, they have yet to surface. Records indicate that Osten screened a copy of the *Emden* newsreel at Bombay's German Club in March 1938 and the editor of *Der Deutsche in Indien* newspaper described the crew's visit in 1937 in strongly visual imagery: "Two huge swastikas, flanked by the flags of Britain and the other German flags, raised themselves against the night-time black of the garden. Hundreds upon hundreds of oil lamps threw their light into the night, lending the garden a fairytale aspect" (Frahm 1937, 9).

FIG. 2 Josef Wirsching and Camera Assistant
1958
Gelatin Silver Print, 111 x 145 mm
JWA/ACP: 2019.01.0125

Josef Wirsching and a Camera Assistant packing lenses and camera equipment at the Kamalistan Studios.

The image of the *Emden*'s crew marching through the streets of Bombay under both British and German flags masked the political tension between these European neighbours. Nevertheless, although German activity in India was being more closely scrutinized at this stage, Anglo-German relations remained cordial, at least superficially. The Governor of Bombay and his wife, the Lord and Lady Brabourne, invited Captain Walter Lohmann and two of his officers to lunch at their residency, Government House. This was an occasion at which Himansu Rai and Devika Rani, both German speakers and themselves frequent visitors to Government House, may well have been present.[5]

Josef Wirsching was born in Munich on March 22, 1903.[6] His father, also Josef, ran a costume supplies business. He was educated up to *Mittelschule* level, and his family report that he trained at the Städtische Gewerbeschule in Munich. Wirsching began his career in cinematography in either 1917 or 1918, when he was apprenticed to a Munich company, Weiss-Blau-Film.[7] Wirsching also appears to have been involved in research and development of camera equipment, in particular with ARRI, established by August Arnold and Robert Richter in Munich in 1917 (Bichard 2008, 72). By the time he travelled to India for the production of *The Light of Asia*, Wirsching had been working at Emelka since 1923, and his filmography indicates that he remained there until the 1932 production of *Kreuzer Emden*.

Wirsching's move to Bombay Talkies in 1935 came two years after the National Socialists had taken power. On August 14, 1933, the Nazis established the Reichsfilmkammer (RFK), the body that would regulate all aspects of the German film industry, dictating the kind of films that could be made and displacing those filmmakers they wished to exclude as undesirable from the new Germany, whether on the basis of ethnicity, sexuality or leftist politics. The result of this was that Germany lost around 2,000 individuals from its cultural industries (Evans 2006, 140). Like Franz Osten and Karl von Spreti, Wirsching was neither an émigré nor an exiled filmmaker and there is no evidence to suggest that he was under any compulsion to leave Germany.

Wirsching's presence in the National Socialist records is sparse.[8] Apart from documents tracing his whereabouts in internment during the war, records related to party membership

FIG. 3 Excerpt of Letter from Josef Wirsching to Devika Rani
17 February, 1941
Courtesy: The Dietze Family Archive

Wirsching was interned as an "enemy alien" during WWII and maintained a professional correspondence with Devika Rani, who took over as production controller of Bombay Talkies after Himansu Rai's death in 1940.

show that in August 1932 he joined the NSDAP (National Socialist Workers' Party), one of the leading bodies of the Nazi organization, and in July 1933, he joined the NSBO (Nationalsozialistische Betriebszellenorganisation), the organization that replaced all trade unions. Both these memberships were cited in his subsequent application to join the Reichsfachschaft Film (RFF) in October 1933, a division within the RFK and by then a mandatory hurdle to permit him to continue working in the German film industry. Beyond providing certificates of birth and baptism to prove the Aryan credentials of parents and grandparents, applicants were also required to prove allegiance to the principles of National Socialism by confirming they had never participated in socialist politics.

This file holds two further documents relating to Wirsching. A letter from Karl von Spreti, dated November 16, 1936, names Wirsching as a party member able to vouch for Wilhelm (Willy) Zolle; and a letter from Wirsching Senior, addressed to the RFF on November 14, 1938, explains that his son was working in India and was paying the annual Winter Aid donation directly in Bombay.

The Winter Aid programme was instituted in September 1933. Ostensibly a voluntary payment to support less fortunate citizens, the reality was different. At best, intimidatory collection methods and public humiliation awaited those who refused to contribute; at worst, refusal might result in the loss of labour or even removal to a concentration camp (Evans 2006, 484–495). Wirsching and his colleagues in Bombay may have been geographically distant from the regime in Berlin, but the metaphysical contours of the Reich, which stretched from the heart of Berlin, included a network of organizations overseas (the consulates in Bombay, Calcutta and Karachi; German companies such as Siemens, AEG and Krupps; missionary societies and the Deutsche Klubs in Bombay and Calcutta) that monitored the activities of Germans in India, sought to persuade dissenters into the fold and encouraged compliance with the regime in Berlin. One must bear in mind that all the Germans working at Bombay Talkies had family members in Germany.

Although Wirsching travelled to Germany for a few weeks at the end of 1937, he never returned to live in his native land. On September 3, 1939, with the onset of the Second World War, Josef Wirsching was interned by the British as an enemy alien, together with Franz Osten and Willy Zolle, leaving their Indian colleagues to complete the production of *Kangan* (1939).[9] Letters between Wirsching and his relatives in Germany illustrate the anguish of family members divided by war, uncertain of one another's safety and continued existence.[10] Bombay Talkies' three Germans were initially interned at the Ahmednagar, Deolali and Dehradun camps, but Wirsching was subsequently moved to the open camp at Satara, where he was finally able to live with his wife, Charlotte, and their son, Peter.[11]

The depth of Wirsching's commitment to the regime in Berlin is impossible to judge. Historical knowledge of how events unfolded from 1925 to 1939 and beyond can never be an unequivocal guide to understanding the responses and reactions of the people for whom those events still lay in an unknown future. What might be observed, however, is that Wirsching progressed from photographing films promoting masculinist power, war and the Fatherland, to films that spoke of the motherland (Bharat Mata) and dealt in topics that considered the status of women, the effects of poverty, community cohesion and the importance of love, along the way acquiring a celebrated status in the history of Indian cinema.

Notes

1. The word *emden* has become a Tamil colloquialism for "strength," "audacity" or "strictness."

2. Daub would later join Richard Eichberg's 1937 expedition to India to photograph *Das indische Grabmal* (1937) and *Der Tiger von Eschnapur* (1938).

3. The BAW Censor certificate 48984A, lists the following scenes: 1. Bombay. 2. Arrival at the entrance to the harbour, the "Gateway of India." 3. Special presentation of the Indian film *Izzat* (honour) directed by a German. 4. The main actress Devika Rani and her partner Ashok Kumar.

4. The *Bombay Chronicle* reported on the newsreel that was produced by Bombay Talkies, suggesting, "It is likely that copies of this film may be sent abroad also, particularly to Germany where naturally it will arouse great interest," March 17, 1937, 10. Whether the *Emden* newsreel reached Germany is unknown, although it is possible that Osten and Wirsching might have taken a copy when they travelled to Germany later that year, as they did *Achhut Kanya* (1936). See *German Cruiser Emden Visits Bombay*. Certificate 17631.

5. See, for example: "Social & Personal," *The Times of India*, February 9, 1934, 8; "Social & Personal," *The Times of India*, May 12, 1937, 4.

6. Some sources use the name Otto Josef Wirsching and Otto Wirsching, and Ashok Kumar refers to him as "Carl Josef Wirsching" in Ghosh, *Ashok Kumar*, 29. A cinematographer by the name of Otto Wirsching is recorded on the encyclopaedic websites of IMDB and Filmportal.de and is credited as working on Ophüls' 1932 film *Die verkaufte Braut* and on *Die Zwei vom Südexpress* (Wohlmuth, 1932). He is referred to as Otto Josef Wirsching by Robert S. Bichard in an article about the developers of the Arriflex camera (2008). In none of the official documentation does Wirsching use this name, and it may be one that simply fell out of use. Since Wirsching himself lists the films by Ophüls and Wohlmuth on his 1933 application to the RFK, it is reasonable to assume that Josef Wirsching and Otto Wirsching are the same person. Kumar's reference to Carl Josef Wirsching may be a lapse of memory.

7. See "The men behind the screen: Directors and Technicians who have made Indian Film History," *The Times of India*, May 5, 1939, A14; Weiss-Blau-Film is mentioned by Horak, 92; "Kino Sommer im Spreeathen," *Kinema*, July 29, 1918, 2; *The Film Year Book: The 1922–23 Film Daily Year Book of Motion Pictures*, 419, records Weiss-Blau-Film at Nyphenburg, Kuglmüllerstrasse 9, Munich.

8. PKJ0121, 950-966, Bundesarchiv, Berlin.

9. BL IOR/L/PJ/8/31, Doc 76.

10. See File R145718. "Nachforschungen nach Deutschland in Feindesland. Einzelfälle British Indien," Win-Wit, In: Politisches Archiv, Berlin.

11. Karl von Spreti had left India on December 31, 1937.

Josef Wirsching's Filmography

GERMANY
(Collated by **Eleanor Halsall**)

- 1925

 The Light of Asia/Die Leuchte Asiens
 Dir: Franz Osten. Cam: Josef Wirsching. Münchener Lichtspielkunst, Great Eastern Corporation, 1925.

- 1926

 Unsere Emden
 Dir: Louis Ralph. Cam: Josef Wirsching. Münchener Lichtspielkunst, 1926.

 Die Kleine Inge und ihre drei Väter
 Dir: Franz Osten. Cam: Franz Koch, Josef Wirsching. Münchener Lichtspielkunst. 1926.

- 1927

 Mein Heidelberg, ich kann Dich nicht vergessen
 Dir: James Bauer. Cam: Franz Koch, Josef Wirsching. Münchener Lichtspielkunst, 1927.

- 1928

 Zwischen zwei Meeren
 Dir: ? Cam: Josef Wirsching, Münchener Lichtspielkunst, 1928.

- 1929

 Spuren im Schnee
 Dir: Willy Reiber. Cam: Franz Koch, Josef Wirsching. Münchener Lichtspielkunst, 1929.

 Waterloo
 Dir: Karl Grune. Cam: Hugo von Kaweczinski, Fritz Arno Wagner, Josef Wirsching. Münchener Lichtspielkunst, 1929.

INDIA
(Select filmography as referenced in this volume)

- 1925

 Prem Sanyas/The Light of Asia
 Dir: Franz Osten. Cam: Josef Wirsching. 1925.

- 1935

 Jawani ki Hawa
 Dir: Franz Osten, Cam: Josef Wirsching. Bombay Talkies, 1935.

- 1936

 Miyaa Biwi/Always Tell Your Wife
 Dir: Franz Osten. Cam: Josef Wirsching. Bombay Talkies, 1936.

 Mamta/Mother
 Dir: Franz Osten. Cam: Josef Wirsching. Bombay Talkies, 1936.

 Jeevan Naiya
 Dir: Franz Osten, Camera: Josef Wirsching. Bombay Talkies, 1936.

 Achhut Kanya
 Dir: Franz Osten, Camera: Josef Wirsching. Bombay Talkies, 1936.

 Janma Bhoomi
 Dir: Franz Osten, Camera: Josef Wirsching. Bombay Talkies, 1936.

- 1937

 Izzat
 Dir: Franz Osten, Camera: Josef Wirsching. Bombay Talkies, 1937.

 Prem Kahani
 Dir: Franz Osten, Camera: Josef Wirsching. Bombay Talkies, 1937.

 Savitri
 Dir: Franz Osten, Camera: Josef Wirsching. Bombay Talkies, 1937.

 Jeevan Prabhat
 Dir: Franz Osten, Camera: Josef Wirsching. Bombay Talkies, 1937.

- 1938

 Nirmala
 Dir Franz Osten, Camera: Josef Wirsching. Bombay Talkies, 1938.

 Vachan
 Dir: Franz Osten, Camera: Josef Wirsching. Bombay Talkies, 1938.

 Bhabhi
 Dir: Franz Osten, Camera: Josef Wirsching. Bombay Talkies, 1938.

- 1939

 Nav Jeevan
 Dir: Franz Osten, Camera: Josef Wirsching. Bombay Talkies, 1939.

 Kangan
 Dir. Franz Osten, Cam: Josef Wirsching. Bombay Talkies, 1939.

 Durga
 Dir. Franz Osten, Cam: Josef Wirsching. Bombay Talkies, 1939.

- 1949

 Ziddi
 Dir: Shahid Lateef. Cam: Josef Wirsching. Bombay Talkies, 1949.

 Mahal
 Dir: Kamal Amrohi. Cam: Josef Wirsching. Bombay Talkies, 1949.

- 1952

 Maa
 Dir: Bimal Roy. Cam: Josef Wirsching. Bombay Talkies, 1952.

- 1932

 Die verkaufte Braut
 Dir: Max Ophüls. Cam: Franz Koch, Reimar Kunze, Josef Wirsching (as Otto Wirsching). Reichsliga-Film GmbH, 1932.

 Die Zwei vom Südexpress
 Dir: Robert Wohlmuth. Cam: Josef Wirsching. Münchener Lichtspielkunst, 1932.

 Kreuzer Emden
 Dir: Louis Ralph. Cam. Josef Wirsching. Münchener Lichtspielkunst, 1932.

- 1933

 Das verliebte Hotel
 Dir: Carl Lamac. Cam: Josef Wirsching. Ondra-Lamac Film. 1933.

- 1934

 Im Lande des silbernen Löwen
 Dir: Josef Wirsching. Cam: Josef Wirsching. Bavaria Film AG, 1934.

 Stoßtrupp 1917
 Dir: Heinz Zöberlein. Cam: Josef Wirsching. Arya Film, 1934.

- 1953

 Shamsheer
 Dir: Gyan Mukherjee. Cam: Josef Wirsching. Bombay Talkies, 1953.

- 1954

 Baad-Baan
 Dir: Phani Majumdar. Cam: Josef Wirsching. Bombay Talkies, 1954.

- 1959

 Sangram
 Dir: Gyan Mukherjee. Cam: Josef Wirsching. Bombay Talkies, 1959.

- 1960

 Dil Apna aur Preet Parai
 Dir: Kishore Sahu. Camera: Josef Wirsching. Mahal Films, Kamal Pictures, 1960.

- 1972

 Pakeezah
 Dir: Kamal Amrohi. Cam: Josef Wirsching. Mahal Films, Kamal Pictures, 1972.

Josef Wirsching
1958
Gelatin Silver Print, 165 x 109 mm
JWA/ACP: 2019.01.0128

Josef Wirsching leaning on his camera with a colleague reading directorial notes at Kamalistan Studios.

Acknowledgements

Working on this publication has been an absolute revelation and privilege for all those involved from the Alkazi Foundation for the Arts. The narrative of talkies cinema in India had one key element waiting to be explored in detail—the life and times of cinematographer Josef Wirsching, who always kept his pocket-size Leica IIIc Rangefinder at hand. If it were not for Prof. Debashree Mukherjee who drew my attention to the Wirsching Archive in 2015, while assiduously archiving a collection of cinema ephemera in our offices, the last several years of engagement with the Wirsching family and collection as well as subsequent exhibitions may not have been realized through the key participation and consolidated efforts of many individuals and organizations.

In the early stages, I had the pleasure of meeting Wirsching's grandsons, Josef and Georg, together with their mother, Rosamma Wirsching. Over several engaged afternoons, Rosamma told us about how she met Peter Wirsching, Josef's (Sr.'s) son, who even ran a dairy farm in Coimbatore before they eventually came to settle in Goa. Her soft-spoken, self-assured and binding spirit were largely responsible for the years of jovial dialogue and warm friendship that followed, and one that needs to be acknowledged as the very first spark that drew us together. Mrs. Wirsching regrettably passed away in 2021 but she made clear to us that all that was preserved by the family was nurtured as a family heirloom through sheer determination, trial and hard work, and this legacy was as much a part of family history as it was a foundational repository of the history of the moving image in the subcontinent.

Rosamma's two sons, Josef and Georg, remain at the core of this entire endeavour—with Josef, as the elder, always talking about the larger narrative of transnational migration that the family was part of; and Georg, as the archivist and caretaker of the collection, retelling their grandfather's life with early cinema in miniscule detail as the hours went by unnoticed. Both incredible siblings spoke of their grandfather's and father's legacy with knowledge and circumspection that was I immediately envious of! Their dedication, devotion and sheer depth of information about the collection, which they preserved in spite of several personal/professional shifts, needs to be given due commendation. They have managed what few families can while moving from place to place—to actively trace and consolidate cultural pasts.

It was coincidentally in the midst of our discussions that another conversation began with Smriti Rajgarhia, Director of the Serendipity Arts Festival in Goa, whose vision for the interdisciplinary became an important vector for what was to come next. Through SAF's partnership, the Alkazi Foundation managed to align many trajectories—the Wirsching's desire to share the collection with the public, Debashree's interest to scrutinize the collection and my own interest to help curate the exhibition with an eye to lens-based media. And it was with the festival's incredible team, support and the sheer vision anchored by Mr. Munjal, that we collectively realized the exhibition for the first time in Goa in 2017. The scenographer, Sudeep Chaudhuri, played a key role in designing this exhibition, which was, I realized henceforth, something of a familial exercise, given Devika Rani—the star and part-founder of the Bombay Talkies—was also part of his extended family tree!

Josef Wirsching
Gelatin Silver Print, 86 x 117 mm
JWA/ACP: 2019.01.0130

Josef Wirsching in a convertible car during filming of moving shots for an early Bombay Talkies film.

From there, the exhibition travelled to Chennai through an extended collaboration with the Goethe Institut, and its Director in the region, Mr. Helmut Schippert, who spearheaded the project on ground. And, finally, the exhibition was subsequently showcased in Delhi, organized by Art Heritage gallery, the sister concern of the Alkazi Foundation for the Arts.

Much of what has happened since has once again been thanks to the editorial guidance of Prof. Mukherjee; the incredible scholarship of the authors; the Foundation's Trustees and the assistance of Jennifer Chowdhry Biswas and Hitanshi Chopra; as well as the Wirschings' drive to see the publication through. Once the manuscript was handed over to the co-publisher, Mapin, our long-term partner and extraordinary arts publisher, it has been carefully managed by Mithila Rangarajan, Neha Manke and Gopal Limbad, working with Bipin Shah and the extended team.

I would like to thank all of the above for bringing this book to life, and especially towards the final stages, research papers on early cinema carefully compiled by the late Dileep Padgaonkar as well as the family archive of Mr. Peter Dietze. We are extremely grateful to all the family estates for generously sharing important letters and articles with us!

And now, we are immensely honoured to present to the public at large, this unique volume on the alternative history of Indian cinema!

Rahaab Allana, Alkazi Foundation

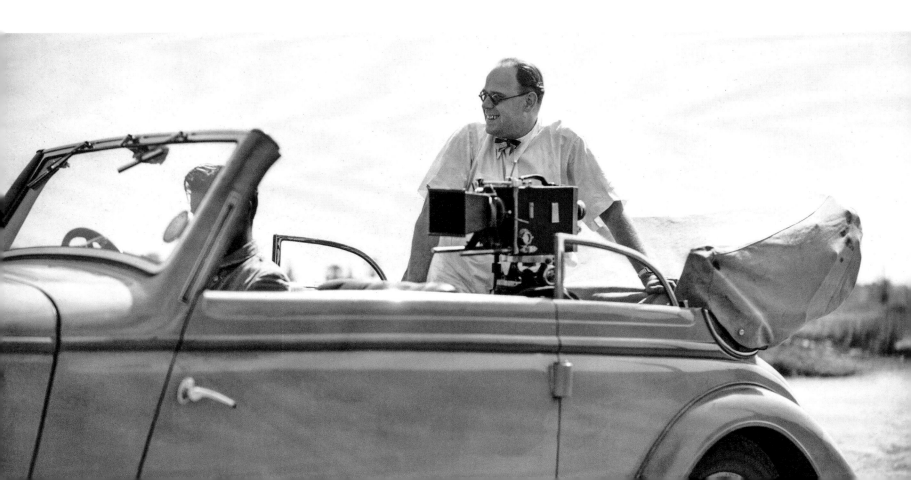

Works Cited

Agamben, Giorgio. 2000. "Notes on Gesture." In *Means without End: Notes on Politics (Theory Out of Bounds)*, translated by Vincenzo Binetti and Cesare Casarino. Minneapolis: University of Minnesota Press.

Akbar, Khatija. 1997. *'I Want to Live': The Story of Madhubala*. Reprint of *Madhubala: Her Life, Her Films* (1977). New Delhi: Hay House.

Barker, Jennifer. 2009. *The Tactile Eye: Touch and the Cinematic Experience*. Berkeley: University of California Press.

Barthes, Roland. 1977. "The Third Meaning: Research Notes on Some Eisenstein Stills." In *Image, Music, Text*, translated by Stephen Heath, 52–68. New York: Noonday Press.

Bazin, André, and Hugh Gray (trans.). 1971 (reprinted 2005). *What Is Cinema? Vol. 2*. Berkeley, Los Angeles: Univ. of California Press.

Beckman, Karen, and Jean Ma, eds. 2008. *Still Moving: Between Cinema and Photography*. Durham: Duke University Press.

Bergfelder, Tim, Sue Harris, and Sarah Street. 2007. *Film Architecture and the Transnational Imagination: Set design in 1930s European Cinema*. Amsterdam: Amsterdam University Press.

Bichard, Robert S. 2008. "90 Years of Precision," *American Cinematographer*, vol. 89, no. 6 (2008): 68–81.

Burgin, Victor. 2004. *The Remembered Film*. London: Reaktion Books.

Campany, David. 2008. *Photography and Cinema* London: Reaktion Books.

Caroll, Noël. 1990. *The Philosophy of Horror or Paradoxes of the Heart*. London: Routledge.

Collier, Lionel. 1929. "Trade Shows Surveyed." *Kinematograph Weekly*, vol. 38 (June), cited in *Film Architecture*, 118.

Confino, Alon. 1997. *The Nation as a Local Metaphor: Württemberg, Imperial Germany, and National Memory, 1871-1918*. Chapel Hill, NC: University of North Carolina Press.

Deep, Mohan. 1998. *Simply Scandalous: Meena Kumari*. Mumbai: Magna Books.

———. 1996. *The Mystery and Mystique of Madhubala*. Mumbai: Magna Books.

Desai, Meghnad. 2013. *Pakeezah: An Ode to a Bygone World*. New Delhi: Harper Collins.

Dwyer, Rachel. 2011. "Bombay Gothic: 60 years of *Mahal/The Mansion*, dir. Kamal Amrohi, 1949." In *Beyond the Boundaries of Bollywood: The Many Forms of Hindi Cinema*, edited by Rachel Dwyer and Jerry Pinto, 130–155. Oxford: Oxford University Press.

Dwyer, Rachel. 2006. *Filming the Gods: Religion and Indian Cinema*. London: Routledge.

Eisner, Lotte H. 1969. *The Haunted Screen: Expressionism in the German Cinema and the Influence of Max Reinhardt*. London: Thames and Hudson.

Elcott, Noam. 2018. "The Phantasmagoric Dispositif." In *Picture Industry: A Provisional History of the Technical Image, 1844-2018*, edited by Walead Beshty, 788–800. Feldmeilen, Switzerland: LUMA Foundation; Annandale-on-Hudson, New York: Center for Curatorial Studies, Bard College.

Evans, Richard. 2006. *The Third Reich in Power, 1933–1939*. London: Penguin Books.

Fay, Jennifer. 2018. *Inhospitable World: Film in the Time of the Anthropocene*. New York, NY: Oxford University Press.

Frahm, Peter. 1937. "Besuch der Emden–Festtage in Bombay." *Der Deutsche in Indien*, vol. 12, no. 9 (April 1937): 9.

Freud, Sigmund. 1965. "The Uncanny." In *The Penguin Freud Library, Vol. 14: Art and Literature*, 335–376. London: Penguin.

Ghosh, Nabendu. 1997. *Ashok Kumar: His Life and Times*. New Delhi: Harper Collins.

Gunning, Tom. 2014. "Cinema of Digits: The Elusive Touch, the Evasive Grasp, the Open Gesture." Presentation at the Center for 21st Century Studies, University of Wisconsin-Milwaukee (December). Unpublished manuscript.

Gunning, Tom. 1994. *D. W. Griffith and the Origins of American Narrative Film: The Early Years at Biograph*. Urbana: University of Illinois Press.

Halsall, Eleanor Anne. 2016. *The Indo-German Beginnings of Bombay Talkies, 1925–1939*, PhD diss., SOAS, University of London.

Henderson, K.T. 1914. *The Bombardment of Madras on the 22nd September 1914, by the German Cruiser "Emden."* From photographs, etc. Madras.

Holzer, Anton. 2018. "Picture Stories. The Rise of the Photoessay in the Weimar Republic." *International Journal for History, Culture and Modernity*, vol. 6, no. 1 (2018): 1–39.

Horak, Jan Christopher. 1996. "Munich's First Fiction Feature: Die Wahrheit." In *A Second Life: German Cinema's First Decades*, edited by Thomas Elsaesser and Michael Wedel, 86–92. Amsterdam: Amsterdam University Press.

Inaga, Shigemi. 2009. "The Interaction of Bengali and Japanese Artistic Milieus in the First Half of the 20th c (1901–1945)." *Japan Review* (2009): 149–181.

Jaikumar, Priya. 2006. *Cinema at the End of Empire: A Politics of Transition in Britain and India*. Durham: Duke University Press.

———. 2019. *Where Histories Reside: India as Filmed Space*. Durham: Duke University Press.

Kester, Bernadette. 2003. *Film Front Weimar: Representations of the First World War in German Films of the Weimar Period (1919-1933)*. Amsterdam: Amsterdam University Press.

Kidambi, Prashant, Manjiri Kamat, and Rachel Dwyer. 2019. *Bombay Before Mumbai: Essays in Honour of Jim Masselos*. London; New York; Gurgaon, India: Hurst Publishers; Oxford University Press; Penguin.

Kracauer, Siegfried. 1995. "Calico-World." In *The Mass Ornament: Weimar Essays*, edited and translated by Thomas Y. Levin, 281–290. Cambridge, Mass: Harvard University Press.

———. 1995. "Calico-World." In *The Mass Ornament: Weimar Essays*, edited and translated by Thomas Y. Levin, 81–288. Cambridge, Mass: Harvard University Press.

———. 1993. "Photography." (Originally published in *Frankfurter Zeitung*, October 28, 1927) *Critical Inquiry*, vol. 19, no. 3 (1993): 421–436.

Kumari, Meena. 2014. *Meena Kumari: The Poet, A Life Beyond Cinema*. Translated by Noorul Hasan. New Delhi: Roli Books.

Lejeune, Caroline. 1927 "A War Film from Germany. The Story of the Emden." *The Manchester Guardian*, May 27, 1927: 16.

Mahadevan, Sudhir. 2013. "Archives and Origins: the Material and Vernacular Cultures of Photography in India." *TransAsia Photography Review*, vol. 4, no. 1 (2013).

———. 2015. *A Very Old Machine: The Many Origins of the Cinema in India*. Albany: State University of New York Press.

Majumdar, Neepa. 2009. *Wanted Cultured Ladies Only!: Female Stardom and Cinema in India, 1930s-1950s*. Urbana: University of Illinois Press; Delhi: Oxford University Press.

Malik, Amita. 1958. "Padma Shri Devika Rani: An Interview with the First Lady of the Indian Screen." *Filmfare*, March 14, 1958: 33–37.

Manjapra, Kris. 2014. *Age of Entanglement: German and Indian Intellectuals Across Empire*. Cambridge: Harvard University Press.

Manto, Sa'adat Ḥasan. 2008. *Bitter Fruit: The Very Best of Saadat Hasan Manto*, translated by Khalid Hasan, 270–278, 461–469. New Delhi: Penguin Books.
———. 2000. *Stars from Another Sky: The Bombay Film World of the 1940s*. Gurgaon, India: Penguin (reprint).

Marks, Laura U. 1999. *The Skin of the Film: Intercultural Cinema, Embodiment, and the Senses*. Durham, N.C.: Duke University Press.

Mazzarella, William. 2013. *Censorium: Cinema and the Open Edge of Mass Publicity*. Durham; London: Duke University Press.

McBride, Patrizia C. 2016. *The Chatter of the Visible*. Ann Arbor: University of Michigan Press.

Mehta, Vinod. 2013. *Meena Kumari: The Classic Biography*. Noida: Harper Collins.

Merleau-Ponty, Maurice. 2007. "The Intertwining—the Chiasm." In *The Merleau-Ponty Reader*, edited by Ted Toadvine and Leonard Lawlor, 393–414. Evanston, IL: Northwestern University Press.

Mitchell, W. J. T. 2002. "Showing Seeing: A Critique of Visual Culture." *Journal of Visual Culture*, vol. 1, no. 2 (2002): 165–181.
Mitra, Samarpita. 2013. "Periodical Readership in Early Twentieth Century Bengal." *Modern Asian Studies*, vol. 47, no. 1 (2013): 204–249.

Moltke, Johannes Von. 2005. *No Place Like Home: Locations of Heimat in German Cinema*. Berkeley: University of California Press.

Mukherjee, Debashree. 2020. *Bombay Hustle: Making Movies in a Colonial City*. New York: Columbia University Press.

———. 2018. "A Cinematic Imagination: Josef Wirsching and the Bombay Talkies." In *Projects/Processes, Volume I*, edited by Nandita Jaishankar and Arnav Adhikari, 51–67. New Delhi: Serendipity Arts Foundation.

———. 2016. "Scandalous Evidence: Looking for the Bombay Film Actress in an Absent Archive (1930s–1940s)." In *Doing Women's Film History: Reframing Cinema's Past and Future*, edited by Christine Gledhill and Jill Knight, 29–41 Urbana: University of Illinois Press.

———. 2015. *Bombay Modern: A History of Film Production in Late Colonial India (1930s–1940s)*, PhD diss., New York University.

———. 2014. Annotations on "Achhut Kanya". Indiancine.ma. Accessed on February 2, 2019. https://indiancine.ma/BXG/player/F

———. 2009. "Good Girls, Bad Girls." Seminar (Web edition), 598, 2009. Accessed on July 29, 2019. https://www.india-seminar.com/2009/598/598_debashree_mukherjee.htm

Nardelli, Matilde. 2012. "Leafing Through Cinema." In *Framing Film: Cinema and the Visual Arts,* edited by Steven Allen and Laura Hubner. Bristol, UK: Intellect.

Orpana, Jennifer. 2018. "Finding Family in The Times of India's Mid-Century Kodak Ads." *TransAsia Photography Review*, vol. 9 (2018): 1.

Peters, John Durham. 2018. "Infrastructuralism." In *Picture Industry: A Provisional History of the Technical Image, 1844-2018*, edited by Walead Beshty, 768–71. Feldmeilen, Switzerland: LUMA Foundation; Annandale-on-Hudson, New York: Center for Curatorial Studies, Bard College.

Pinney, Christopher. 1997. *Camera Indica: The Social Life of Indian Photographs*. Chicago: University of Chicago Press.

Prasad, M. Madhava. 1998. *Ideology of the Hindi Film: A Historical Construction*. Delhi: Oxford University Press.

Rajadhyaksha, Ashish. 1987. "The Phalke Era." *Journal of Arts and Ideas*, no. 14–15 (July–December 1987): 47–75.

Rancière, Jacques. 2009. "Contemporary Art and the Politics of Aesthetics". In *Communities of Sense: Rethinking Aesthetics and Politics,* edited by Beth Hinderliter, William Kaizen, Vered Maimon, Jaleh Mansoor and Seth McCormick, 31–50. Durham: Duke University Press.

Rodowick, D. N. 2007. *The Virtual Life of Film*. Cambridge, MA: Harvard University Press.

Roychoudhuri, Ranu. 2017. "Documentary Photography, Decolonization, and the Making of 'Secular Icons': Reading Sunil Janah's Photographs from the 1940s through the 1950s." *BioScope: South Asian Screen Studies*, vol. 8, no. 1 (September 2017): 46–80.

Sangari, Kumkum. 1990. "Mirabai and the Spiritual Economy of Bhakti." *Economic and Political Weekly*, vol. 25, no. 27 (July 1990): 1464–1475.

Shetty, Prasad. 2012. "Bombay Talkies and Other Stories of Malad." Bard Studio. April 2012. https://bardstudio.in/bombay-talkies-and-other-stories-of-malad/

Shiel, Mark. 2015. "Classical Hollywood, 1928-1946." In *Art Direction & Production Design*, edited by Lucy Fischer, 48–72. New Brunswick, NJ: Rutgers University Press.

Sobchack, Vivian. 1992. *The Address of the Eye: A Phenomenology of Film Experience*. Princeton: Princeton University Press.

Stetler, Pepper. 2011. "The Object, the Archive and the Origins of *Neue Sachlichkeit* Photography." *History of Photography*, vol. 35, no. 3 (August 2011): 281–95.

Stimson, Blake. 2006. *The Pivot of the World: Photography and its Nation*. Cambridge, MA: MIT Press.

Subramaniam, Arundhathi, ed. 2014. *Eating God: A Book of Bhakti Poetry*. Gurgaon, India: Penguin.

Tappin, Stuart. 2002. "The Early Use of Reinforced Concrete in India." *Construction History*, vol. 18 (2002): 79–98.

Thomas, Rosie. 2014. *Bombay Before Bollywood: Film City Fantasies*. Hyderabad: Orient Black Swan.

Us-Salam, Ziya. 2010. "Murthy's Moment." *The Hindu*, January 21, 2010. https://www.thehindu.com/features/cinema/Murthys-moment/article16838796.ece

Wagg, Valerie. 1946. "Dadar: India's Hollywood," *Chicago Daily Tribune*, July 21, 1946.

Wollen, Peter. 2007. "Fire and Ice." In *The Cinematic,* edited by David Campany, 108–13. London, UK; Cambridge, MA: Whitechapel; MIT Press.

SUGGESTED READING

Barnouw, Erik, and Subrahmanyam Krishnaswamy. 1980. *Indian Film*. New York: Oxford University Press.

Bhaumik, Kaushik. 2001. *The Emergence of the Bombay Film Industry*. PhD diss., Cambridge University.

Booth, Gregory. 2008. *Behind the Curtain: Making Music in Mumbai's Film Studios*. Oxford & New York: Oxford University Press.

Dass, Manishita. 2016. *Outside the Lettered City: Cinema, Modernity, and the Public Sphere in Late Colonial India*. New York: Oxford University Press.

Gangar, Amrit. 2001. *Franz Osten and the Bombay Talkies: A Journey From Munich to Malad*. Bombay: Max Mueller Bhavan.

Pal, Niranjan, P. K. Nair, Kusum Pant Joshi, and Lalit Mohan Joshi. 2011. *Niranjan Pal: A Forgotten Legend & Such is Life: An Autobiography*. London: South Asian Cinema Foundation.

Rajadhyaksha, Ashish, and Paul Willemen. 1998. *Encyclopedia of Indian Cinema*. New Delhi: Oxford University Press.

Vasudevan, Ravi. 2011. *Melodramatic Public: Film Form and Spectatorship in Indian Cinema*. New York: Palgrave Macmillan.

Virdi, Jyotika. 2003. *The Cinematic ImagiNation: Indian Popular Films as Social History*. New Brunswick, N.J.: Rutgers University Press.

Vitali, Valentina. 2008. *Hindi Action Cinema: Industries, Narratives, Bodies*. Bloomington: Indiana University Press.

Index

A

Aath Din 167
Abbas, K. A. 36, 125, 165, 169, 171, 178
Acharya, N. R. 77, 157, 163
Achhut Kanya 24, 40, 45, 51, 58, 63, 65, 87, 88, 106, 108, 112, 114, 115, 120, 129, 141, 144, 159, 168, 171, 185, 186, 191
Agamben, Giorgio 102, 190
Ajanta Cinetone 179
Alam Ara 178
Ali, Mumtaz 36, 40, 41, 68, 77, 89
Always Tell Your Wife 23, 36, 72, 128, 160, 186
amateur photography 54
Amrohi, Kamal 20, 34, 46, 108, 118, 119, 120, 122, 123, 125, 159, 179, 186, 187, 190
Anand, Dev 24, 25, 176, 179
Andaz 179
Andrée, Madame 36, 37, 61, 176
Anjaan 163, 168
anti-anti-illusionist stance 71
anti-illusionism 70
Anyaya 176
Arnold, August 13, 183
Art Deco 26, 38, 51, 106, 108
Asphalt 132
Atget, Eugène 78
Atre, P. K. 165, 178
Azad 129
Azurie, Madame 36, 39, 42

B

Baazi 179
Bachchan, Amitabh 178
Backstage Media 63
Bahadur, Rai 42, 160, 161, 178
Bandhan 39, 163, 165, 168, 171
Bandini 179
Banerjee, Saradindu 129, 178
Barthes, Ronald 60, 92, 93, 98, 99, 103, 190
 elaboration of cinema's obtuse meaning 93, 98
 evaluation of stills from Sergei Eisenstein's *Ivan the Terrible and Battleship Potemkin* 93
Basant 118, 163, 171, 173
Bauhaus 26, 38, 51, 108
BAW Censor certificate 185

Bazin, André 73, 190
behind-the-scenes photograph 45
Bengali reformist novels 38, 51
Bengal school portraiture 26, 36
Berliner 49, 56, 182
Berliner illustrierte Nachtausgabe, also Berliner 49, 56
Bhabhi 46, 65, 128, 129, 131, 132, 134, 137, 147, 165, 171, 186
bhadralok 157
Bhakti tradition 85
Bhaumik, Kaushik 8, 11, 46, 47, 159, 192
Bhavnani, Mohan 26
Bhils 85, 90, 101
Bilwamangal 159
Blue Angel 132
Bombay Film Industry 192
 influence of German Expressionism 29
Bombay Talkies 11, 14, 17, 19, 20, 23, 24, 25, 27, 28, 29, 31, 33, 34, 35, 36, 37, 38, 39, 40, 41, 42, 45, 46, 47, 49, 50, 51, 52, 53, 56, 58, 60, 61, 63, 64, 67, 68, 70, 72, 73, 74, 77, 78, 81, 83, 84, 86, 87, 88, 89, 94, 96, 99, 100, 105, 106, 107, 108, 109, 111, 112, 114, 115, 117, 118, 120, 124, 125, 127, 128, 129, 130, 131, 132, 134, 137, 138, 141, 142, 143, 144, 146, 147, 148, 151, 152, 153, 154, 156, 157, 159, 160, 161, 162, 163, 164, 165, 167, 168, 169, 171, 172, 173, 174, 176, 177, 178, 179, 182, 183, 184, 185, 186, 190, 191, 192
 cosmopolitan crew at 36
 departments 35, 36
 equipment 14, 20, 21, 36, 57, 58, 63, 65, 137, 153, 154, 183
 films 14, 17, 20, 23, 24, 26, 27, 28, 29, 31, 35, 37, 38, 39, 40, 41, 45, 46, 50, 51, 56, 87, 88, 90, 101, 105, 106, 107, 108, 109, 112, 115, 117, 118, 123, 125, 127, 128, 132, 142, 146, 157, 160, 163, 165, 167, 168, 169, 171, 172, 173, 176, 177, 179, 181, 182, 183, 185
 founders 35, 178
 German employees 41
 housing arrangement for salaried staff 36
 legacy of 125, 177
 major stars. *see* Chaudhuri, Devika Rani; Kumar, Ashok
 melodramatic screenplays 31
 mission 35, 85
 mythological film 64, 143
 Najmul Hussain incident 168
 outdoor shots 143
 persons 36, 161, 163
 relationship of Manto with 106, 125, 167

 scriptwriting 165
 selection parameters 35
 sets and locations 152
 shareholders and directors 35
 studio complex 20, 36, 142
 team of European personnel 35, 51, 159, 160
 use of mise-en-scène 34, 125
Bonobhojon 142, 147
Bose 31, 147, 173, 179
Nandalal Bose 147
Nitin Bose 179
Brabourne, Lord and Lady 183
Brecht, Bertolt 28
Burgin, Victor 73, 190
Burman, S. D. 179

C

Cabinet of Dr. Caligari 132
Campany, David 70, 190, 192
candid pictures 50
Casshyap, J. S. 36, 165, 168, 176
Chakrabarty, Amiya 171, 173
Chalti ka Naam Gaadi 118, 179
Char Aankhen 163, 171
Chattopadhyay, Ramananda 143
Chaudhuri, Devika Rani 35, 105
Chitnis, Leela 41, 117, 168, 171, 176
Choudhury, Hiten 173
Chughtai, Ismat 106
Cinemascope 120, 123
clapper boy 42, 68
Creed, Charles 160, 177
cultural exchange in cinema 26

D

Daera 20, 179
Dalit character 115
Daub, Ewald 181, 185
Deedar 179
Delhi Durbars (1877, 1903 and 1911) 54
dépaysement 78
Desai Chimanlal 172, 179
Desai Meghnad 123, 190
Desai V. H. 41, 131, 132
Devdas 179
Devi, Maya 42, 49, 67, 68, 129
Devi, Renuka (Khurshid Mirza) 41, 129, 134

Devi, Saraswati 36, 39, 109
Devi, Seeta 106, 107
Devi, Sunita 89
Dharamsey, Virchand 8, 11, 46, 47, 159
Die Form 78
Dietze, Peter 142
Dil Apna aur Preet Parai 20, 42, 44, 106, 108, 116, 118, 119, 120, 187
Dinshaw, F.E. 142, 161
distribution of cinema theatres 41
Do Bigha Zamin 179
documentary photography 78
Door Gagan ki Chhaon Mein 179
Durga 129, 186
Dutt, Guru 118, 179
Dwivedi, Ramchandra Narayanji 178
Dwyer, Rachel 8, 11, 45, 105, 117, 190, 191

E

Eastmancolor 123
Emden 11, 47, 181, 182, 183, 185, 187, 190, 191
Emden-based films 47, 181, 182, 183
 Die Manner der Emden 181
 Emden—Havens Fribytare 182
 Kreuzer Emden 11, 181, 182, 183, 187
 Mit Kreuzer Emden in die Welt 182
 The Raider Emden 182
 Unsere Emden 181, 186
Emelka 13, 14, 15, 19, 24, 26, 27, 28, 29, 31, 55, 167, 181, 182, 183
event photography 50

F

*fakir*s 56
Fay, Jennifer 127, 190
female extras 63
film financing 63
Filmistan 37, 42, 117, 162, 163, 165, 167, 171, 176, 178
Filmistan studio 41, 112, 162, 165, 167, 172, 177
filmmaking 13, 21, 24, 25, 42, 47, 74, 86, 93, 132, 153, 159
film theatres per capita 41
"Film Und Foto" exhibition 74
French Impressionism 78

G

Ganga Jamuna 179
Gateway of India 54, 55, 128, 185

German chromolithographic techniques 26
German Expressionism 29, 31, 51, 78
Goebbels, Joseph 112
Grand, Camilie Le 160, 177
Great Eastern Film Corporation (Delhi) 15, 27, 28, 29, 31, 55, 167
Greenberg, Clement 70
Gubernatis, Count Angelo de 160, 177
Guha, Shrishanti 142, 147
Guide 179
Gunning, Tom 83, 93, 98, 190

H

Half Ticket 179
Halsall, Eleanor 8, 11, 29, 47, 106, 187, 190
Hare Rama Hare Krishna 179
Heimat 146, 147, 191
Hesse, Herman 28
Hindu-Muslim riots 133
Hitchcock, Alfred 26
Hollywood 24, 25, 107, 142, 157, 192
Holzer, Anton 56, 190
Homji 36, 39, 109
Manek Homji 36, 39, 109
Hussain, Najmul 23, 36, 88, 109, 161, 167, 168

I

idiosyncratic personal gestures 102
Illustrated Weekly of India 54
images document processes 57
 motion in stills 57
Imperial Film Company 178
Indianness 46
The Indian Tomb 26
Indrasabha 178
industrial photography 54, 79
Izzat 11, 25, 37, 45, 60, 61, 68, 81, 83, 84, 85, 86, 87, 88, 89, 90, 91, 94, 96, 98, 99, 100, 101, 102, 103, 120, 128, 129, 152, 153, 154, 165, 167, 168, 169, 176, 178, 182, 185, 186
 cinematographic shoot 84
 depiction of inequalities of power, desire and control 85
 fantasy and impersonations in 93
 film's dramatic tension 85
 final sequence 89
 gestures of capture 89
 plots 51, 85, 90, 91, 131, 132, 133
 romance parallel plot 85
 romance 51, 85, 87, 108, 117, 182

J

Jaikumar, Priya 8, 11, 45, 57, 81, 83, 107, 115, 157, 190
Janma Bhoomi 88, 129, 186
Jawani ki Hawa 17, 23, 31, 39, 42, 51, 53, 56, 57, 58, 61, 63, 67, 74, 78, 109, 111, 128, 138, 141, 163, 167, 168, 173, 186
Jeevan Naiya 19, 33, 34, 47, 88, 101, 105, 112, 128, 130, 186
Jeevan Prabhat 40, 42, 65, 68, 129, 138, 154, 165, 168, 186
Jhoola 163, 171

K

Kagaz ke Phool 179
Kakuzo, Okakura 147
Kamal, Amrohi 20, 34, 44, 46, 108, 118, 120, 122, 123, 125, 159, 177, 179, 186, 190
Kangan 106, 117, 129, 163, 165, 168, 171, 184, 186
Kanpo, Arai 147
Kapal Kundala 160
Kapoor, Raj 177, 178, 179
Karma 106, 107, 161
Karmakar, Radhu 179
Kathak dance 38
Khan III, Aga 160
Kiermeier, Willi 14, 19, 28, 31
Kingdon, Dorothy 159, 177
Kismet 24, 39, 117, 163, 171, 172, 173, 178
Kodak camera 56
"Kodak Girl" 56
Kracauer, Siegfried 49, 50, 71, 72, 137, 191
Kramrisch, Stella 26
Krishna Film Company 161, 178
Krishna Movietone 179
Kumar, Ashok 24, 37, 40, 41, 42, 45, 46, 49, 53, 57, 73, 83, 84, 85, 87, 88, 94, 101, 102, 109, 112, 114, 117, 118, 123, 124, 125, 130, 144, 152, 156, 162, 163, 167, 168, 169, 171, 173, 176, 177, 178, 179, 185, 190
Kumar, Dilip 125, 171, 177, 179
Kumar, Kishore 176, 179
Kumar, Raj 46, 119, 123
Kumari, Meena (Mahjabeen Bano) 45, 105, 108, 118, 119, 120, 122, 123, 124, 125, 144, 190, 191
Kumar-Rani starrers 88

L

Lall, Chuni 42, 160, 161, 178
lighting set-up 65, 132, 141
　　sources 24, 34, 46, 70, 177, 185
The Light of Asia 13, 14, 15, 17, 26, 27, 28, 29, 31, 55, 56, 106, 132, 167, 181, 183, 186
Liguoro, Eugenio de 160, 177, 178
Lohmann, Captain Walter 183

M

Maa 176, 186
Madan J. J. 160, 178
Madan Theatres 159, 178
Madhubala (Mumtaz Jahan Begum Dehlavi) 45, 105, 108, 116, 117, 118, 119, 125, 177, 190
Madhumati 179
Mahadevan, Sudhir 8, 11, 42, 49, 52, 56, 79, 153, 191
Mahal 20, 34, 35, 42, 45, 107, 108, 116, 117, 118, 119, 120, 122, 123, 176, 177, 179, 186, 190
Maharaja of Jaipur 14, 28
Majumdar, Phani 108, 115, 163, 176, 187, 191
Mamta 138, 168, 172, 186
Mamta or *Mother* 138, 172
Manjapra, Kris 29, 106, 191
Mann, Thomas 28
Manoos 115
Manto, Sa'adat Hasan 101, 106, 125, 131, 167, 178, 191
Marathas 85
Marconi, T. 160, 161, 178
Marey, Étienne-Jules 57
Mashaal 176
Mathur, R. D. 123, 163
Max Reinhardt's Kammertheater 25
McBride, Patrizia 52, 79, 191
Meera 77, 134, 164
Ménilmontant 57
Merleau-Ponty, Maurice 70, 79, 191
Metro-Goldwyn-Mayer Studios 70
Milan 165, 173, 179
Mirza Ghalib 167
Fali Mistry 123
Jal Mistry 123
Miyaa Biwi 36, 72, 168, 186
Mohammed, Ghulam 123
Mr and Mrs 55 118

Mud 167
Mughal-e-Azam 118, 123, 163, 179
Mukherjee, Debashree 3, 8, 11, 23, 41, 46, 51, 60, 122, 127, 142, 178, 191
Mukherjee, Gyan 36, 73, 163, 165, 169, 171, 172, 187
Mukherjee, Sashadhar 36, 42, 52, 67, 68, 117, 154, 161, 162, 163, 165, 167, 171, 178
Müller, Captain Karl von 181
Mumbai Samachar 128
Muqaddar 176
Murthy, V. K. 123, 192

N

Nadira 123
Naqvi, Najam 36, 63, 163, 165, 167
Nateeja 165
nationalism 51, 108
National Socialism 184
　　Nazified German film industry 29
　　NSDAP (National Socialist Workers' Party) 184
　　Reichsfachschaft Film (RFF) 184
　　Reichsfilmkammer (RFK) 183
naturalism 34, 108
Naya Sansar 39, 163, 165, 168, 169, 171
Neue Sachlichkeit, or New Objectivity/Sobriety 74, 192
New Objectivity movement 74
Nicky (Wirschings' pet dog) 51, 54
Nirmala 49, 51, 53, 67, 109, 114, 124, 129, 160, 163, 171, 174, 186
Nurjehan 160

O

onscreen spaces 83
Orpana, Jennifer 56, 191
Osten, Franz 14, 15, 17, 19, 23, 25, 27, 28, 29, 31, 33, 34, 36, 39, 40, 41, 42, 47, 49, 50, 52, 53, 54, 55, 56, 57, 58, 60, 61, 63, 64, 67, 68, 70, 72, 74, 77, 78, 81, 83, 84, 86, 88, 89, 94, 96, 99, 100, 102, 105, 106, 107, 108, 109, 111, 112, 114, 120, 124, 127, 128, 130, 132, 134, 138, 141, 144, 146, 148, 151, 152, 153, 154, 156, 157, 159, 160, 163, 164, 165, 167, 168, 169, 171, 172, 173, 174, 176, 181, 182, 183, 184, 185, 186, 192
Ostermayr brothers (Franz, Peter and Ottmarr) 25

P

Padosan 179
Pai, Dattaram N. 36, 46, 167
Pakeezah 20, 21, 35, 42, 45, 46, 106, 108, 118, 122, 123, 124, 159, 179, 187, 190
Pal, Niranjan 13, 26, 31, 36, 112, 165, 167, 192
Pareenja, R. D. 25, 36, 39, 117, 127, 163, 167, 171, 173
Parsi theatre 25, 160
Patel, Maneklal 161
Peters, John Durham 63, 65, 191
Phalke, D. G. 125
photography 13, 21, 24, 25, 26, 27, 39, 42, 49, 50, 51, 54, 57, 70, 72, 74, 78, 79, 182
　　amateur 54, 56
　　candid pictures 50
　　cinemascope 120, 123
　　colour plate illustrations 146
　　Eastmancolor 123
　　ethnographic and archaeological 54
　　event 50, 57, 90, 99
　　industrial 25, 26, 38, 54, 79, 106
　　location images 83, 153
　　Neue Sachlichkeit or New Objectivity/Sobriety 74, 192
　　photojournalism 54, 56, 78
　　production stills 50, 83, 157
　　profilmic plus photographs 102
　　publicity stills 65, 78
　　sequence image 73, 74
　　snapshot 42, 54, 56, 57, 74
　　technicolor 123
photo-illustrated newspapers 50, 54
photojournalism 54, 56, 78
Pommer, Erich 132
Prabasi 142, 143, 146, 147
Prabhat Studios 115
Pradeep, Kavi 163, 178
Prasad, Kamta 88, 159, 169
Prem Kahani 128, 129, 186
private family album snapshot 54
Production stills 24, 137
profilmic plus photographs 102
profilmic space 83, 101
Progressive Writers' Movement 106
proprioception 102, 103
publicity stills 65, 78
Punar Milan 165
Pyaasa 172, 179

R

Rai, Himansu 13, 14, 20, 26, 27, 28, 31, 35, 36, 42, 47, 50, 57, 58, 81, 83, 88, 94, 106, 107, 108, 117, 131, 132, 142, 160, 161, 162, 163, 167, 168, 171, 173, 178, 183, 184
Rajadhyaksha, Ashish 125, 192
Rajvansh, Motilal 178
Raksharekha 178
Rancière, Jacques 51, 52, 192
Ranjit Movietone 179
Rayvon, Baron von 159
realism 34, 107, 108, 117, 181
Renger-Patzsch, Albert 74, 78
Richter, Robert 183
Roerich, Svetoslav 42, 117
Romeo and Juliet (Shakespeare) 85
Rose-France 57
Roy, Bimal 125, 162, 176, 179, 186

S

Sagar Film Company 179
Sagar Movietone 179
Sahu, Kishore 44, 116, 118, 120, 138, 168, 187
Sander, August 74
Sanskrit play 157
Saroj Movietone 167, 179
Sati Savitri 143
Savitri 46, 49, 50, 64, 65, 142, 143, 146, 147, 148, 151, 152, 153, 156, 157, 160, 178, 186
Schultes, Bertl 14, 19, 28, 31
scriptwriting 165
Seksaria, Govindram 173, 179
sequence image 73, 74
sets and locations 152
 outdoor shots 143
 soundproofed studio floors 137
 sound stages 36, 70, 137
 spaces 52, 54, 65, 83, 137
 terrace set 137
Shah, Naseeruddin 178
Shaheed 171, 176, 179
Shamsheer 73, 187
Shantaram, V. 26
Shanti, Mumtaz 171
Shetty, Prasad 142, 192
Shikari 162
Shiraz 28, 106, 107
snapshot 42, 54, 56, 57, 74
social films 17, 51, 108
spaces of production and rehearsal 65
spatial inventory 49
Spreti, Karl Graf Von 17, 37, 42, 108, 157, 183, 184, 185
Steichen, Edward 50, 79
still photography 25, 29, 34, 40, 45, 47, 52, 57, 65, 70, 72, 73, 74, 79, 93, 99, 102, 105, 107, 111, 112, 119, 122, 123, 144, 159, 163, 167, 185
studio portraiture 54
Sukanya Savitri 143
Sulochana 167
Sumurun 26
Suraiya 118
Swope, John 70

T

Tagore, Abanindranath 146, 147
 Bharat Mata 146, 185
Tagore, Rabindranath 26, 27, 108
Taikan, Yokoyama 147
Tamasha 176
Temple, Sir Richard 47, 142, 161, 163
The Tiger of Eschnapur 26
The Times of India 24, 56, 181, 185, 191
touring tent cinemas 41

U

UFA Studios 35

V

Vachan 47, 52, 70, 73, 77, 127, 163, 164, 171, 186
Vacha, Savak 36, 37, 42, 46, 68, 117, 118, 154, 161, 162, 163, 173, 176, 177
Varma, Raja Ravi 26, 142, 143
Vimochanam 178

W

Wadkar, Hansa 41
Weiss-Blau-Film 13, 26, 183, 185
Western Ghats 34, 46
Weston, Edward 70, 71
Winter Aid programme 184
Wirsching, Charlotte 13, 14, 17, 20, 21, 29, 61, 116, 119, 120, 184
Wirsching, Josef 3, 8, 11, 13, 14, 15, 17, 19, 20, 21, 23, 24, 25, 26, 28, 29, 31, 33, 39, 42, 45, 47, 49, 50, 53, 54, 55, 58, 63, 67, 78, 79, 83, 89, 105, 106, 109, 111, 116, 120, 128, 129, 137, 141, 144, 151, 152, 156, 157, 159, 163, 167, 169, 181, 183, 184, 185, 186, 187, 191
 camera techniques
 cinematography skill
 filmography 183, 186
 lighting styles 34
 migration to Bombay 29, 78
 outdoor location shooting 34, 106
 partnership with Amrohi 34
Wirsching's photography 57, 74, 85, 153, 157
 approach 57, 123
 archive 13, 20, 23, 35, 42, 46, 101, 172
 "backstage" photos 63, 71, 72
 darkness and moonlit shots 31, 108, 117, 118
 gestural hierarchies of power and desire 87
 heterogeneous temporalities of images 60
 in *Izzat* film 45, 83, 98, 99, 101
 locational photographs 24, 42, 45, 50, 83, 102, 108, 137, 152, 153, 157
 modes of registering time in still image 57, 60, 63, 147
 nature of space 54, 56, 65, 74, 83, 101, 118, 137, 153
 order of elements 49, 50
 of star images 45, 105, 112, 118, 125
Wollen, Peter 57, 60, 192

Y

Yahudi 162
Yama-o-Savitri 147

Z

Zehri Saap 178
Ziddi 24, 176, 186
Zolle, Wilhelm (Willy) 17, 184

FOR HER TO FALL IN LOVE WAS FORBIDDEN IT WAS A SIN SHE WAS TOLD "A NAUTCH GIRL IS BORN TO DELIGHT OTHERS, SUCH IS HER DESTINY" - SHE PREFERRED TO DIE A THOUSAND DEATHS THAN TO LIVE AS A BODY WITHOUT SOUL – AND YET WHEN HER RESTLESS SOUL COULD NOT SUPPRESS THIS SURGING DESIRE "TO LOVE AND TO BE LOVED" SHE TOOK BIRTH AS KAMAL AMROHI'S PAKEEZAH